Festival graphics

by
GAIL DEIBLER FINKE

with introduction by
KELLY KOLAR

MADISON SQUARE PRESS

ISBN 0-942604-60-0
Library of Congress Catalog Card Number 97-075833

Cover and Book design by Klotz Graphix

Distributed in North America to the trade and art markets by
North Light Books, an imprint of F/W Publications, Inc.
1507 Dana Avenue, Cincinnati, Ohio 45207 • 1-800/289-0963

Distributed throughout the rest of the world by:
Hearst Books International
1350 Avenue of the Americas, New York, New York 10019

Published by:
Madison Square Press
10 East 23rd Street New York, New York 10010 Fax: (212) 979-2207, Phone (212) 505-0950

Printed in Hong Kong

For **William Marshal**

contents

The Events:

Preface

Welcome to a New Graphic World

My venture into the world of festival graphics began a year ago. I thought it would be more of a guided tour than an old-fashioned safari, but I was wrong. What I innocently assumed would be a walk along a well-trodden path, filled with helpful designers and event planners who had been that way many times before, was in many ways an uncharted jungle. Every event, it seemed, required a new road. Everyone agrees that graphics are important, even vital, to a festival's success, but no one has put together a field guide to event design.

Until now. With the help of men and women who have made their way into the jungle, I've assembled this look at the best of festival and event design. Here you'll find festivals of all sizes and types, one-time events and long-running favorites. All have one thing in common: a consistent graphic identity that enhances their activities and atmosphere.

The principles of graphic identity are easy to follow. In these pages you'll see them applied in many ways. Four block-buster events show what can be achieved with big budgets and gung-ho organizers—but their accomplishments can be scaled down to any budget. The World Cup's powerhouse design team had nearly half a million dollars to spend at each game site, enough to create fantasy landscapes of pyramidal, wood-and-canvas "trees," as well as to transform each stadium inside and out. But using the same principles, designers can accomplish the same goals with only a miniscule budget.

I'd like to thank many people for guiding me through the jungle. Kelly Kolar and Robert Probst introduced me to event design before I knew there was such a thing. Brad Copeland spent many hours helping me understand the monumental undertaking of Olympic Games design. Bill Campbell at the Kentucky Derby Festival and Mark and Jeanette Brennan at Seattle's Ski to Sea festival let me in on the secrets of two of the country's most successful events. Tom Kwiatek and Margaret Barchine at the Bethlehem Musikfest Association showed me how one committee can transform a town with festivals.

John Goldman at GoldmanArts introduced me to the International Festivals & Events Association, where Bruce Skinner, Steve Kennedy, and Mark Tucker gave me invaluable information about the festivals and events industry. Event planner Maury Blitz let me see his perspective on the importance of design. My thanks to Jan Lorenc and Kyle Fisk, who let me excerpt parts of their unpublished master's theses. And finally, thanks to all the people whose work appears here. Doubtless many other festivals deserve to be showcased, but few document their graphics. Perhaps this book will change that.

Welcome to the new world of festival graphics. I hope this guide will help clear the path.

Gail D. Finke

May 1997,

Cincinnati

4

CONFESSIONS OF A DESIGN DIRECTOR
by Kelly Kolar

"Radical design is possible in Ohio," my teacher, mentor, and friend Robert Probst said in Print magazine. This influenced me to believe that anything is possible if you put your mind and spirit to it. So did a universal philosophy that good design is good design, whether it's an advertising campaign, graphics on a t-shirt, or a hot dog wrapper. Each presents an opportunity. Tom Peters, a marketing genius and author of The Pursuit of Wow, refers to that opportunity when he says, "ANYTHING can be made to be special."

Successful design can make an event memorable, no matter how large or small its production.

We have all seen the world change through the hands of talented designers. One of my mentors, the late Nick Sidjakov of SBG in San Francisco, told me that when he and his partners started their business they asked themselves, "Where could we as designers make a difference?" They focused on packaging, and after several years and numerous design awards they had elevated the visual appearance of packaging and the consumer's expectations of it.

As the design profession has grown, design excellence has expanded in many other directions. Today people are increasingly aware of "good design" on all levels. Educated consumers demand and expect a higher standard than ever before. This expectation includes all forms of consumer spending, especially entertainment. Psychologists tell us that as the world becomes increasingly demanding, we seek many forms of relaxation. Marketing tells us that entertainment is one of them. In the last decade we have seen an explosion of growth in the entertainment market, as well as in another area that has become a focus for designers: environmental graphic design.

Event design is a special breed of environmental graphic design. It is about creating a memorable image for visitors, and establishing an identity in an environment. It includes transportation and wayfinding, operations, interpretive and educational exhibits, entertainment, and promotion of products and sponsors. Event design is a kind of hybrid, retailing a product and entertaining a consumer at the same time.

A Little History

When I began working in event design, nearly a decade ago, I was fortunate to work with a client that had a vision. The Greater Cincinnati Bicentennial Commission believed design should play a major role in every bicentennial event. Tall Stacks, the culmination of Cincinnati's bicentennial celebration, has become the signature event the original visionaries hoped for. Repeated in 1992 and 1995, and scheduled again for 1999, Tall Stacks has been successful in part because of an emphasis on design that is not common in the the event and festival industry, yet.

The Commission began planning and fundraising for the 1988 event in 1984. The leaders took a radical step by recognizing the importance of design. Chairman Joseph S. Stern directed Rick Greiwe, the executive director, to research how other cities created their signature events and celebrations. He visited the Indianapolis 500, Boston's Tall Ships, and the Kentucky Derby Festival. He also researched the 1984 Olympic Games in Los Angeles, and noted the incredible publicity generated there by architects and graphic designers.

Intrigued, he invited the design director of the 1984 Olympics, Larry Klein, to visit Cincinnati and speak to designers about the opportunities offered by the Commission's design competition. All of his research led Greiwe to one conclusion: It was imperative that a consistent, understandable, and festive graphic design system be applied to all signage, merchandise, printed and promotional materials, and venue decoration. This meant a look very different from the "carny" look common to so many festivals.

My involvement in the project started when I was a senior at the University of Cincinnati's College of Design, Architecture, Art and Planning. As the pilot project for the School of Design's first course in environmental graphic design, our class entered the public design competition for the city's Bicentennial. Our interdisciplinary student/faculty team created a "look," a color scheme, and a comprehensive system of icons. We won, and I was later hired as design director by the Bicentennial Commission.

My first job description was a mighty tall order: "Responsibility is to implement the Bicentennial Design Standards Guide in event advertising, merchandising, venue design, environmental design, sponsor promotions and product licensing. The expected result is a coordinated design system for Greater Cincinnati which communicates an exciting visual message to visitors and area residents."

There were five Bicentennial events to coordinate. I had approval over use of the graphic system in all advertising and promotional materials, and I worked with the event director to ensure that each venue carried the Bicentennial look. My job was really to create the visual thread that would weave all the events, promotions, educational materials, and permanent legacies (including a new riverfront park and identity projects throughout the city) into a whole. And it had to create a dramatic, memorable image in the minds of a million residents and visitors.

Learning by Fire

My father would have described the way I approached the job of design director as "attitude is more important than

fact." I had no preconceived ideas of what was not possible. In my mind's eye, I saw only opportunity. Larry Klein helped me in consultation numerous times, but the fact is that you can't teach event design. You must learn by doing, even if that means being thrown into the fire.

To help me, I developed a group of masterminds referred to as the "design advisory board." They met on a regular basis to consult on difficult decisions and sticky situations. A five-person, in-house design team produced the work throughout the year, working closely with the area designers and advertising agencies that were embracing the look for hundreds of smaller events and educational programs.

Producing five events in twelve months offered many benefits and challenges. We learned quickly, and were able to recycle many of the environmental design components. We created a venue design system, applying different colors, typefaces, and "topper" designs to the same signs and industrial cardboard tubes. This allowed us to create an individual character for each event. For instance, the giant cardboard tubes used as balloon releases and colonnades at the park dedication were then used as bleacher marks lining the streets for the parade, and finally as boat entrances for Tall Stacks.

Tall Stacks became a regular event, and I became the design director. Just as the new design developed for the 1992

event had its roots in the 1988 celebration, the way my studio works with the Tall Stacks Commission is similar to the way I worked with the Bicentennial Commission. We are technically contractors, but are referred to as "off-site staff." It is important to note that the design director, public relations director, event director, marketing director and education program coordinator have an equal playing field. We share the same philosophy and belief that all five components are equally important. The executive director manages the team and makes final decisions if disputes arise.

The Tall Stacks Commission has benefited from using the same team of designers, because we are so familiar with the goals, mission, and philosophy of the event. Our relationship has also maintained a consistent quality of graphic standards, which really came to life at the 1992 celebration. Each event, we build onto what we accomplished previously. This also ensures the most efficient recycling of materials, tools, exhibits, props, and displays. The event improves with the constant enhancements to each venue.

Learning About Event Design

Because there is no formal education available for event design, one must learn it through a cumulative process that begins with a good design education and develops with an increased understanding of environmental graphic design.

The field of environmental graphic design is difficult to define, because projects often require interdisciplinary design solutions and teams of people from various professions such as architecture, landscape design, lighting, construction management, staging, promotion, advertising, wayfinding, and transportation.

The event designers featured in this book have a wide range of educational backgrounds, and have all gone through a process necessary to create good festival design. That process starts with a good education in either graphics, industrial design, interior design, or architecture. An educational philosophy that emphasizes the design process, problem-solving, and design appropriateness, rather than one focusing on aesthetics, will best serve any designer in today's complex society. Next comes gaining an understanding of how to integrate two- and three-dimensional design to help people connect with the built environment.

One way to do this is through interdisciplinary workshops, projects, or classes. A graduate level thesis project for a respected institution would provide the best opportunity to experiment, explore, and be innovative at creating a comprehensive graphic "look" for an event. An entry-level position with a design firm that integrates several design disciplines provides the best "hands-on" approach.

The Society for Environmental Graphic Design (202-638-5555) is an excellent resource for both formal and continuing education. The SEGD Education Foundation provides listings for educational institutions that teach environmental graphics. Few books or magazines cover the field. Books that I find helpful are Placemakers: Creating Public Art That Tells You Where You Are, by Ronald Lee Fleming and Renata von Tscharner; and any of the Print Casebooks focusing on environmental graphic design. Books I refer to for festival design are The Olympic Image: The First 100 Years, by Wei Yu; and Anniversary Celebration Handbook: A Planning Guide for Cities, Counties and States, by Richard J. Griewe with Phyllis Layton. Useful references on Tall Stacks are Cincinnati 88: The Bicentennial Year in Review, by Mary Lynn Ricks; and Tall Stacks, by J. Miles Wolf.

Dimension

When it comes time to design for a festival or event, you must learn by doing. At our studio, we explore all avenues for research and analysis before beginning any project. We prepare ourselves with many kinds of research, including visits to libraries, bookstores, and similar sites or projects; and by interviewing architects, urban planners, designers, clients, customers, marketing experts, educators, and event planners.

Traveling to the site and photographing the venues are criti-

cal to create a mental sense of place. We create image boards of "issues and opportunities" that give us a basis for our explorations. This resource, along with the design books and magazines mentioned above, will serve you well throughout the design process.

You cannot design your program in a vacuum. The best solutions include multiple perspectives, and are arrived at after several critiques. Build a team of experts or "master-minds" to help you throughout the project. Be conscious of their time, and get their best input by being organized at your meetings and presentations.

To harness the power of design for an event, it's important that the designers play a role in every aspect. For instance, at Tall Stacks every element on site, whether the graphics on napkins or on an entry gate, goes through our studio for design or approval. You must be similarly committed to implementing your design philosophy and strategy in every facet of your event, because many times it's attention to detail that makes the big picture whole.

If you can control all visual aspects of the event, you will have fewer disappointments at the outcome. I have heard time and time again that designers are not proud of their work when they give up the construction document and implementation phases of production. For the best results, you must see the design through from A to Z, including visiting the contractors throughout the process and being on site to inspect the quality of installation. Tight supervision is the only way to ensure quality control.

A mission statement is critical to your success in creating a visual voice. You can use it to create a clear, strong, and consistent message, so that every act and communication contributes to your marketing strategy. When our team sits down to create a look for an event, we strive to make it:

- Memorable –out of the ordinary and full of surprise
- Energetic –not loud, but filled with spirit that comes from within
- Satisfactory to all participants –clients, sponsors, designers, consumers, and volunteers
- Successful –at selling the "product"

If you achieve these elements, you will have a successful event that will create demand for its return.

There are many benefits to having a design standard that plays a significant role in your event. The power of design drives our philosophy, in a way that's shared by many forward-thinking companies such as Starbucks, Chrysler, and Nike. To us, design is so much more than aesthetics. It means solving the consumers' problems, addressing their every concern: how they get to the event site, where they park, how they navigate the site and find what they came for, whether or not they enjoy themselves safely, making sure they recognize the event sponsors and even, in this age of environmental concern, making certain they're recycling!

When you address all these elements, you create a well-designed venue that embodies quality, integrity, and assurance. As Rick Greiwe, executive director for Tall Stacks, says, "It's what sets us apart from other events and makes you fall in love with it time and time again."

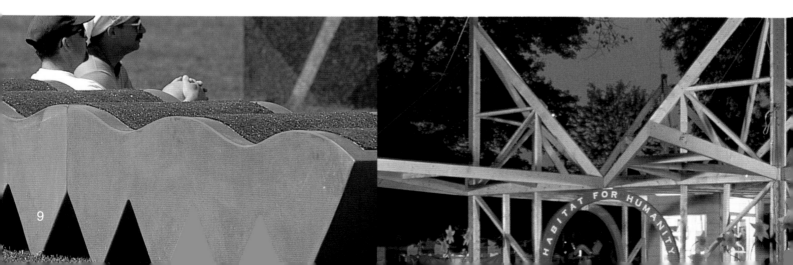

Opportunity to Grow

There aren't many events like Tall Stacks. But every community has at least one event that would benefit from really good design, and most communities have more than one. Knowing the difference design can make to an event, I encourage all event planners to seek out designers. And I encourage all designers who want to move beyond two-dimensional work to look into festival design.

Designing festivals was not something that I planned to do upon entering design school, but I was fortunate to have jumped through the window of opportunity when it was open. For me it has been a great opportunity to expand my design philosophy into so many different mediums. It has been exciting to work with such a diverse realm of manufacturers, and to learn about all the different methods of production, materials, and installation. One day you will be coordinating scaffold riggers and core drillers, and the next day detailing embroidery thread for a six-color patch! Event design has proven to be a continual learning experience, and as designer that's what I strive for with every project. Design is an educational process, and there is always room for improvement and refinement at the next event.

My First Five Events

My first job after college was designing Cincinnati's year-long bicentennial celebration: five major events and innumerable small ones. Here is a sampling of what I learned from this "advanced course" in event design.

The Countdown

We began the Bicentennial year on New Year's Eve, with 27 performance venues sprinkled throughout the downtown buildings connected by second-level "skywalks." The six-hour party, similar to Boston's First Night, ended with a laser light show on the public square. Thirty thousand people rung in the new year while historic slides and images from the Bicentennial icon system were projected on downtown buildings.

At this first event we learned about the vulnerability of unfinished industrial cardboard tubes ... outside, they become soggy and useless! And their Sackcrete anchors left a concrete mess. We learned to order the tubes (donated by a local paper company) with an interior wax coating, and to finish them at the top and bottom. And we designed reusable wooden bases, painted to match the concrete and weighted with sand.

We also decorated our volunteers with funky Tyvec vests, with the theory that one size fits all. This does not work on the majority of people! For the rest of the year we stuck with solid-color pants and designed t-shirts, hats, pins, and name tags for a visible and consistent look.

The Dedication

This three-day event was the dedication of the Bicentennial legacy gift to the city, a 22-acre, state-of-the-art recreational park. The celebration included entertainment, food, fun and

games for the whole family.

The park was itself the decoration and celebration. Our design intent was to complement, not compete, with the park. We focused on creating consistent signage at food courts, decorating the 3,000 welcoming volunteers, and coordinating the look into all items brought into the park. Shopping bags, merchandise, napkins, cups, and even the trash receptacles carried our pictograms and motifs.

The Homecoming

This was perhaps our greatest challenge, five separate events packed into ten days. The peak days began with "200 Years on Parade," continued by a dazzling evening tribute to hometown celebrities, and ending with a fireworks show on the eve of the 1988 All Star Game (also held in Cincinnati). We created "the world's largest birthday cake," shooting off fireworks from the tops of downtown buildings. We had only one rooftop fire, which was quickly extinguished but which caused quite a stir for insurance, safety, and fire officials.

Designing the parade was a gigantic project. How do you decorate a concrete "streetscape" and create a festive sense of place with the streets closed for only 12 hours prior to the event? Our answer was to maximize the use of bold, brilliant color. We hung streamers from the tops of light poles and banners along the bleacher sections, and painted a blue stripe along the parade route. The most powerful statement was covering a whole city block with our Bicentennial blue. I found discontinued marine-grade blue carpet at a Dalton, GA, factory and ordered it shipped up. Remember to check the size of your shipments so you're prepared to receive them! A city block's worth of carpet is a truckload.

Be careful of aesthetically pleasing ideas that don't work well in reality. We painted the 88 logo on the center of the carpet, so we could tell participants to "smile when you hit the logo, you're on TV!" This was great in theory, but we didn't know to have all the parade animals walk over the design ahead of time to get used to it. A few close calls with charging horses and an elephant made us redirect the animals around the logo.

Tall Stacks

One million people came to celebrate the year's crowning glory: Tall Stacks, a celebration of the stern-wheeler age in America. For 50 hours, we created a temporary theme park on the riverfront, complete with more than 20 steamboats, historic recreations, and contemporary exhibitry. The event also became a legacy; it's been repeated twice and will be held again in 1999.

From the beginning, the design for Tall Stacks was a collaboration among many talented designers, architects, landscape architects, scenery painters, planners and dedicated volunteers -- more than 6,000 people. We set up our own committee of volunteers for event decorations and props. They helped to plant 2,000 donated mums, and distribute hundreds of pumpkins, gourds, and bails of straw along with antique carts and boat memorabilia. We paint 275 cardboard tubes, bases, and toppers for each event. In addition, we make most of the signs and exhibits with teams of fraternity students and retired people. For the hardest labor, we've even tapped into county probation workers performing community service. Because Tall Stacks is a non-profit organization on a tight budget, we've learned to be resourceful in seeking donations and assistance.

The Birthday

Cincinnati's official birthday on December 28 was completed with a reenactment of the city's founding and a party at the Convention Center. People viewed time capsules created by students for school projects, ate birthday cake, and waited for the opening of the time capsule sealed for the city's centennial in 1888.

A silent auction of Bicentennial memorabilia helped raise funds for the Tall Stacks Commission, and dispose of things that would have otherwise gone to waste. At each subsequent Tall Stacks, we've sold off perishable items such as pumpkins, flowers, and even bales of straw.

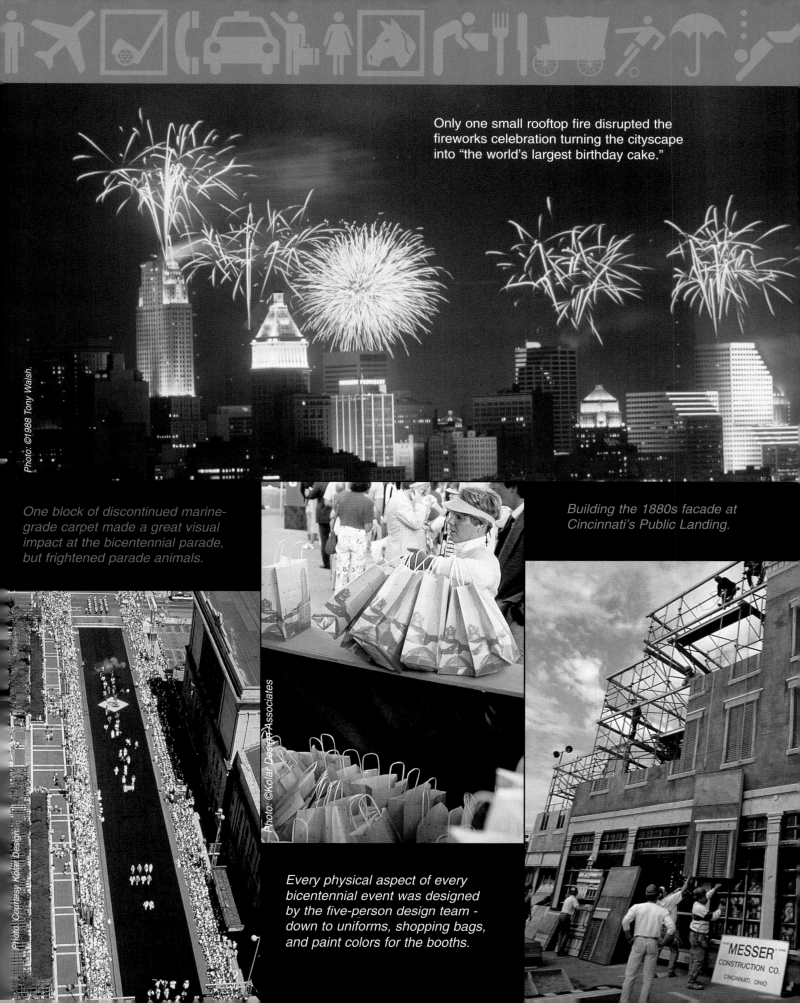

Only one small rooftop fire disrupted the fireworks celebration turning the cityscape into "the world's largest birthday cake."

One block of discontinued marine-grade carpet made a great visual impact at the bicentennial parade, but frightened parade animals.

Building the 1880s facade at Cincinnati's Public Landing.

Every physical aspect of every bicentennial event was designed by the five-person design team - down to uniforms, shopping bags, and paint colors for the booths.

MESSER CONSTRUCTION CO.
CINCINNATI, OHIO

Identity: The Secret Ingredient

All event staffs want two things: lots of attendees, and lots of money from sponsors. More and more, event planners are learning that graphic design can help deliver both.

How? This little-understood tool can improve every phase of an event, from its beginnings as an idea on paper to the final "D day" activities. Design can't create a good event. But it can enhance one, providing a secret ingredient that generates extra income, attendance, merchandise sales, and goodwill. All at a–relatively–small price.

The secret ingredient is identity. For more than a century, companies throughout the world have used it to communicate with their customers and with other companies. By consistently using this "corporate identity," companies show the world who they are and what they do. In business, corporate identity is so important that many design firms specialize in creating design packages for large corporations, for equally large fees.

Companies pay these fees because study after study shows that corporate identity is a sound investment. It brings priceless dividends in customer loyalty and investor confidence. By projecting a consistent and reassuring image throughout their products, packaging, printed pieces, advertising, signs, uniforms, and even building designs, companies show the world that they deliver on their promises.

Festivals and events can use identity the same way, and get the same results. It doesn't have to be expensive, and the principles are simple to understand and use.

What an identity can do

Identity hasn't been important to most event planners, but it's becoming essential. In fact, without good design many events would never happen.

In the past ten years, the number of events and festivals has skyrocketed. Professionals estimate that ten times more festivals and events than there were a decade ago now compete for the same visitors and sponsor dollars. Competition has forced many event planners to adopt strategies from the business world, particularly in fund-raising.

These days, only the smallest events can get by on the money they raise on festival days. The rest need corporate sponsors to pay their bills. Raising money is one of an event staff's most important and difficult jobs. It's particularly difficult with new events, where planners have little more than projections and promises to show potential sponsors.

A good identity, used on stationery, proposals, invitations, and other printed pieces, tells sponsors that a new event is well-run. It gives them something to see and judge, something more tangible than numbers and diagrams. Identity presents a face to the world, and the better the face, the better response planners can expect. In bids for the Olympic Games, for instance, graphic design is as important as infrastructure and hotel space.

New events aren't the only ones that can benefit from identity. The Bellingham, Washington, Chamber of Commerce learned that after holding a spring festival for more than 70 years. After a seminar about design from the International Festival & Events Association, Chamber staffers commissioned an identity package, and saw sponsorship skyrocket. The Ski to Sea Festival, one of the region's best-known and most beloved events, had not changed. But sponsors' perception of it had.

The same is true for attendees. As cities, regions, and even shopping malls race to stage festivals and events, people have more choices than ever before. A design that creates a unified, festive atmosphere will draw people in and make them feel part of a group. The better the design, the better people are likely to feel about the festival, making them want to stay longer and to return. Assuming, that is, that the design accurately reflects the festival, and that the festival is enjoyable.

A good identity can also accomplish many other tasks. Most festivals can concentrate on the few most important to them:

* Building loyalty over time

Known as "equity," this use of identity ensures that, year after year, people can identify the same event and will eventually anticipate it. An identity will do this far more quickly

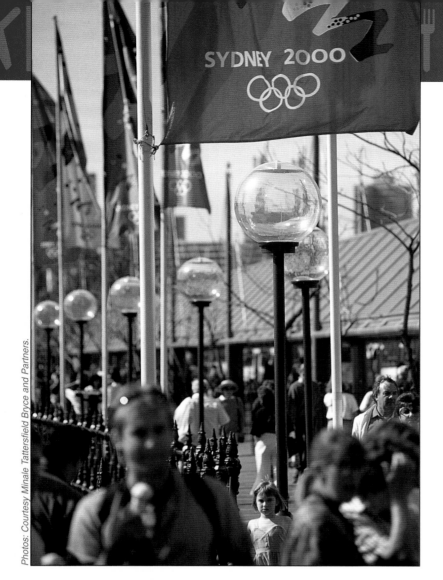

Sydney Olympics:

BUILDING LOYALTY

The graphics for 1984 Los Angeles Olympic Games helped divorce the event from its troubled politics, and set a new standard for festival graphics. Today, bids for the Games always include a graphic identity. These designs are as important as logistics and facilities. In a glance, they communicate a country's hopes and dreams, as well as its understanding of the Olympic ideals.

Graphics for Sydney, Australia's winning bid for the 2000 Games did more than decorate printed documents—they were displayed throughout the city and used with pride during parades, rallies, and other events designed to build local support. The zig-zagging mark in the five colors of the trademarked Olympic rings is based on the shape of the roof at Sydney's world-famous opera house, and on the feel of aboriginal art.

Minale Tattersfield Bryce and Partners
212 Boundary St., Spring Hill,
Brisbane, Queensland, Australia 4067

Commencement:

FESTIVAL ELEMENTS

Graphic design for festivals has much in common with other kinds of design. Boston-based Selbert Perkins Design orchestrated the 1993 commencement ceremony for Northeastern University, President Clinton's first commencement speech. It also launched the school's centennial program. Crowd movement, lighting, sound, and set design were all part of the package, which also included a logo, signs, and banners. The designers worked with television crews to ensure that the design looked good to viewers around the world as well as in the hall.

Selbert Perkins Design
2067 Massachusetts Avenue
Cambridge, MA 02140

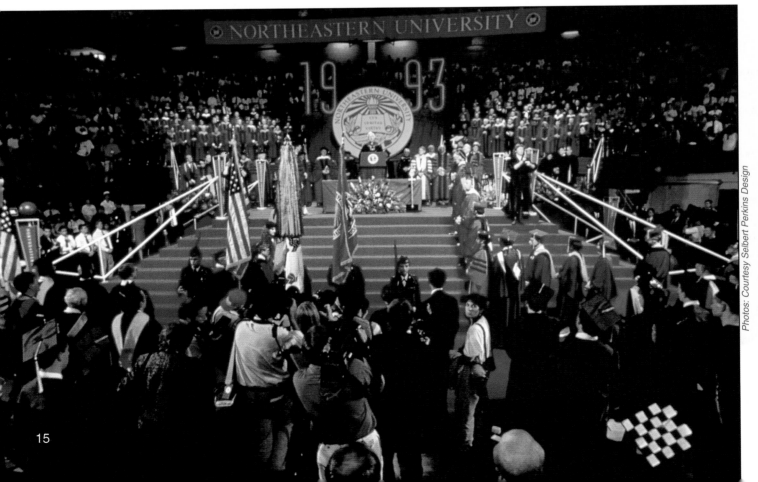

Photos: Courtesy Selbert Perkins Design

15

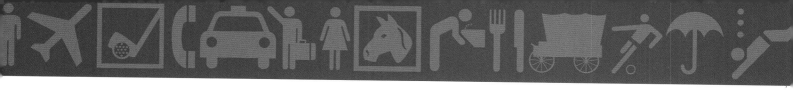

than a name alone, because images are more memorable than words.

Organizers of 7th on Sixth (p. 33), a new event combining the shows of all New York-based fashion designers, hired one of the world's top design firms to create and manage a memorable logo. By emphasizing the logo (rather than designers or clothes) in all advertising, they hope to make the event essential to fashion professionals in only a few seasons.

* Identifying various components

Known as "branding," this identity use is invaluable in business, where "brands" of merchandise gain loyal customers. But branding means much more. By clearly identifying different sites (with signs, banners, etc.) and types of events (with tickets, gateways, uniforms, etc.) a graphic identity unifies many parts that might otherwise be viewed individually.

Competitions at the 1993 World University Games, an Olympic-style event for students, were spread over 14 sites in New York State and southern Canada. Officials chose to use a considerable part of their budget for graphics, visually tying the many parts into one whole.

* Selling merchandise

Another use of branding official merchandise that repeats the festival identity does two important things: 1) It is more likely to sell than other merchandise, providing more money for the festival, and 2) it advertises the festival at no cost to the staff or sponsors.

At Musikfest in Bethlehem, (p. 85) PA, one of the country's biggest music festivals, souvenirs are especially popular. Official posters are such big sellers that the organizers produce two: one typical poster, with the event name and dates, and a limited edition print of the artwork without festival information.

* Transforming space

Very few festivals take place in spaces designed specifically for them. Even special sporting events, such as championship games, usually take place in buildings or fields that have many other uses. With graphic design, a space meant for one thing can be temporarily transformed into one with a different purpose.

When U.S. Major League Soccer began its first season in 1996 (p. 159), the teams played in nine stadiums designed for football games and large football crowds. Organizers used graphics to create a festival at each game—generating excitement and at the same time temporarily making the stadiums smaller.

* Providing clear boundaries

When a festival needs fences, graphic fence covers can make them an asset. When fencing is impractical or unaffordable, signs and other graphics can create clear gateways and boundaries. Graphics can also provide another kind of boundary, visually separating an event from other activities going on at the same time.

The 40-year-old Kentucky Derby Festival (p.149) includes 72 public events over 10 days, including a hot air balloon race, the "race for the golden antlers" between the Delta Queen and Belle of Louisville steamboats, and the largest fireworks show in the United States. Graphics unite these events, and also separate them from private events held by Churchill Downs racetrack, where the Derby is run.

* Introducing a new theme or activity

A new festival depends on its graphic identity to let people know what it's about. For existing events, a new identity can herald a change in event management, or a shift in activities.

The 1992 AmeriFlora flower show (p. 47) relied on graphic design to help people understand that it was both an international floral festival and one of the official events celebrating the 500th anniversary of Columbus's journey to the New World.

* Setting a tone

A graphic identity sets the tone for an event, communicating whether it's exclusive or inclusive, formal or funky.

The graphics for CIGA Weekend at Longchamp (p. 123), the setting for one of France's premier horse races, communicated an atmosphere of wealth and privilege appropriate to the event and its sponsor.

16

* Inspiring devotion

A graphic identity inspires loyalty among paid workers and volunteers, making them feel part of something beyond themselves. It also instills local pride. Maybe this is clearest in designs for Olympic Games bids, which cities adopt and display, sometimes fanatically, to show their support.

How to Get an Identity

Legend has it that the Coca-Cola symbol, the most recognized trademark in the world, was drawn by the pharmacist who invented the drink. That may be the world's luckiest amateur design. While the occasional design dreamed up by an artistic accountant or inventor may be successful, for a sure-fire identity, it's smart to go to a designer.

Corporate identities for giant companies cost tens of thousands of dollars. That money pays for design expertise, but also for tasks such as trademark searches, and research to see if a name is a swear word in another language.

Festivals rarely have that kind of budget. For that reason, few corporate identity firms create festival identities. Even the Centennial Olympic Games in Atlanta, perhaps the largest event ever held, used big-name firms only for the initial design. The organizing committee then turned to local firms or its own staff for applications.

In fact, most event design goes to local designers. Sometimes designers donate their work as a community service or in return for credit. But even paying a full fee can be a bargain. That's because, when it's used consistently, a good identity will increase in value over time.

Because few design firms specialize in events and festivals, most festival identities are created by designers with no previous event experience. For the best design possible, it's important for both clients and designers to understand what makes a good event identity design, and how to apply it. Chapter two will provide that answer.

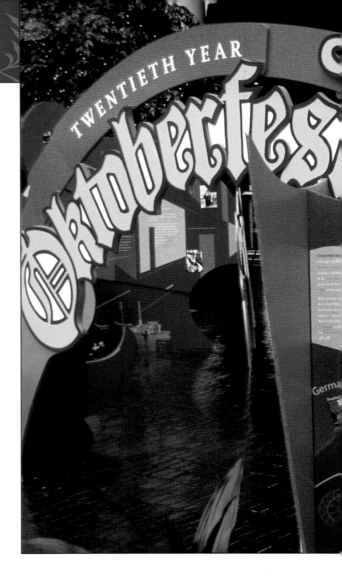

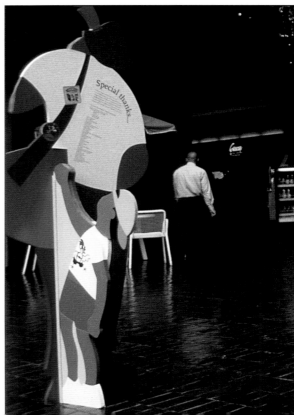

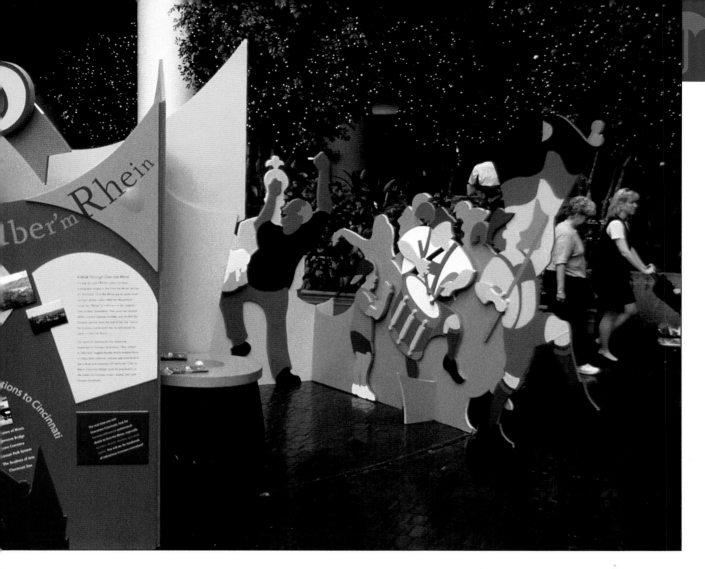

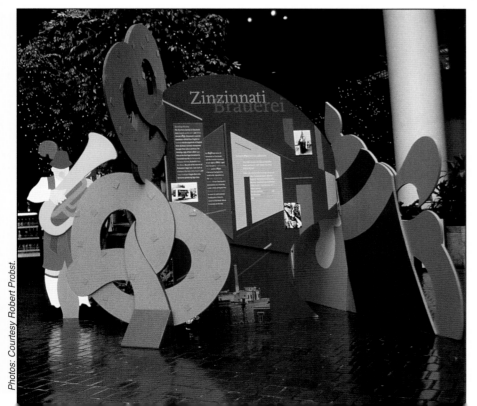

Oktoberfest:

HALF AN IDENTITY

Designed as a class project, these cutout signs and graphics were created by University of Cincinnati students and used as a 1500-sq. ft. traveling exhibition to help celebrate the city's 20-year-old Oktoberfest Zinzinnati. Budget cuts meant that a matching, comprehensive event sign package was never built. The result was a strange juxtaposition: an exciting and engaging identity with no event attached, and a popular but unfocused event without any identity.

University of Cincinnati
College of Design, Architecture,
Art and Planning School of Design
PO Box 210016
Cincinnati, Ohio 45221-0016

The

Brooklyn Academy of Music

1995

Next

Wave

Festival

BAM's 1995 Next Wave Festival is sponsored by Philip Morris Companies Inc.

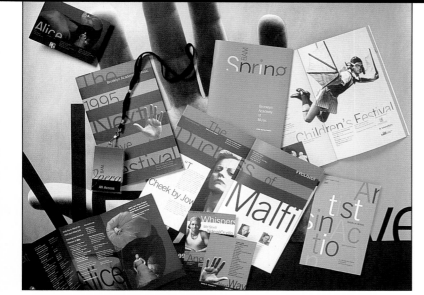

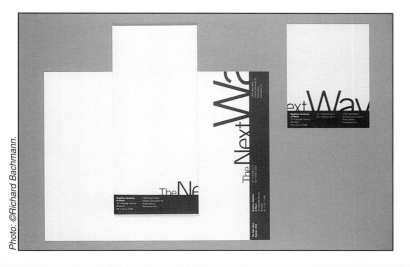

Next Wave Festival:

"FESTIVAL" ONLY IN NAME

Tradition calls a series of related performances a "festival," and often planners go to great lengths to create a sense of public excitement and anticipation. But these almost always remain festivals only in name. Audiences experience each show as separate from the others. A simple package of graphics – signs, banners, colored flags – can help change that, creating the feel of a real, ongoing festival.

The arresting identity created by Pentagram for the Brooklyn Academy of Music's Next Wave Festival has been used since 1995. Although the B.A.M. plans to extend the identity to building signs, it has so far been confined to print, leaving much of its potential untapped.

Pentagram Design
204 Fifth Avenue
New York, NY 10010

Miami Performing Arts Series:

THE STREET BANNER OPPORTUNITY

Now common in urban areas, street banner programs are decorative and informative. Usually controlled by a government agency, they can be used by events and festivals as advance advertising or as part of the event decorations. These designs advertise a performing arts series. The university's in-house fabricators cut the graphics from adhesive vinyl and reuse the vinyl fabric bases.

Miami University
Planning and Construction,
Physical Facilities Department 103
Edwards House Oxford, Ohio 45056

Miami University Performing Arts Series Street Banners

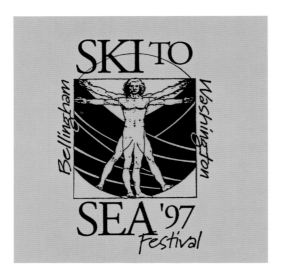

Ski to Sea Festival:

IDENTITY CONVERTS

For 78 years, Bellingham, WA, has held a spring festival. For 24 years, it's been centered on the 83-mile Ski to Sea race, which begins at Mount Baker and ends at a park on the shore of Bellingham Bay. Eight-person relay teams from around the world compete in the race, which includes cross country and downhill skiing, running, biking and mountain biking, canoeing, and sea kayaking. The official festival takes place at the finish line.

The Ski to Sea festival stretches over three weekends and includes a parade, a carnival, an art show, youth and adult races, and a community maritime festival. Although the festival has been popular for decades, attracting several hundred race teams and more than 50,000 spectators for the main race alone, five years ago the Bellingham Chamber of Commerce decided to test a theory. Presenters at the International Festivals and Events Association national conference insisted that a professional graphic identity could make a big difference to even successful festivals.

So the Chamber hired a designer. The result, according to Chamber President Mark Brennan, was such a dramatic increase in sponsorship that the identity program has continued ever since. Each year, designer Scott Montgomery creates a new image for posters, brochures and merchandise. The designs have been popular with both visitors as well as sponsors.

Montgomery and Associates, 344 South Garden St., Bellingham, Washington 98225

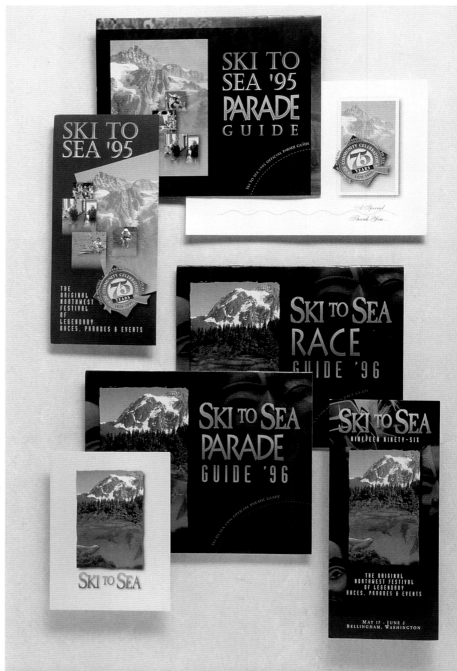

Racefest Fort Worth, 1997:

RAINED OUT

To welcome NASCAR racing to its new Texas Motor Speedway, Fort Worth held a two-day festival spread throughout its downtown entertainment district and historic stockyards. Nature didn't cooperate—rain ruined all but the evening concerts. But rain didn't dampen Fort Worth's enthusiasm for racing or celebrations, and plans are still on track to make Racefest an annual event.

While Racefest has a corporate logo, the festival graphics were based on the official poster—a red and black image of a speeding race car. The festival slogan, "Hear the Thunder," was arranged to suggest that speed. Besides brochures and advertising, the image was also used on official merchandise.

Witherspoon Advertising/Public Relations
1000 West Weatherford, Fort Worth, Texas 76102

The Ideal Identity

CASE STUDY: Kyle Fisk's Designs for "Century in Flight"

The 1984 Los Angeles Olympic Games revolutionized festival graphics. They gave us terms ("the Look of the Games" and the graphic "kit of parts") that defined how designers think about using graphics, and they gave us a level of quality designers still use as a benchmark.

What is their legacy? A way of using identity to unite an event's marketing, environment, and merchandising. The ideal festival identity is a single, flexible design connecting advertising, brochures, posters, banners, uniforms, signs, concessions and souvenirs, so that they work together for maximum appeal to visitors and sponsors, just as corporate identity builds loyalty among its customers and investors.

Many events can't afford that ideal. But many more simply don't know how or why to spend their money on "mere" graphic design. What follows is an outline of the ideal festival identity. Illustrating it are designs for Dayton, Ohio's planned celebration of the centennial of powered flight, scheduled for 2003. The festival will include events of many kinds spaced over the year.

Like many start-up festivals, the 2003 Committee staff didn't have the budget for such a comprehensive design, which might cost $35,000 - $40,000 from an established firm. Happily, Dayton is only an hour from the University of Cincinnati, which offers classes in environmental graphic design, a specialty focusing on signs and other three-dimensional graphics. Graduate student Kyle Fisk was looking for a monumental subject for his master's thesis. The result was a complete set of design standards for the festival, at no charge.

Kyle C. Fisk Design Consultancy

8209 Rhine Way

Centerville, Ohio 45458

phone/fax: 937-435-5154

The Parts of a Festival Identity

The "look" of a festival means the design that creates its overall visual impression. Its many pieces are sometimes called a "kit of parts," which means a set of graphics and other designed pieces that can be put together many different ways. The graphic parts are the logo, colors, typefaces, and additional shapes or images. The physical parts are signs and structures, whether custom shapes and materials or specifications (colors, sizes, etc.) for rented or off-the-shelf items.

Logo

The foundation of any identity system is the logo, which includes the festival name in a distinctive typeface, a focal image, and one or more colors. The logo should be used on all event stationery, print graphics, and advertising, as well as wherever possible at the event.

The colors must be easy to reproduce, and should be readily available from many vendors. The logo must reproduce well at various sizes—from the tiny print on a business card to a mural several stories high. And if the event will receive television coverage, the logo colors must be able to be broadcast clearly. These requirements are often overlooked by designers who generally do only print work.

Vendors, sponsors, and anyone else connected with the event should always use the camera-ready logo artwork provided by a designer. Any time an image is redrawn, it is changed. Before long, the continuity is lost.

A second logo developed for the partnership between similar committees in Dayton and Kitty Hawk, North Carolina.

CENTURY OF FLIGHT ™
DAYTON, OHIO

official logo

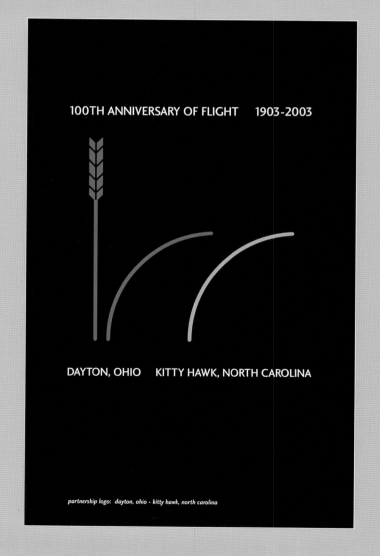

100TH ANNIVERSARY OF FLIGHT 1903-2003

DAYTON, OHIO KITTY HAWK, NORTH CAROLINA

partnership logo: dayton, ohio - kitty hawk, north carolina

Logo Standards

For an additional charge, designers will create drawings of the logo in different colors or configurations, for instance, showing what to do with a black image and a black t-shirt, or how to best arrange a vertical logo for a horizontal piece of paper. Frequently, design standards specifically forbid certain colors or arrangements. This is to keep the design flexible without losing its identity.

Additional Elements: Typefaces

Often, the typeface chosen for a logo is either hand-drawn or so stylized that it's impractical for other uses. Even when the logo typeface is standard, designers may also choose one or more other typefaces to harmonize with it. Several harmonious typefaces are visually pleasing, but even one typeface used consistently makes an immense difference in the impression an event projects. For practical purposes, the typefaces chosen should be readily available to vendors such as printers and vinyl cutters, and as computer fonts or typefaces.

Additional Elements: Images

For an additional charge, designers can also create a standard set of images that can be used with the logo. These decorative elements add variety but provide a consistent look. Comprehensive graphic standards show acceptable and unacceptable uses of these images, and explain how to combine them creatively.

Additional Elements: Color

Because they are to convey the essence of a festival or event at a glance, logos must be simple. A two-color logo can provide all the color needed for some events, but most benefit from a larger palette. As with colors for logos, additional event colors should be available in inks, paints, adhesive vinyls, and cloth, so they can be used as much as possible.

Colors can be simply decorative, or can be used for color coding.

Additional Elements: Artwork

Many events introduce new graphics every year by having an official poster. The festival identity isn't lost, and the new poster is often eagerly awaited by event fans. This kind of changing artwork is also good for merchandise sales, because attendees can collect each year's souvenirs.

Venue Applications: Banners

Banners create a big impact for a relatively small price. Many materials and decorating methods are available, but for the best value, manufacturers recommend appliqued fabric. Appliqued banners can be made in small runs, and will last many years.

Banners can be made in many shapes, and are festive even without any decoration. They can be hung from tents, signs, and temporary poles. Many cities now regulate banners on public light poles, another good place for festival banners. Other festive fabric signs include inflatable balloons and characters, and long tubes of light fabric that float in the breeze like outdoor mobiles.

Venue Applications: Signs

Many event staffs overlook signs, hoping at best that their event won't need them, and at worst, that a hand-printed notice on posterboard will do. But signs are almost always a great help to visitors, and can easily be an inexpensive way to reinforce the graphic identity.

Easy substitutes for handwritten cardboard signs abound. A screenprinter or sign shop can print hundreds (or thousands) of cardboard sheets with a background image that staff members can write on. And with a vinyl-cutting machine and a standard type font, staff members or volunteers can make signs that look close to professional at a much lower cost. For smaller signs, a quickprinter can reproduce a background image onto letter-sized paper that staff members can use in their laser printers. Even laser-printed signs on plain white paper are an improvement, and a quickprinter can laminate them so that they hold up to wind and rain.

100TH ANNIVERSARY OF FLIGHT 1903-2003

DAYTON, OHIO KITTY HAWK, NORTH CAROLINA

100TH ANNIVERSARY OF FLIGHT 1903-2003

DAYTON, OHIO KITTY HAWK, NORTH CAROLINA

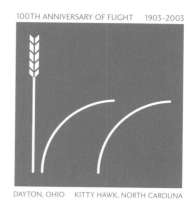

100TH ANNIVERSARY OF FLIGHT 1903-2003

DAYTON, OHIO KITTY HAWK, NORTH CAROLINA

Environmental Theme (Autumn)

Environmental Theme (Winter)

Festive Event (Spring)

Festive Event (Autumn)

Environmental Theme (Summer)

Environmental Theme (Spring)

Festive Event (Winter)

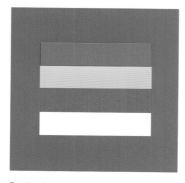

Festive Event (Summer)

The design guide specifies permitted variations.

The designer chose three color palettes that can be combined many ways throughout the year.

Many events can benefit from real signs made by sign fabricators. Parking signs, highway directional signs, pedestrian directional signs, and site identification signs are only some of the possibilities. Such signs, made of wood, metal, or plastic, are a significant expense, but they can usually be reused for many years, or sold. Historical and cultural festivals may also benefit from informational signs presenting educational text and photos.

Occasionally, sign companies will donate or loan more spectacular signs to festivals, in exchange for publicity. While not an option for most events, it is well worth pursuing if a large sign manufacturer is local, or if the event will receive media coverage for its design.

Venue Applications:
Gateways and Other Structures

Because of their size and importance, gateways and other structures make an immense impression. There are many alternatives to basic rented structures. The simplest and least expensive may be to augment such structures with signs, banners, streamers, and other graphics.

One common "structure" is the architectural column made from industrial cardboard tubes, which can be cut to various heights and decorated with painted, printed, or adhesive vinyl graphics. They can be used alone or arranged in colonnades, grouped together for a sculpture effect, or topped with banners, sculptures, or signs.

Some festivals find that it pays to build their own gateways and booths. These can be made of wood, cardboard tubes, fabric, or even recycled junk (see page XX). Some large events may hire architects to create unusual fabric tents or awnings. All of these create a distinctive look.

Applications:
Site-Specific Uses

Many events have specific needs that others do not. Fencing is integral to some events; landscaping to others. A graphic identity can make any site-specific requirements part of a harmonious whole.

Applications:
Souvenirs and Uniforms

Mugs, keychains, clothing, and other souvenirs that bear images from a festival identity sell better than those that don't. They are more appealing because they are usually more attractive, and because they do a better job of reminding people of the event. Whenever possible, souvenir items should include the official logo or other graphics, and should be in the festival colors.

Uniforms for volunteers and paid staff should also be marked with the event identity. They should make the event staff easy to identify, and should also be enjoyable for the staff to wear. Many events find that their official staff shirts, jackets, ties, hats, or other clothing items are proudly worn long after the event. All such sentimental items actually advertise the event for months or years, and so ought to be designed carefully.

Applications:
Print Collateral, Television, Multimedia

From stationery to paper cups, the number of printed pieces an event generates can be truly daunting. With an identity system, however, designing these pieces is much less difficult. The more unified all the printed pieces are, the better impression the event will make. On the other hand, pieces that are not unified destroy the design continuity, even if they are attractive.

Because commercials and web sites are frequently donated, their design is often outside the event staff's control. Nevertheless, both should use the festival identity. They're powerful advertising tools that make people anticipate a certain look. When a potential visitor "tours" a web site and then gets an event brochure that has a completely different look and feel, he or she will be confused and wonder which is accurate.

Getting the Best Value from an Identity

A good festival identity creates an excellent impression that builds loyalty among visitors, helps sell event merchandise,

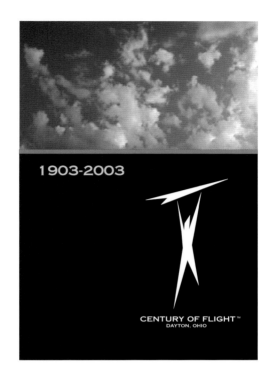

To fit a variety of events, Fisk designed a hierarchy of three poster types.

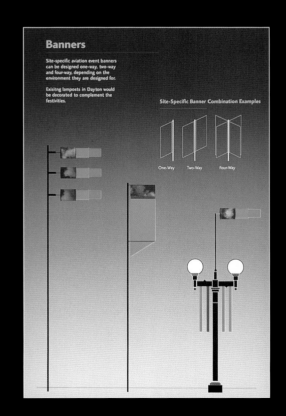

The design guide shows possible banner designs, with and without applied decoration.

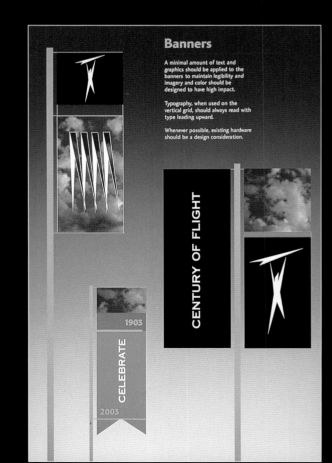

28

and attracts corporate sponsors. If a complete graphic iden-tity package (design of all pieces, custom signs and booths, etc.) is beyond an event staff's reach, they can build one over several years.

The first year, staff should invest in a simple graphic stan-dards system. If the festival has been going on for some time, the existing logo should be incorporated in the new standards, either "as is" or redrawn. If money is a problem, the staff may be able to recruit a design firm as a sponsor, contributing the work instead of money. Students and retired designers are other possible sources for free or low-cost design.

The first year, the new identity should be used on all printed pieces and on every new item produced for the festival. Items such as banners, staff clothing, and paper goods should be ordered in the festival colors. Hand-written signs should be replaced with, at the very least, computer print-outs.

After the first year, the staff can build the festival identity by gradually adding new items and replacing old ones (like sta-tionery) as they run out. If money is available, designers can expand the system with new designs. If not, a staff design manager (either paid or volunteer) should oversee the identi-ty, so that it's used correctly and new items don't have a dif-ferent look.

While designers are specifically trained to use identity, other people can learn to do so. The only danger is that people who are not designers will be too lax, and will allow other images, colors, typefaces, and grids to overwhelm the iden-tity. When that happens, all the money, time, and effort spent on the identity is wasted.

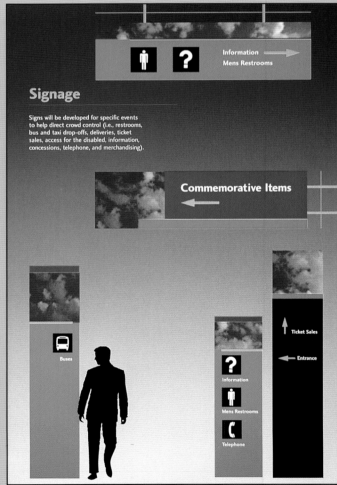

Signage

Signs will be developed for specific events to help direct crowd control (i.e., restrooms, bus and taxi drop-offs, deliveries, ticket sales, access for the disabled, information, concessions, telephone, and merchandising).

Information
Mens Restrooms

Commemorative Items

Buses

Ticket Sales

Entrance

Information

Mens Restrooms

Telephone

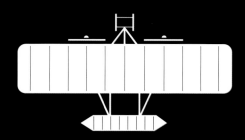

The graphic standards include pictograms and additional artwork.

Removable decals for cars, trucks, and public transportation would advertise the events and identify official vehicles.

Fisk created plans for highway and secondary road signs, as well as pedestrian signs marking booths and directing traffic.

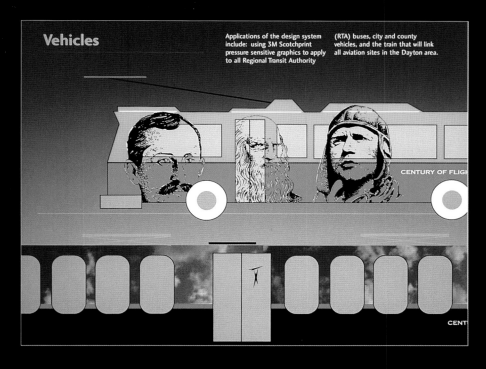

Vehicles

Applications of the design system include: using 3M Scotchprint pressure sensitive graphics to apply to all Regional Transit Authority (RTA) buses, city and county vehicles, and the train that will link all aviation sites in the Dayton area.

CENTURY OF FLIGHT

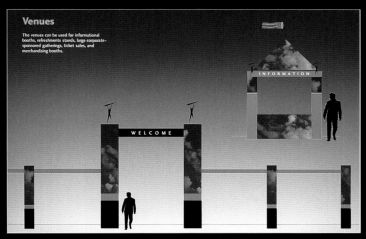

Venues

The venues can be used for informational booths, refreshments stands, large corporate-sponsored gatherings, ticket sales, and merchandising booths.

INFORMATION

WELCOME

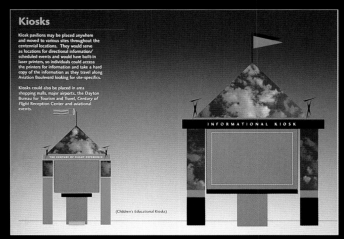

Kiosks

Kiosk pavilions may be placed anywhere and moved to various sites throughout the centennial locations. They would serve as locations for directional information/ scheduled events and would have built-in laser printers, so individuals could access the printers for information and take a hard copy of the information as they travel along Aviation Boulevard looking for site-specifics.

Kiosks could also be placed in area shopping malls, major airports, the Dayton Bureau for Tourism and Travel, Century of Flight Reception Center and aviation events.

INFORMATIONAL KIOSK

THE CENTURY OF FLIGHT EXPERIENCE

(Children's Educational Kiosks)

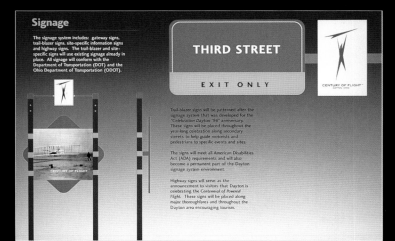

Signage

The signage system includes: gateway signs, trail-blazer signs, site-specific information signs and highway signs. The trail-blazer and site-specific signs will use existing signage already in place. All signage will conform with the Department of Transportation (DOT) and the Ohio Department of Transportation (ODOT).

THIRD STREET

EXIT ONLY

CENTURY OF FLIGHT
DAYTON, OHIO

CENTURY OF FLIGHT

Trail-blazer signs will be patterned after the signage system that was developed for the "Celebration Dayton '96" anniversary. These signs will be placed throughout the year-long celebration along secondary streets to help guide motorists and pedestrians to specific events and sites.

The signs will meet all American Disabilities Act (ADA) requirements and will also become a permanent part of the Dayton signage system environment.

Highway signs will serve as the announcement to visitors that Dayton is celebrating the Centennial of Powered Flight. These signs will be placed along major thoroughfares and throughout the Dayton area encouraging tourism.

The designer created a family of gateways, booths, and informational kiosks that can be broken down and reused throughout the year.

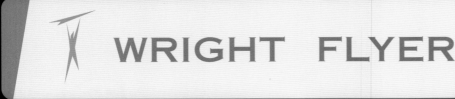

WRIGHT FLYER

Fisk designed a toy "Wright flyer" as a souvenir to be sold at concession stands and distributed at school and community festivals.

Graphic standards usually show how the design can be used for merchandise and uniforms. Such drawings are meant as examples for vendors, not as finished designs.

Commemorative Items

A variety of commemorative pins and jewelry will feature the logo and pictograms and other elements from the Design Style Guide. Using a variety of material, such as precious metals, plastics and rubber, will offer individuals various price-point options.

Assortments of commemorative shopping bags that can be distributed throughout area shopping stores will be available. Different sizes ranging from standard size shopping bags and shoe bags will be available to consumers.

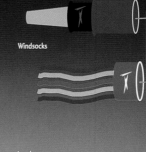

Windsocks

Shopping Bags

Jewelry

CENTURY OF FLIGHT

Touch Here Move Ahead Exit

CENTURY OF FLIGHT

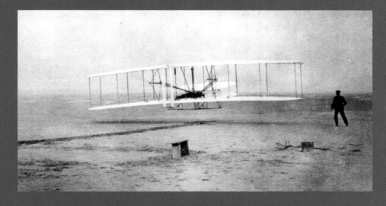

Wilbur and Orville Wright made their historic flight on December 3, 1903, at Kill Devil Hills, Kitty Hawk, North Carolina. It was the first successful attempt at flying a heavier than air-powered machine

Often less controlled than printed graphics, television and internet graphics should still repeat the identity design.

Fashionable Graphics

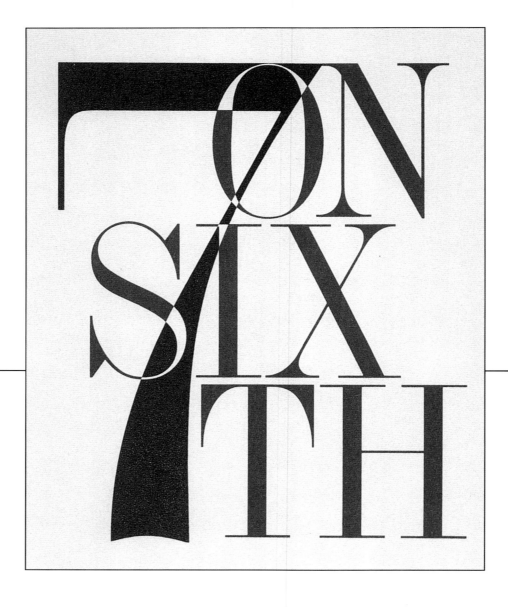

In 1993, the 175 designer-members of the Council of Fashion Designers of America banded together with other leading New York City fashion designers to hold all their seasonal shows in one location. They needed an identity for the twice-yearly event aimed at attracting buyers and press agents from around the world.

The name symbolizes an imaginary intersection of Seventh Avenue, New York's garment district, and Sixth Avenue, which borders the event site. Around it, Pentagram designed a logo as classic as a tailored suit.

But the essence of fashion is change. Therefore, every time the rented tents go up on in Bryant Park, Pentagram adapts the logo to the season's fashion - all the while keeping its essential structure.

Pentagram Design
204 Fifth Avenue
New York, NY 10010

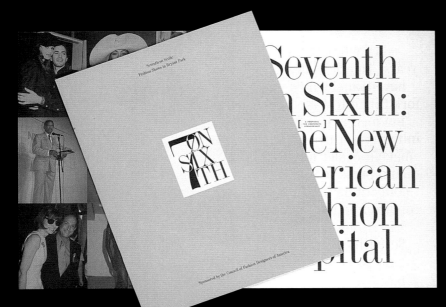

The to-the-trade fashion show logo is stark and classic. A framework for creative changes, it also reproduces well on print graphics.

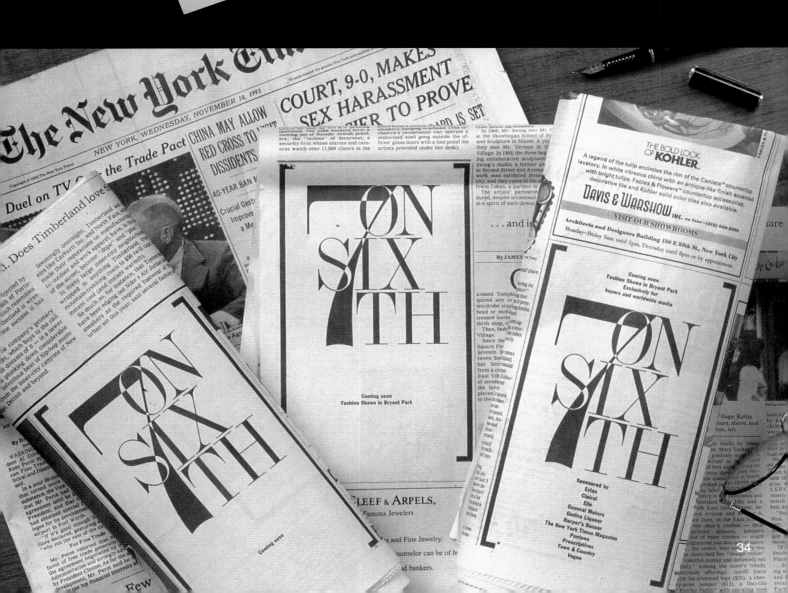

SEVENTH ON SIXTH:
FASHION SHOWS
IN BRYANT PARK
SALUTES
ITS SPONSORS
EVIAN
CADILLAC
CLAIROL
ELLE
GODIVA LIQUEUR
HARPER'S BAZAAR
THE NEW YORK
TIMES MAGAZINE
PANTONE
PRESCRIPTIVES
TOWN & COUNTRY
VOGUE

Applied to event signs and uniforms, the identity helped make a unified event out of previously unconnected fashion shows.

The Spring 1996 Collections

October 28th to November 3rd

Seven on Sixth

Passport

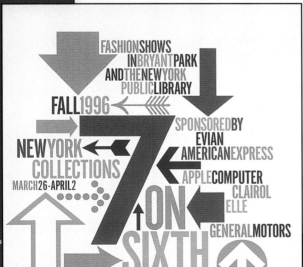

Twice a year, Pentagram interprets the logo in a style suited to the season's fashions.

Attracting Attention

Beyond the event itself, planners of the 1996 World Amateur Golf Championships wanted to attract attention to the event's site: Manila. The planners saw the Championships as an important part of an international effort to market the Philippines, and so commissioned graphics for nearby public spaces, as well as the Manila Southwoods Golf Course.

Designers included tents, signs, banners, flags, merchandise, and fence covers in the identity graphic package. Bright colors and simple images contributed to a celebratory atmosphere designed to create good feelings about the Philippines as well as about the games. To keep players from being distracted, graphics on the course itself were confined to the green flags and pin, and to colored ropes and stanchions.

Selbert Perkins Design
2067 Massachusetts Avenue
Cambridge, MA 02140
phone: 617-497-6605

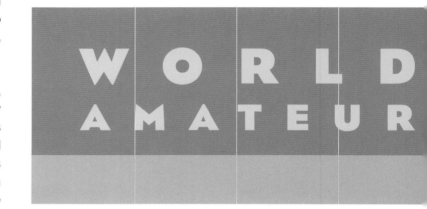

The event identity featured a clever combination of a globe and a golf ball, to symbolize its international status. But it also included the word "Philippines," to emphasize its site.

Official merchandise depended as much on the event colors, a palette of bright tropical hues, as on its logo and distinctive typeface.

GOLF
PHILIPPINES'96

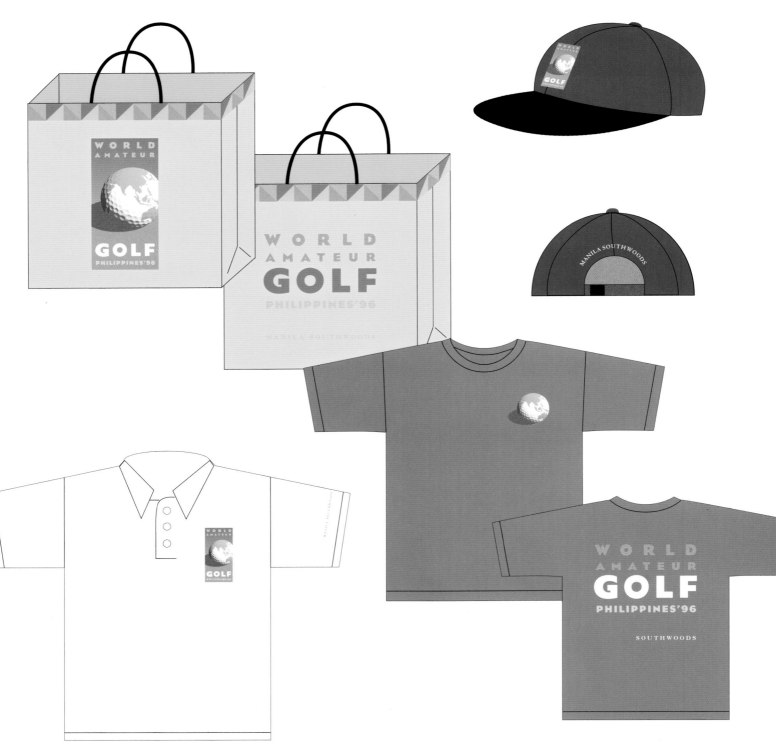

Official merchandise depended as much on the event colors, a palette of bright tropical hues, as on its logo and distinctive typeface.

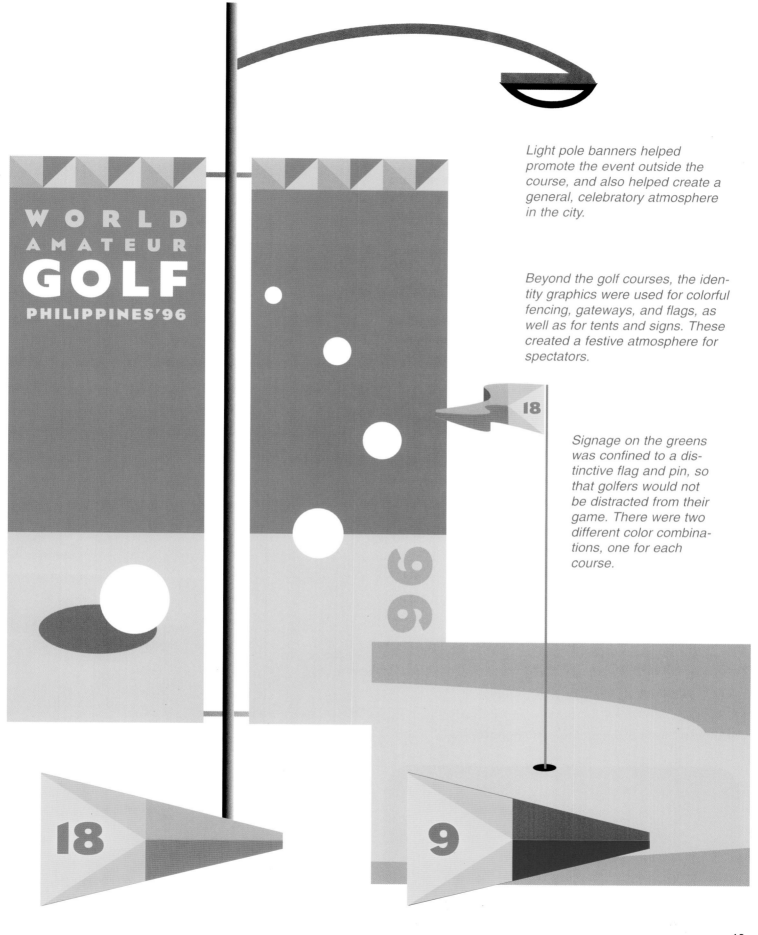

Light pole banners helped promote the event outside the course, and also helped create a general, celebratory atmosphere in the city.

Beyond the golf courses, the identity graphics were used for colorful fencing, gateways, and flags, as well as for tents and signs. These created a festive atmosphere for spectators.

Signage on the greens was confined to a distinctive flag and pin, so that golfers would not be distracted from their game. There were two different color combinations, one for each course.

Transforming a Space

Though a permanent, seasonal attraction, the skating rink at Penn's Landing in Philadelphia has much in common with more ephemeral events. It has its own identity and its own corporate sponsors, it attracts more than 68,000 visitors, and it temporarily transforms a public space.

For three months each winter a skating rink erected on the banks of the Delaware River becomes a seasonal attraction. The site of ice shows, parades, and the city's New Year's Eve celebration, RiverRink is a popular addition to the popular park.

Banners and other graphics mark the park's seasonal uses. For RiverRink, identity graphics consist of a logo incorporating the major sponsor's name, the figure of a female skater, a wave pattern, and a palette of cool colors. These elements are applied to signs, banners, uniforms, structures, vehicles, and even the surface of the rink itself.

Cloud and Gehshan Associates, Inc.

919 South Street

Philadelphia, PA 19147

Fabrication:

Southern Signs & Sales, Inc., Willingboro, NJ

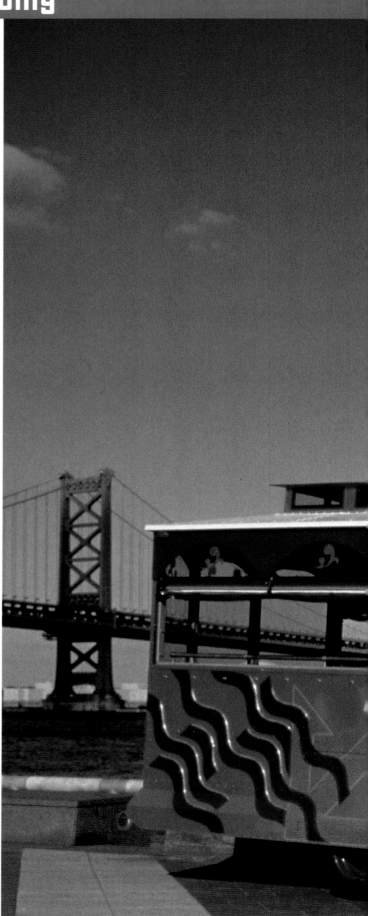

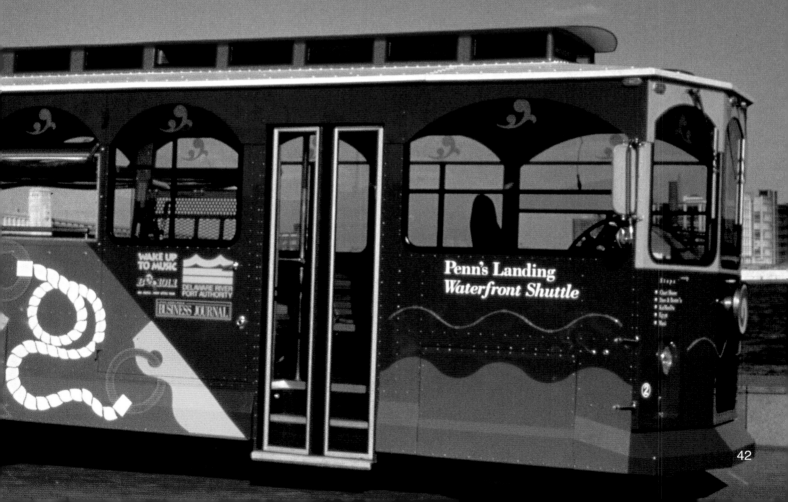

The park's identity graphics change throughout the year, but all are related. Applied to signs, banners, structures and vehicles, they add to the park's festive look and create a consistent sense of place.

WAKE UP
TO MUSIC

DELAWARE RIVER
PORT AUTHORITY

BUSINESS JOURNAL

Penn's Landing
Waterfront Shuttle

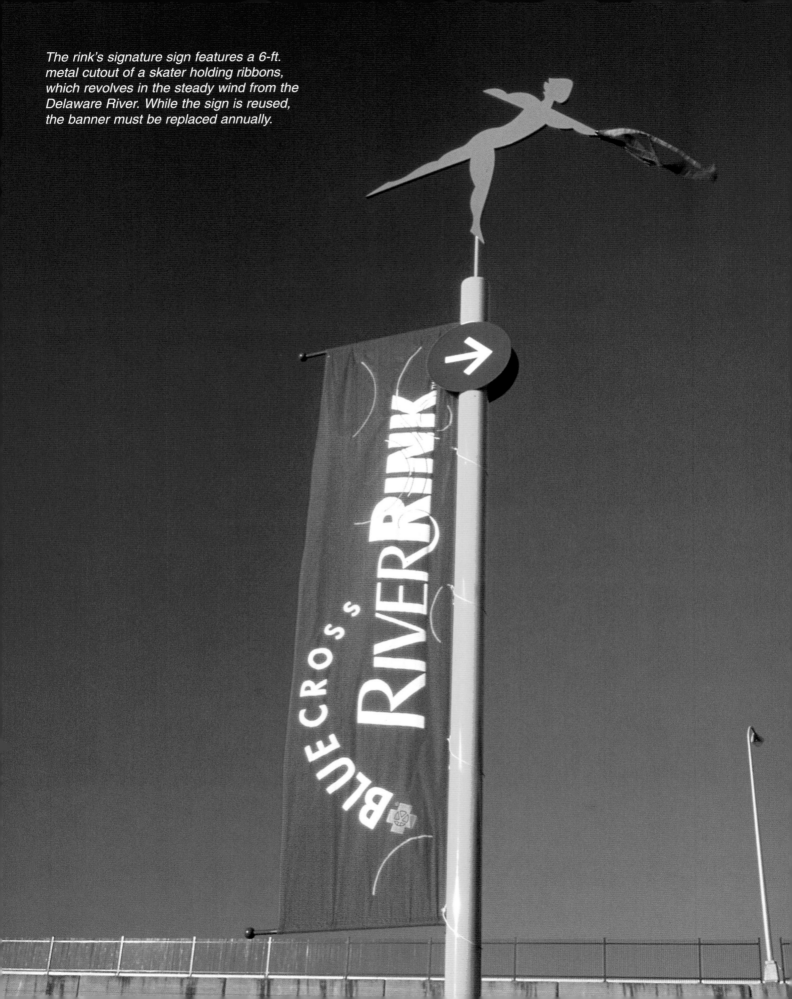

The rink's signature sign features a 6-ft. metal cutout of a skater holding ribbons, which revolves in the steady wind from the Delaware River. While the sign is reused, the banner must be replaced annually.

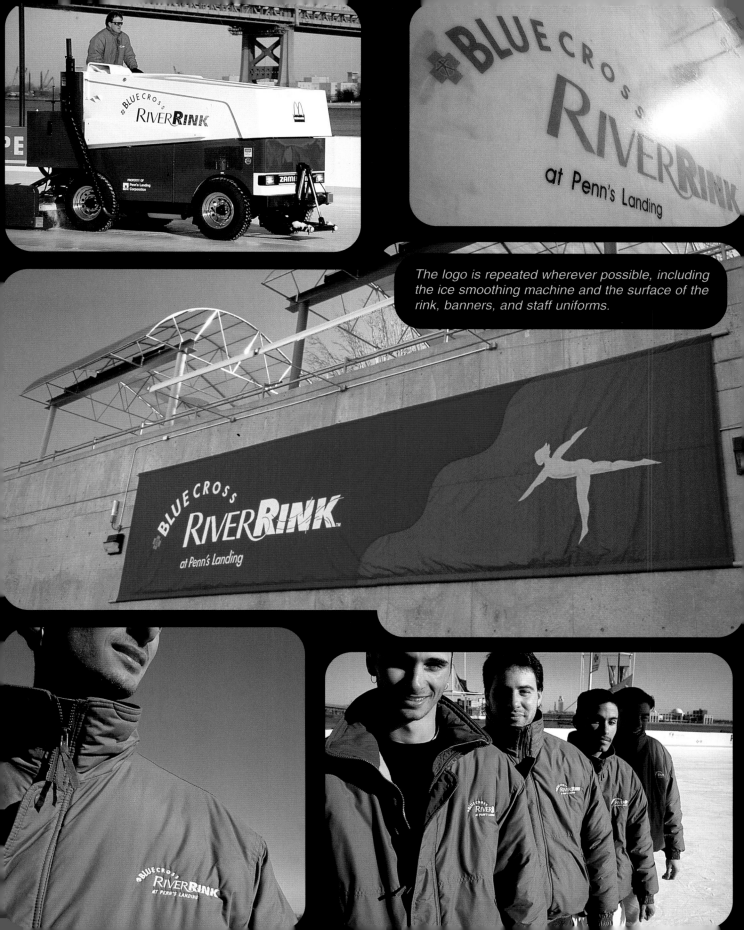

The logo is repeated wherever possible, including the ice smoothing machine and the surface of the rink, banners, and staff uniforms.

In the event's third year, Penn's Landing Corporation added another four revolving skater signs to build on the festive identity.

Directional and identification signs continue the graphic identity. Durable traffic signs are stored until winter, while building signs are made of removable adhesive vinyl and are replaced each year.

Photos: Tom Crane Photography.

46

Durable, But Temporary

Originally planned as a two-week, international horticultural competition, AmeriFlora evolved into a six-month festival, the "centerpiece attraction" of the U.S. Quincentennary (five hundredth anniversary). The $95 million cultural and floral exposition covered an 88-acre park in Columbus, Ohio, and hosted 5.5 million visitors.

The cheerful identity was easily adapted to print graphics, medals, structures, vehicles and thousands of signs (including 3,500 engraved plant identification plaques). Signs and structures also featured maypole ribbons and "old-world" images. The festival's size meant that it needed complete directional sign systems for drivers and pedestrians, as well as maps and site signs. The festival's length meant that planners could not cut corners on sign materials, so designers Degnen Associates specified durable metal and carved wooden signs, as well as a garden of banners, flags, kites, and streamers in inexpensive vinyl.

After the festival, all the signs and structures were sold for reuse, or as souvenirs. Many one-time festivals recoup signage expenses (in this case, about $500,000) with sales.

Degnen Associates

181 Thurman Ave.

Columbus, Ohio 43206

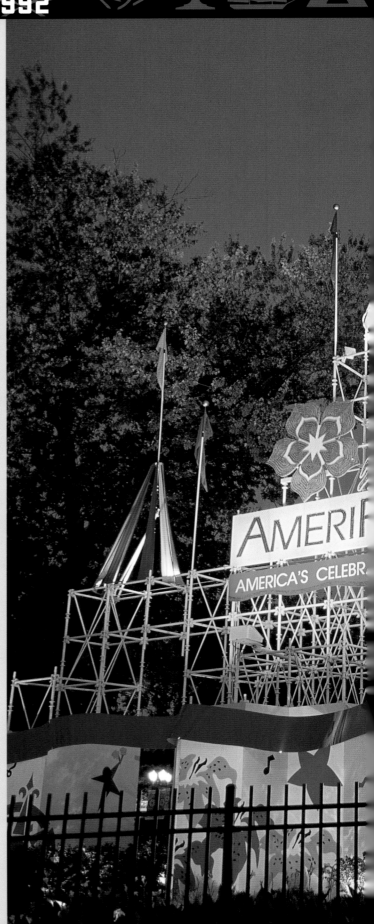

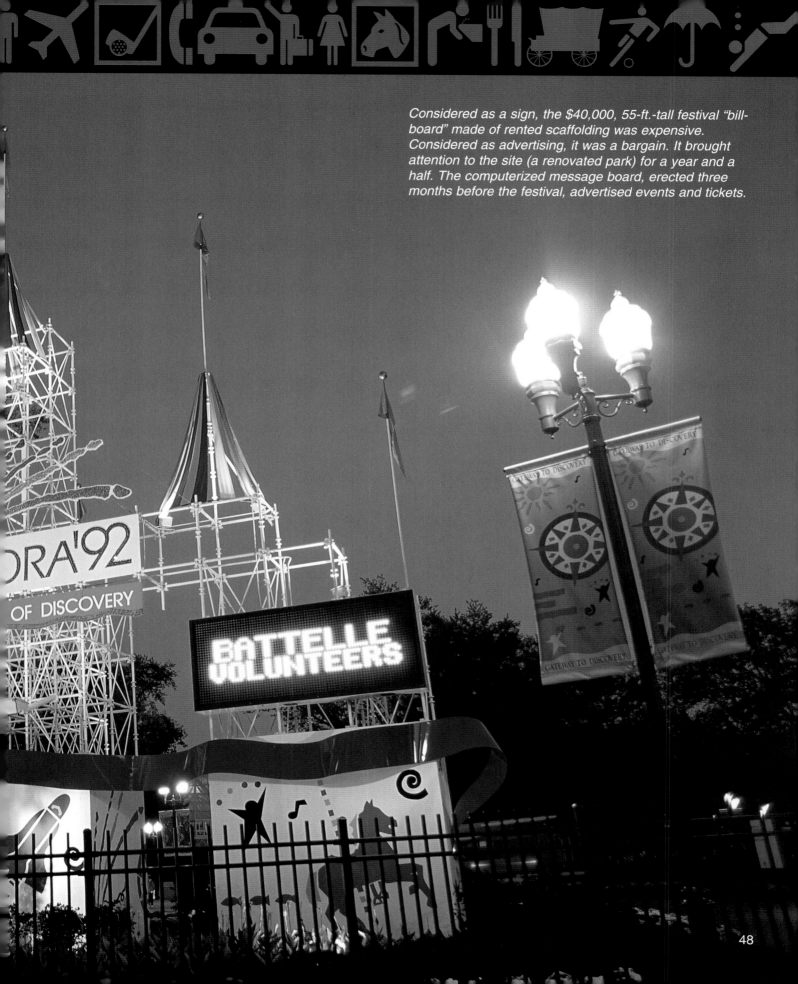

Considered as a sign, the $40,000, 55-ft.-tall festival "bill-board" made of rented scaffolding was expensive. Considered as advertising, it was a bargain. It brought attention to the site (a renovated park) for a year and a half. The computerized message board, erected three months before the festival, advertised events and tickets.

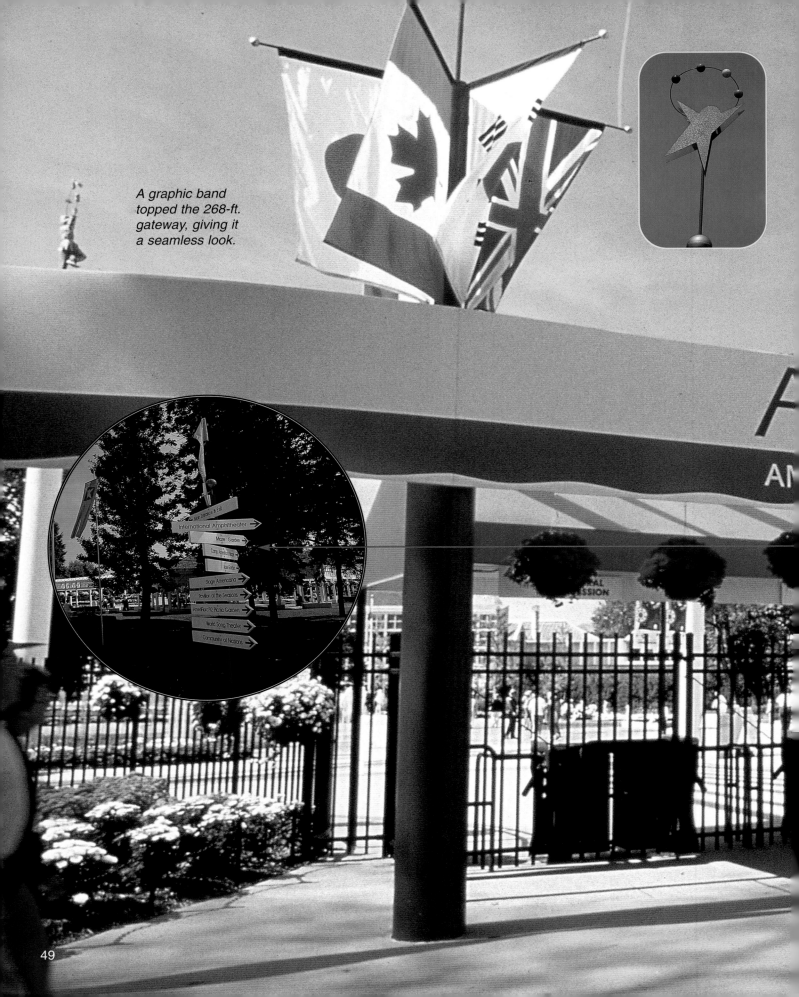

A graphic band topped the 268-ft. gateway, giving it a seamless look.

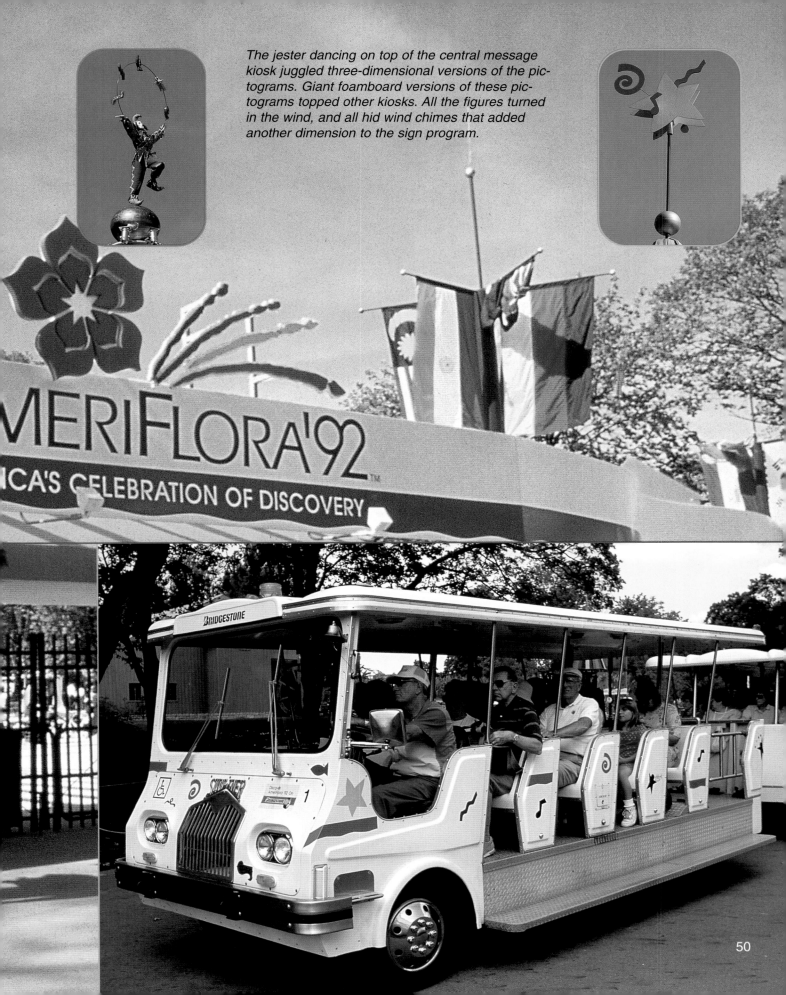

The jester dancing on top of the central message kiosk juggled three-dimensional versions of the pictograms. Giant foamboard versions of these pictograms topped other kiosks. All the figures turned in the wind, and all hid wind chimes that added another dimension to the sign program.

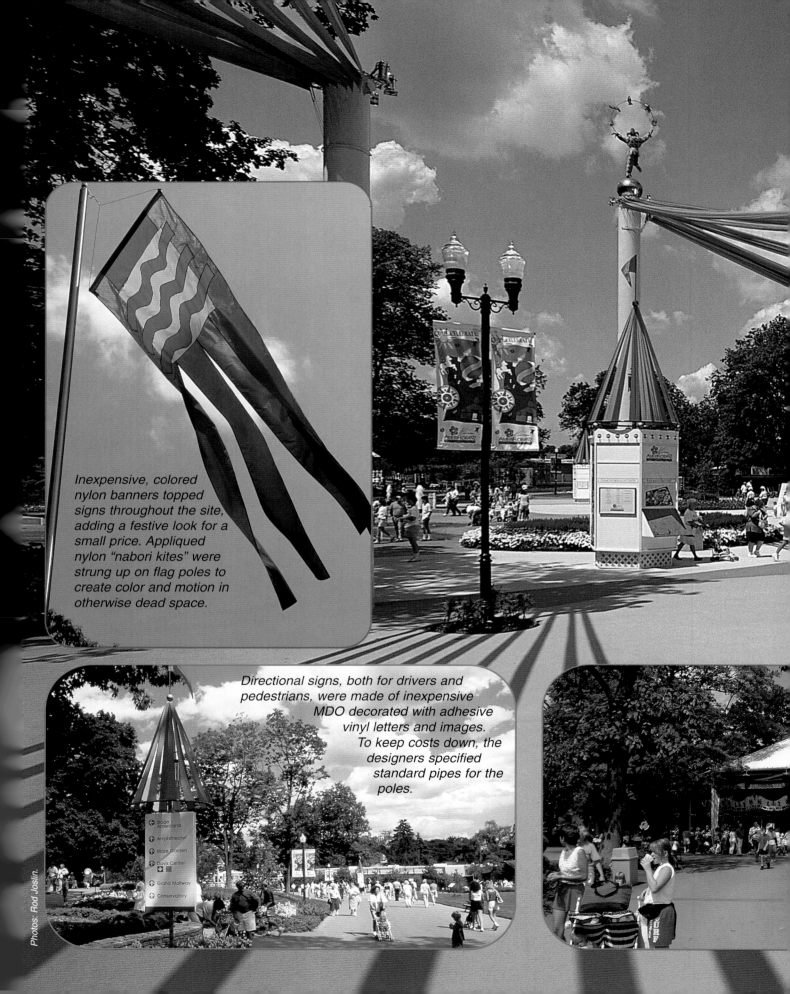

Inexpensive, colored nylon banners topped signs throughout the site, adding a festive look for a small price. Appliqued nylon "nabori kites" were strung up on flag poles to create color and motion in otherwise dead space.

Directional signs, both for drivers and pedestrians, were made of inexpensive MDO decorated with adhesive vinyl letters and images. To keep costs down, the designers specified standard pipes for the poles.

Photos: Rod Joslin.

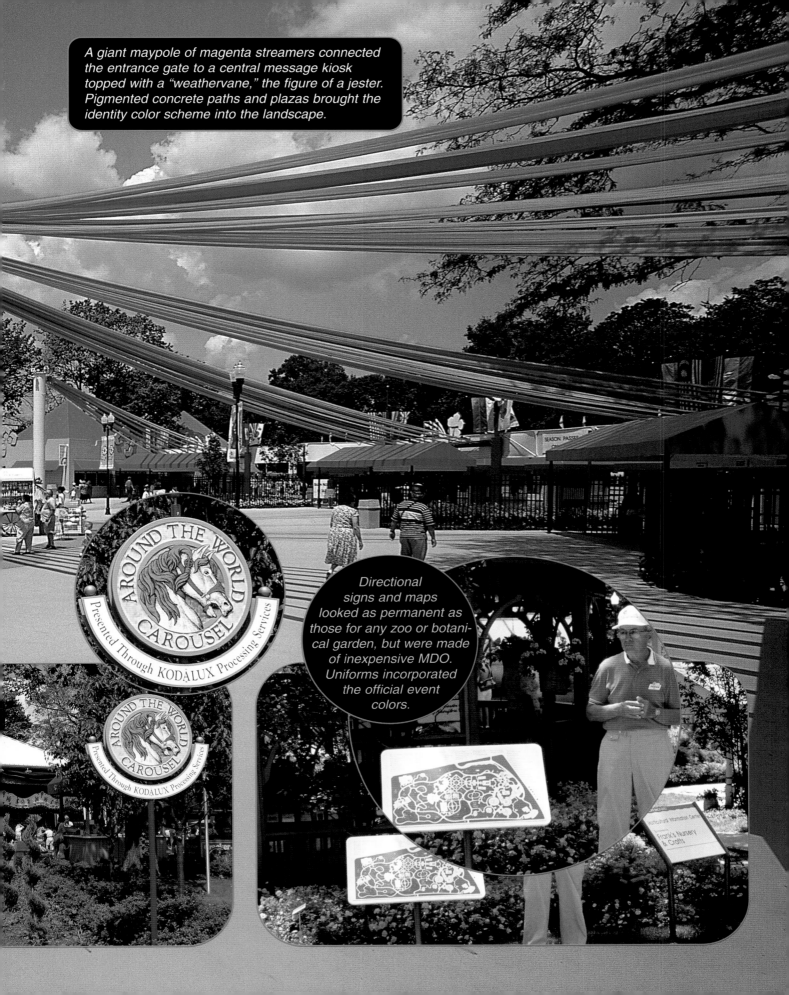

A giant maypole of magenta streamers connected the entrance gate to a central message kiosk topped with a "weathervane," the figure of a jester. Pigmented concrete paths and plazas brought the identity color scheme into the landscape.

Directional signs and maps looked as permanent as those for any zoo or botanical garden, but were made of inexpensive MDO. Uniforms incorporated the official event colors.

AROUND THE WORLD
CAROUSEL
Presented Through KODALUX Processing Services

AROUND THE WORLD
CAROUSEL
Presented Through KODALUX Processing Services

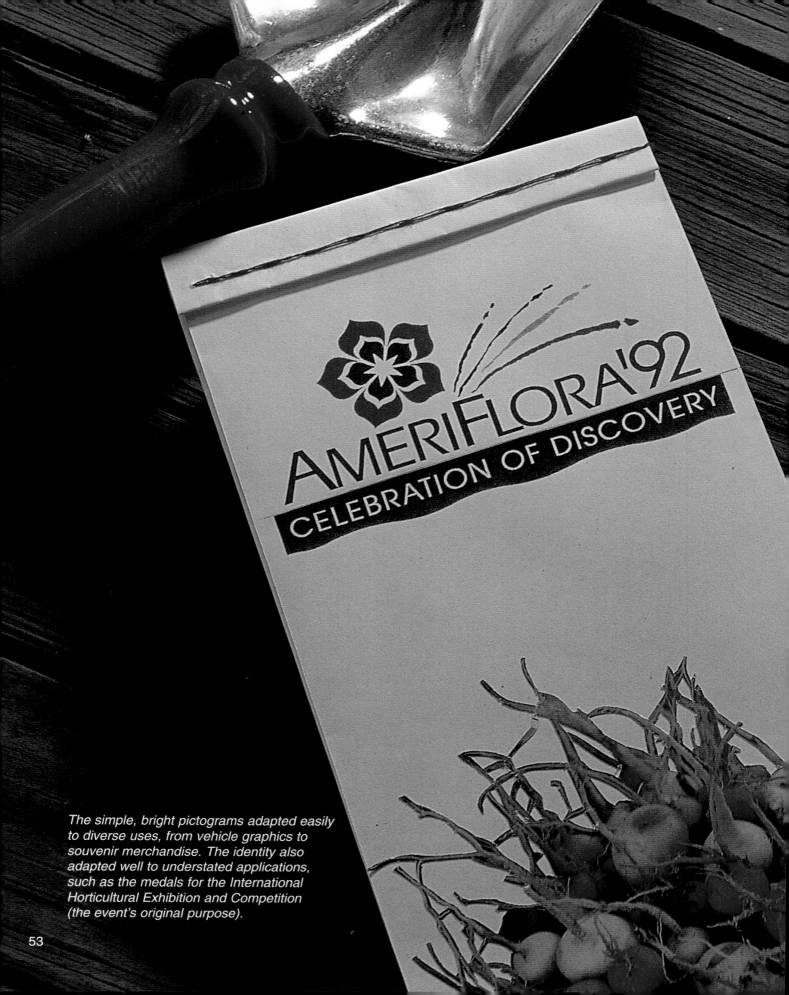

The simple, bright pictograms adapted easily to diverse uses, from vehicle graphics to souvenir merchandise. The identity also adapted well to understated applications, such as the medals for the International Horticultural Exhibition and Competition (the event's original purpose).

53

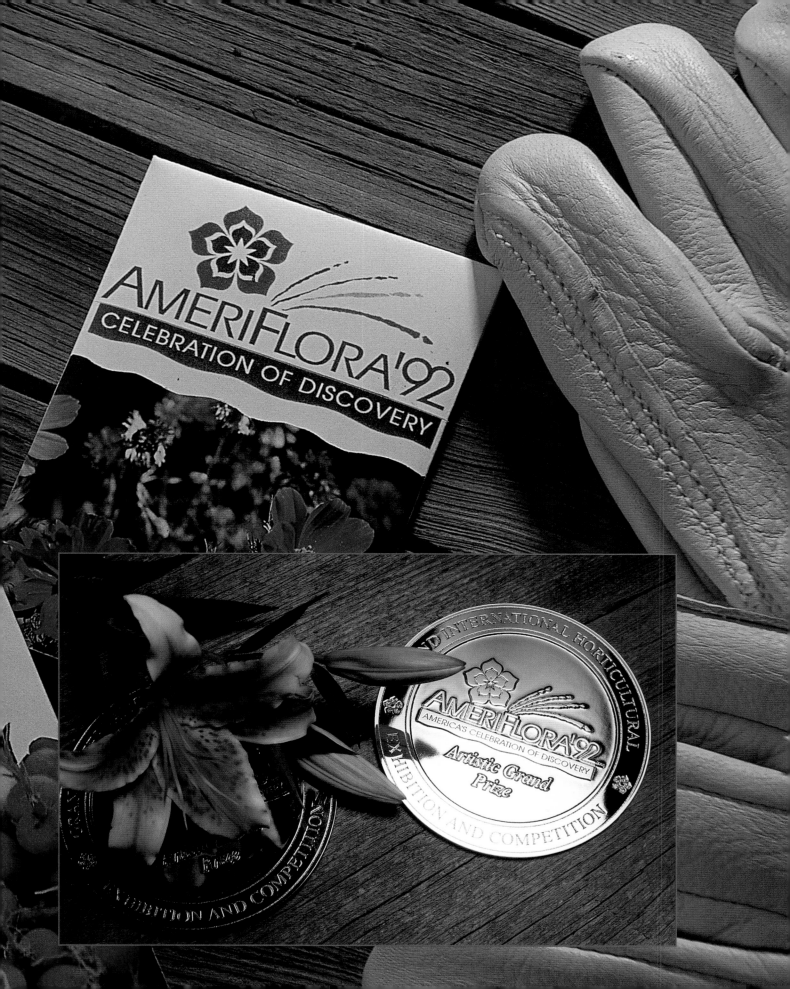

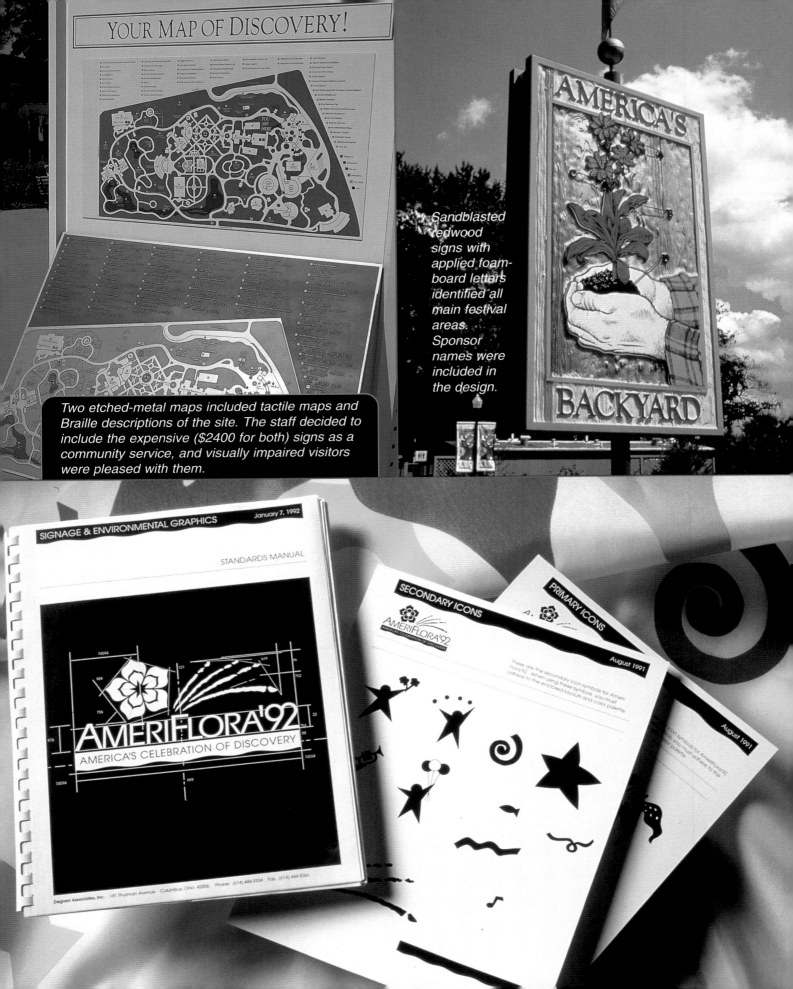

YOUR MAP OF DISCOVERY!

Two etched-metal maps included tactile maps and Braille descriptions of the site. The staff decided to include the expensive ($2400 for both) signs as a community service, and visually impaired visitors were pleased with them.

Sandblasted redwood signs with applied foam-board letters identified all main festival areas. Sponsor names were included in the design.

AMERICA'S BACKYARD

SIGNAGE & ENVIRONMENTAL GRAPHICS January 7, 1992

STANDARDS MANUAL

AMERIFLORA'92
AMERICA'S CELEBRATION OF DISCOVERY

Degnen Associates, Inc. 181 Thurman Avenue Columbus, Ohio 43206 Phone: (614) 444-3334 Fax: (614) 444-3066

SECONDARY ICONS

PRIMARY ICONS

A.

AMERIFLORA'92
AMERICA'S CELEBRATION OF DISCOVERY

August 1991

These are the secondary icon symbols for Ameri-Flora'92. When using these symbols, you must adhere to the enclosed layouts and color palette.

August 1991

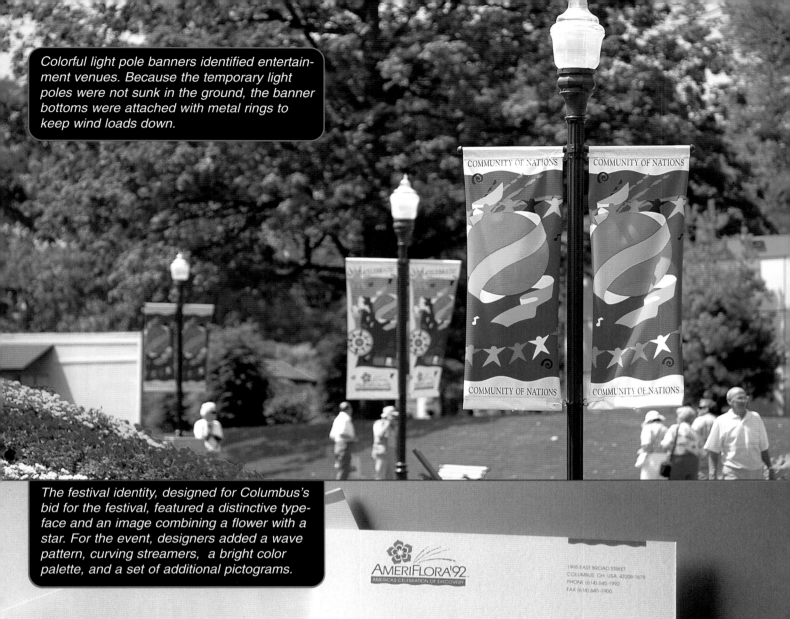

Colorful light pole banners identified entertainment venues. Because the temporary light poles were not sunk in the ground, the banner bottoms were attached with metal rings to keep wind loads down.

The festival identity, designed for Columbus's bid for the festival, featured a distinctive typeface and an image combining a flower with a star. For the event, designers added a wave pattern, curving streamers, a bright color palette, and a set of additional pictograms.

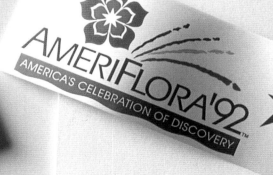

Bazaar Bizzoso

The Bazaar Bizzoso, the contemporary area of the Atlanta Festival for the Arts, has no graphic identity. But thanks to architect/designer Jan Lorenc, it has signs, gateways, and other graphics.

Developed over several years, the graphics were designed and constructed by volunteers out of junk or donated materials. These are stored and used again, in new combinations, for each festival. Many of the artists, inspired by the graphics, decorate their booths in a similar way. Thus, the graphics create a wacky, celebratory look at almost no cost to the festival.

Lorenc + Yoo Design

109 Vickery Street

Roswell, GA 30075

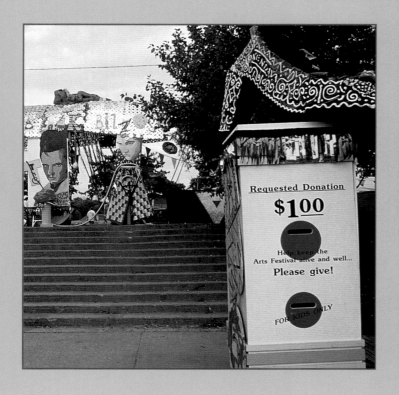

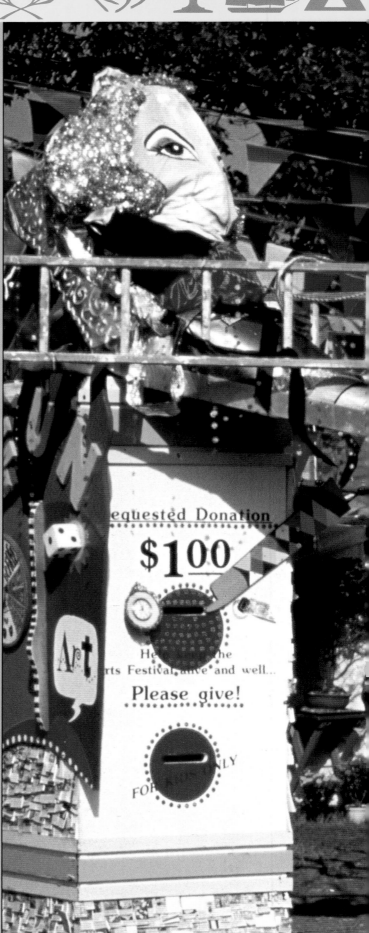

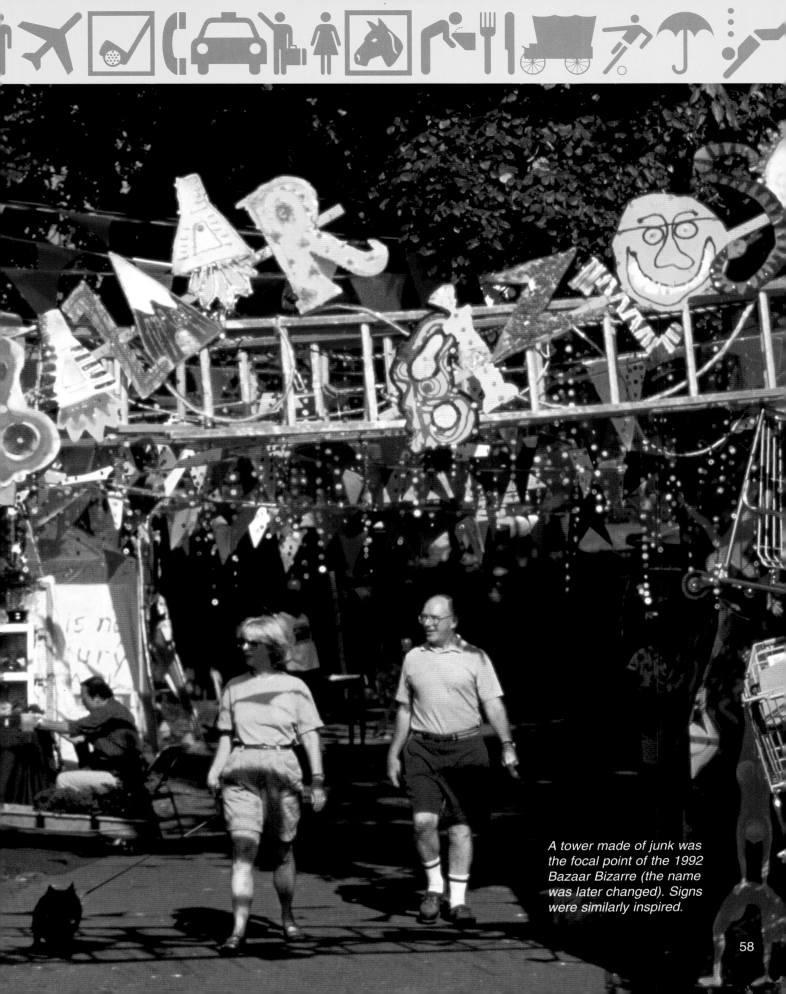

A tower made of junk was the focal point of the 1992 Bazaar Bizarre (the name was later changed). Signs were similarly inspired.

58

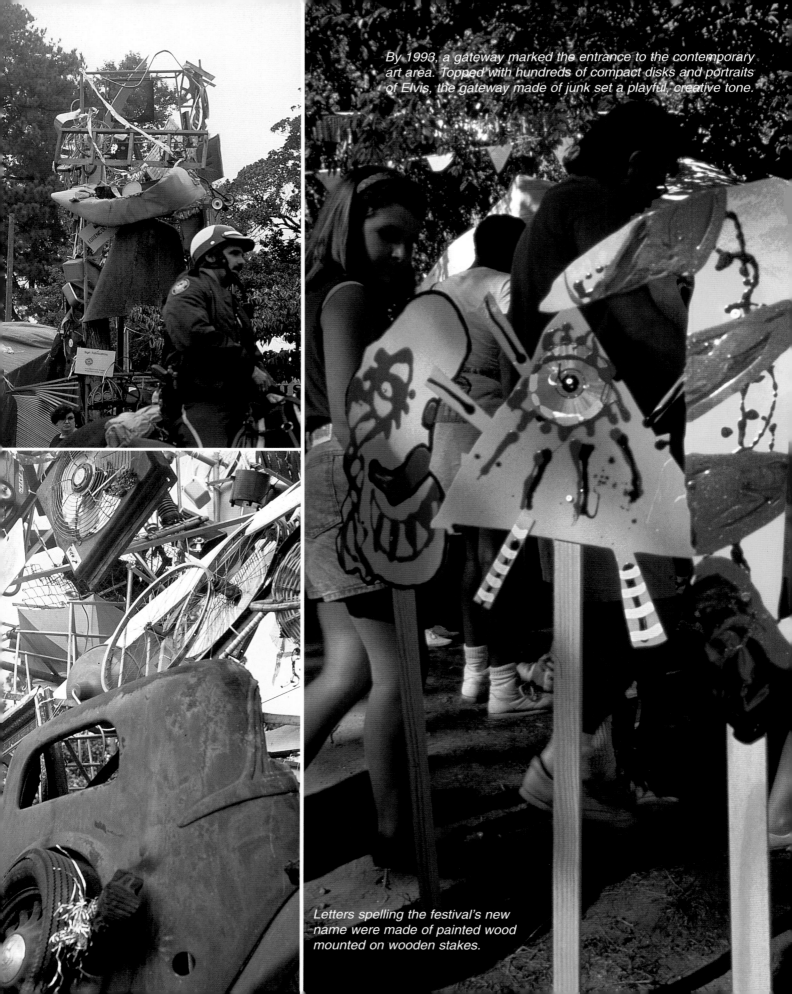

By 1993, a gateway marked the entrance to the contemporary art area. Topped with hundreds of compact disks and portraits of Elvis, the gateway made of junk set a playful, creative tone.

Letters spelling the festival's new name were made of painted wood mounted on wooden stakes.

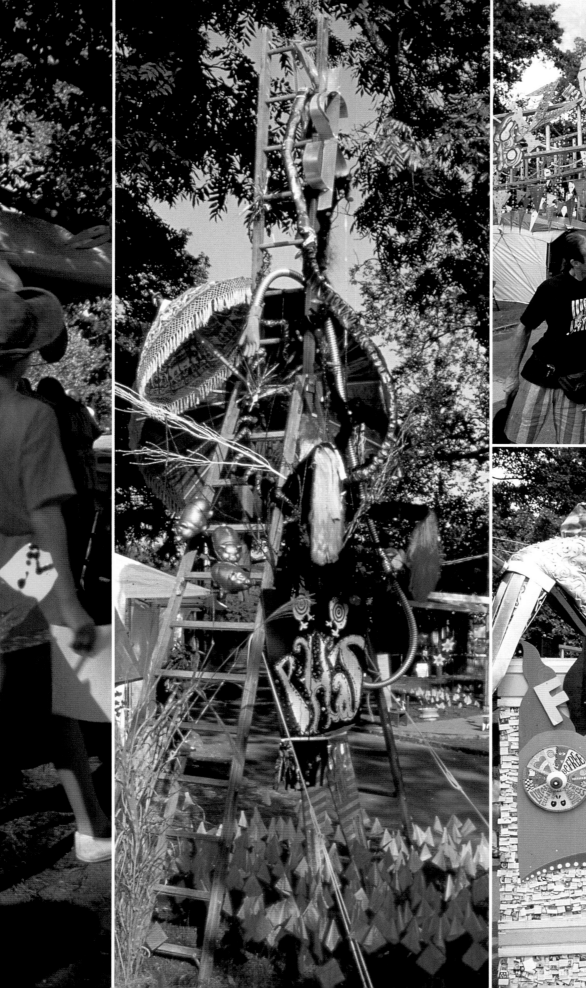

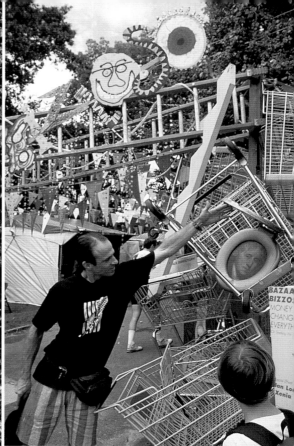

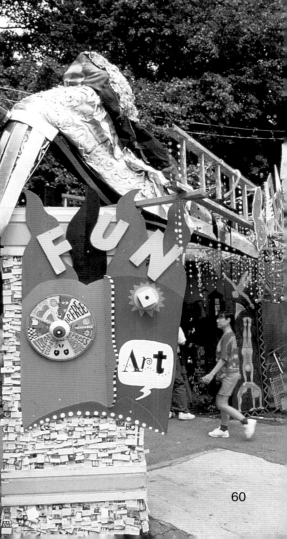

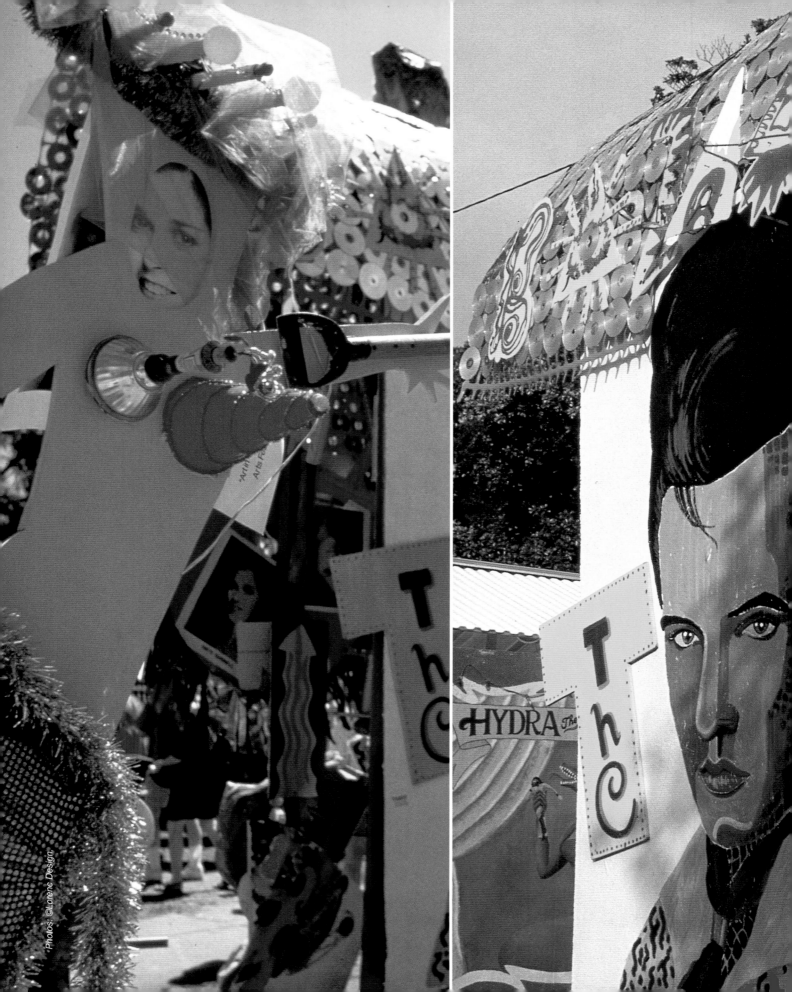

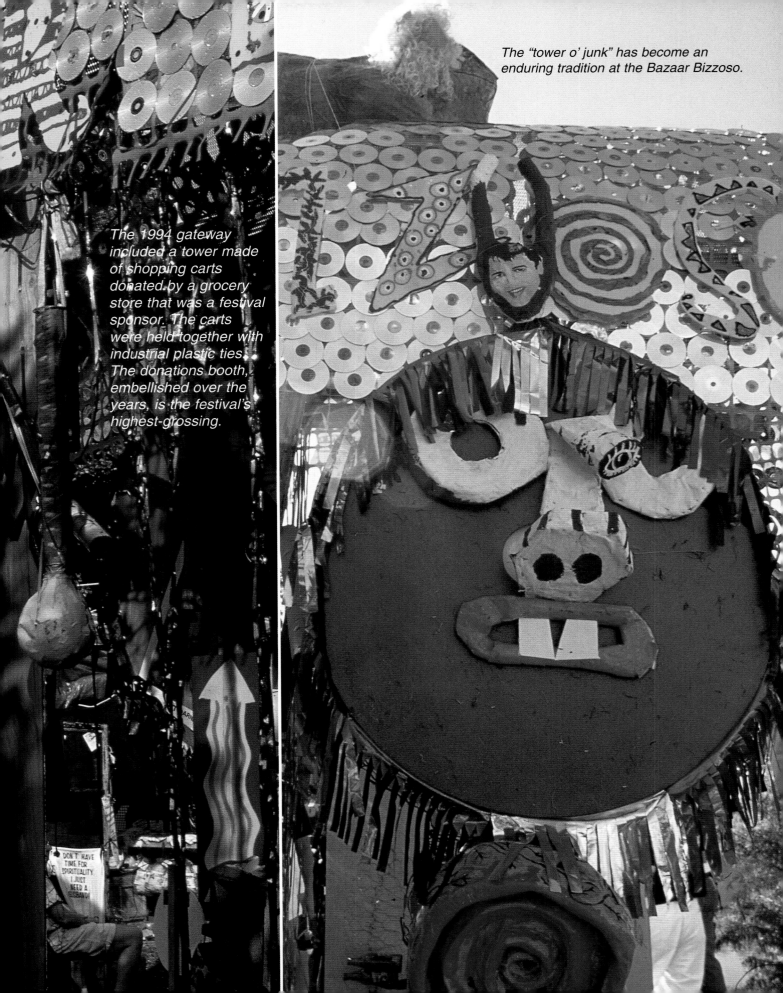

The "tower o' junk" has become an enduring tradition at the Bazaar Bizzoso.

The 1994 gateway included a tower made of shopping carts donated by a grocery store that was a festival sponsor. The carts were held together with industrial plastic ties. The donations booth, embellished over the years, is the festival's highest-grossing.

DON'T HAVE TIME FOR SPIRITUALITY. I JUST NEED A CISSAND!

Art as Signs

For one night, art revealed what goes on inside New York City's landmark General Post Office. For the Brooklyn Academy of Music's annual fundraising gala, artist/designer Leni Schwendinger transformed the two-block-long building facade with computerized projectors and hand-painted glass slides.

These temporary graphics, arranged in a show called "Public Dramas/Passionate Correspondents," explored how mail is sorted and delivered, a process generally hidden from view.

Technical challenges abounded in this project, which used five projectors to create 200- x 50-ft. images. Schwendinger had to create mattes to ensure that the graphics would be clear on the site, which was far from flat. She also used anamorphosis, a perspective technique that allows viewers to see different images from different locations.

Light Projects Ltd.

448 West 37th St., 8G

New York, NY 10018

A technical triumph, the show transformed the facade of New York's two-block-long General Post Office, creating an arresting identity for one evening. The images, which explored the hidden process of mail sorting and delivery, were visible from several angles so that viewers could see them as they walked or drove by.

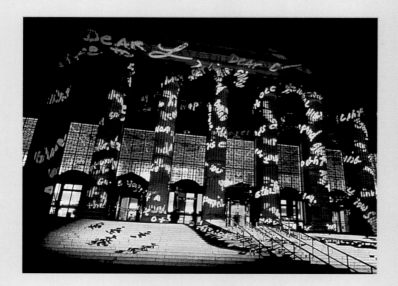

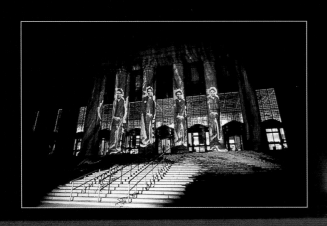

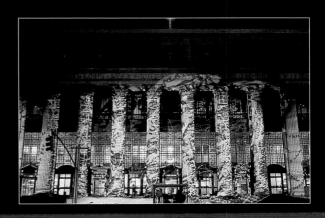

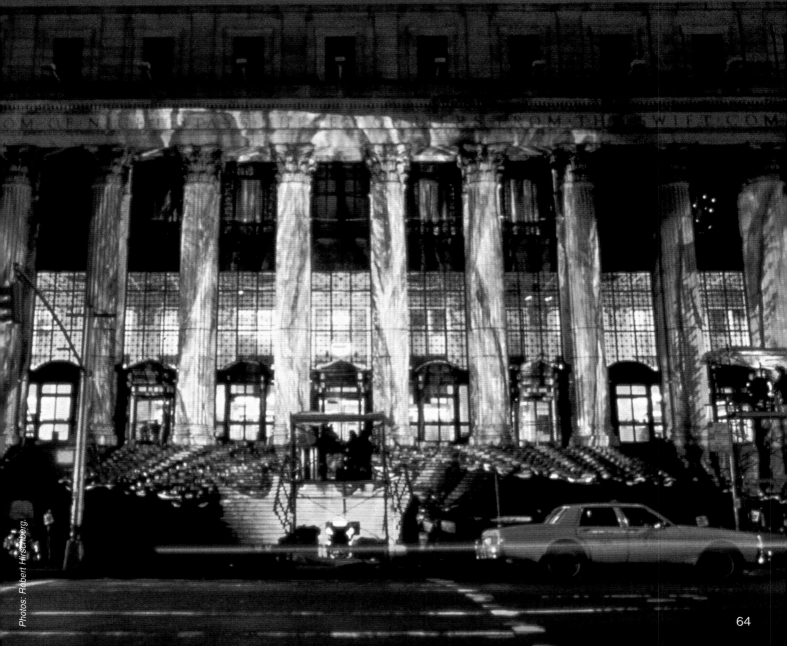

Photos: Robert Hirschberg.

64

Building an Identity

Tall Stacks began in 1988 as one of Cincinnati's official bicentennial celebrations, and has become one of the region's top festivals. Held every four years, the four-day celebration gathers historic and reproduction steamboats from US rivers for tours, cruises, and races. With performances, exhibits, and historic recreation, it brings the "steamboatin'" era back to three cities on two sides of the Ohio River.

Designer Kelly Kolar became a part of Tall Stacks as a student at the University of Cincinnati. She was on a student team that entered the Bicentennial Commission's contest to design the festival graphics, and was eventually hired as design director. She has built on and expanded the festival identity for each of its three incarnations.

Combining elements of graphic and theme park design, the Tall Stacks identity is based on design elements of the 1800s, including woodcuts, steel engravings, and printer's ornaments, all simplified and updated with modern colors and type. Festival signs and graphics are also united by the use of giant columns made of painted industrial cardboard tubing. All structures and signs are made by volunteers.

By 1995, the festival had developed into six performance areas and five themed areas: the Public Landing and Riverfront, the Tom Sawyerville children's area, the Newport Barracks for American Civil War reenactors, an educational exhibit, and a walking tour and crafter area in Covington, KY. All were united by a common graphic look, one that has also been carried over into many permanent signs and graphics in both Ohio and Kentucky.

Kolar Design

308 E. 8th Street

Cincinnati, Ohio 45202

Kelly Kolar, principal of Kolar Design and design director for Tall Stacks, with client Richard J. Greiwe, executive director of Tall Stacks, and Joseph S. Stern, past chairman of the Greater Cincinnati Bicentennial Commission.

ADMISSION TICKETS

ADMISSION

Ticket booths made of ply-wood and wooden lattice carry on the design. Their corrugated roofs fit the look.

In Covington, KY, an exhibit allowed visitors to walk onto a replica packet boat. The exhibit's sponsor, Corporex, is named in the grillwork between the stacks.

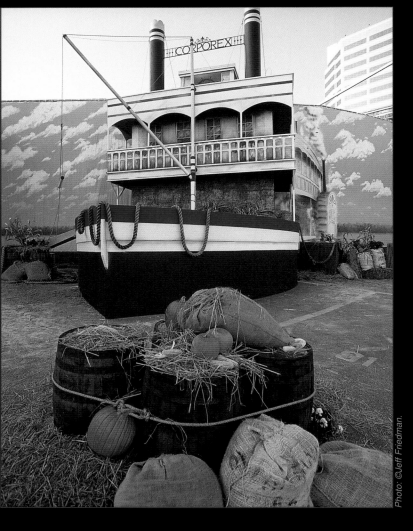

Photo: ©Jeff Friedman.

A volunteer at the first Tall Stacks celebration wears the official uniform. Graphics gave t-shirts and plastic boater hats a 19th-century feel.

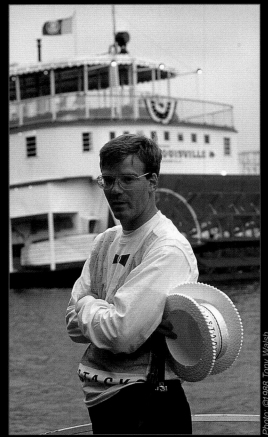

Photo: ©1988 Tony Walsh.

Graphics transformed a walk-through sculpture at Cincinnati's Bicentennial Commons park, making it a festival entrance. Square kiosks at each entrance included maps, entertainment schedules, and a list of sponsors. Seventy-five kiosks were spaced throughout the event.

Photo: ©Jeff Friedman

Architraves, color-coded teal, helped visitors queue for boat tours and cruises. Large dock numbers kept people from getting lost on the long, crowded riverfront. Throughout the event, costumed volunteers strolled about the venues, adding to the atmosphere.

Photo: ©Jeff Friedman.

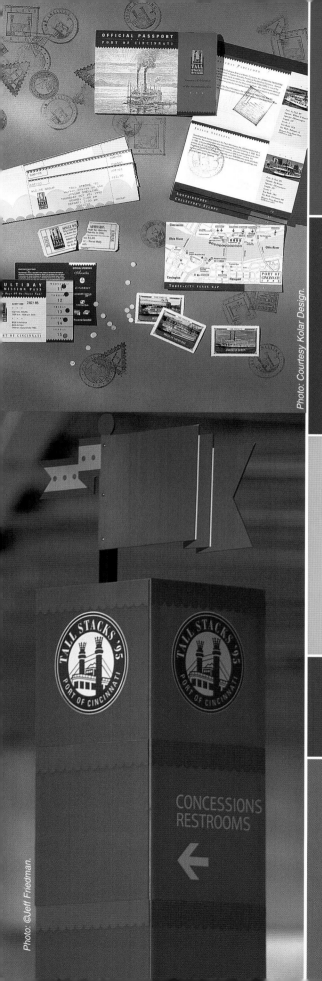

More than 20 steamboats are the main attraction at Tall Stacks, and their distinctive look inspires all the graphic design. Visitors can tour or ride most steamboats, and can purchase "passports" to take aboard. Each ship has her own specially designed passport stamp; these are also used on souvenir merchandise.

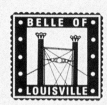

Red marked all information signs. Tall "tower of power" signs, made of pigmented, corrugated plastic, stood out over the crowd, directing visitors to concessions.

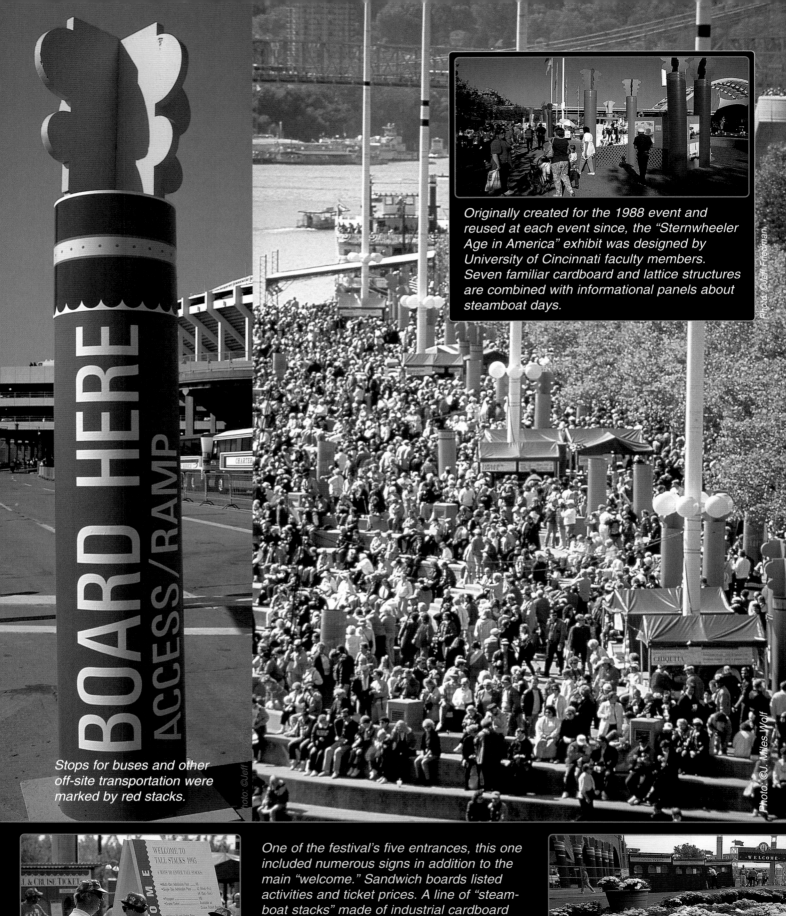

Originally created for the 1988 event and reused at each event since, the "Sternwheeler Age in America" exhibit was designed by University of Cincinnati faculty members. Seven familiar cardboard and lattice structures are combined with informational panels about steamboat days.

Photo: ©Jeff Friedman.

Photo: ©J. Miles Wolf

Stops for buses and other off-site transportation were marked by red stacks.

Photo: ©Jeff

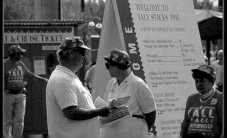

One of the festival's five entrances, this one included numerous signs in addition to the main "welcome." Sandwich boards listed activities and ticket prices. A line of "steamboat stacks" made of industrial cardboard tubes listed major sponsors. The gates were constructed so that they could be opened for fire trucks or ambulances.

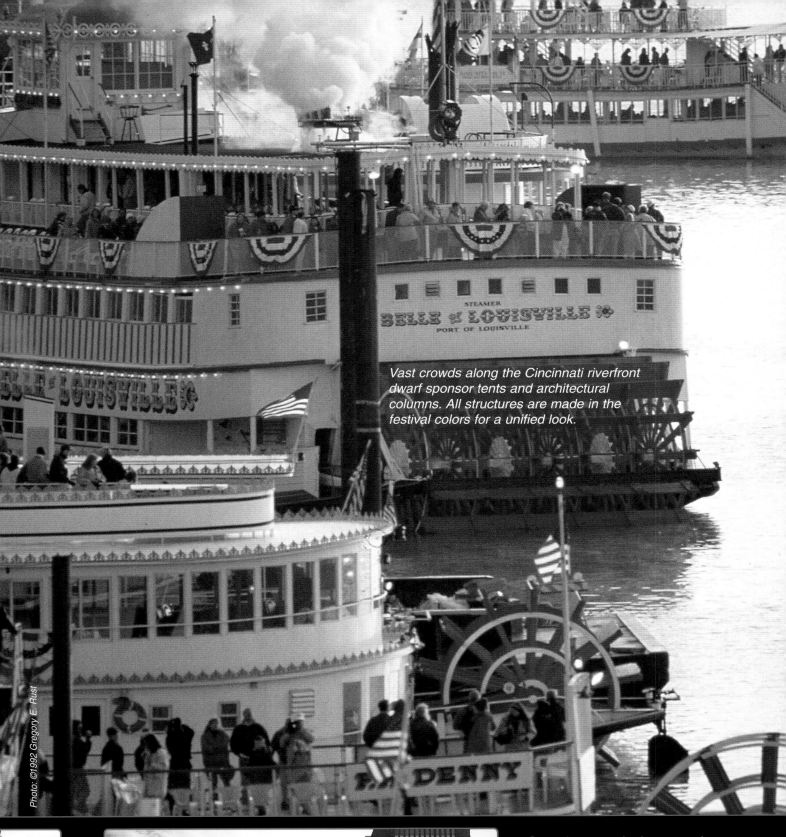

Photo: ©1992 Gregory E. Rust

Vast crowds along the Cincinnati riverfront dwarf sponsor tents and architectural columns. All structures are made in the festival colors for a unified look.

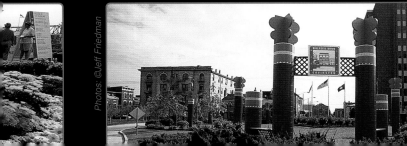

Photos: ©Jeff Friedman

Steamboats and other attractions were marked by architraves made of industrial cardboard tubes with foamboard toppers, painted lattice, and wood. This arrangement greeted drivers entering the Covington, Kentucky, site of a walking tour and craft fair.

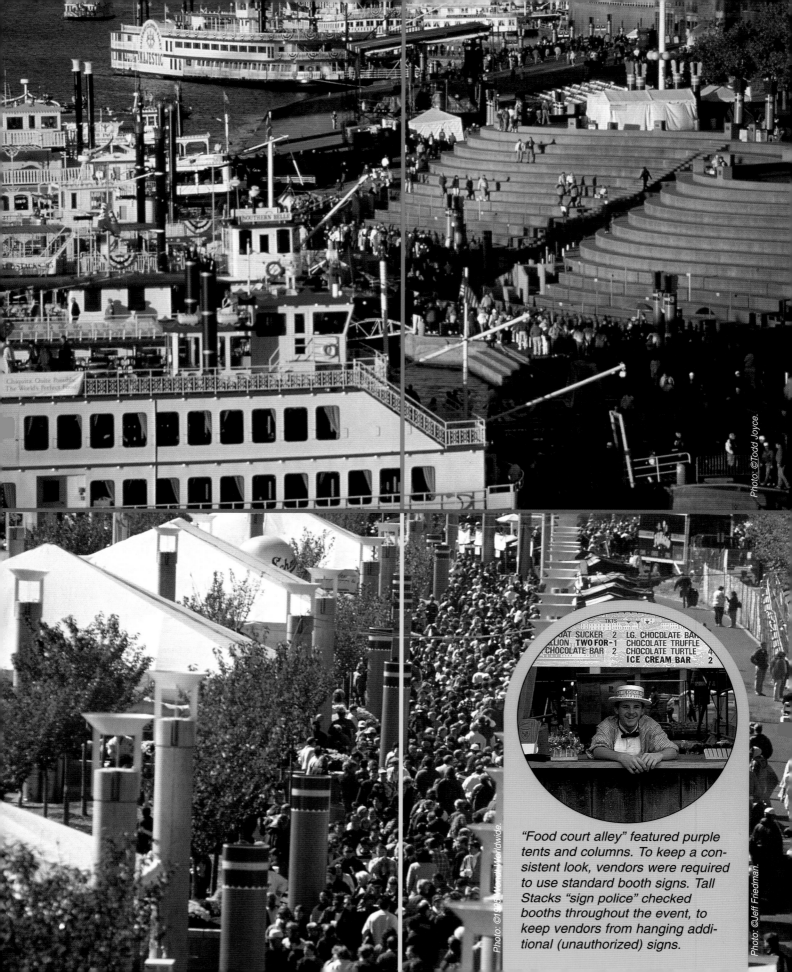

"Food court alley" featured purple tents and columns. To keep a consistent look, vendors were required to use standard booth signs. Tall Stacks "sign police" checked booths throughout the event, to keep vendors from hanging additional (unauthorized) signs.

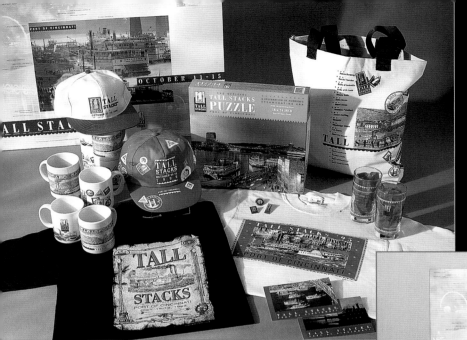

Souvenir merchandise of all kinds incorporated the identity graphics. Collectible posters, pins, hats, and t-shirts sold briskly, as did more usual souvenirs.

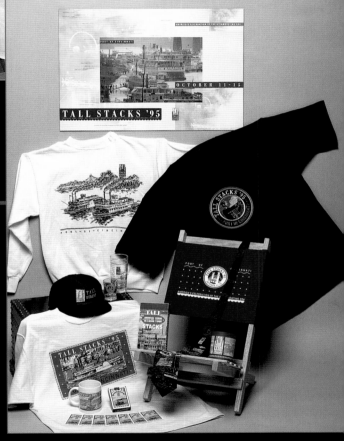

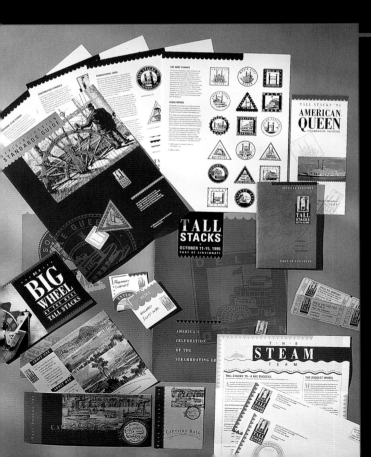

Print graphics, including tickets, brochures and invitations, all shared a consistent graphic look.

At the Newport Barracks in Newport, KY, American Civil War reenactors camped, cooked, and drilled for spectators. Wooden facades and enough props to fill 18 semi trucks created a realistic backdrop for their activities.

Photo: ©K. Simmons.

Photo: ©1992 John M. Krekel.

Giant wooden facades transformed Cincinnati's Public Landing into an 1880s street. Sponsor names are painted on the shop fronts (which were also concession booths).

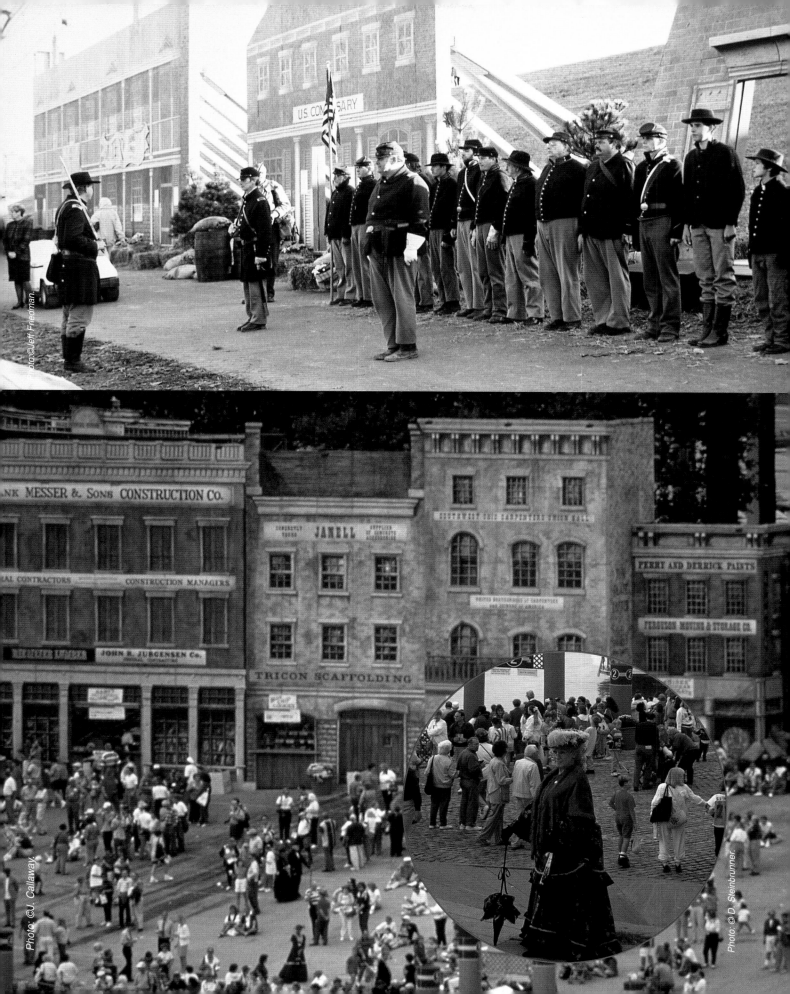

Tom Sawyerville

Students Design Children's Venue

University of Cincinnati students designed many of the sets and graphics for Tom Sawyerville, a children's area based on the steamboat-era children's classic. Combining theme park and game design with graphic and environmental graphic design, Tom Sawyerville lets children learn and play at the same time. It debuted at the 1992 Tall Stacks festival.

Designers came up with the idea for Tom Sawyerville at a workshop with area teachers. Design students from the class of 1995 worked on the design concepts, and Kolar Design hired one of the students, Nancy Smith, to create final art. Kolar Design created new activities and areas, such as "Huck's Hideaway," for 1995.

University of Cincinnati College of Design,
Architecture, Art and Planning
School of Design
PO Box 210016
Cincinnati, Ohio 45221-0016

Fabrication: University of Cincinnati students;
Adex Inc.; Ted Hendricks and Associates;
Geograph Industries; ABC Signs

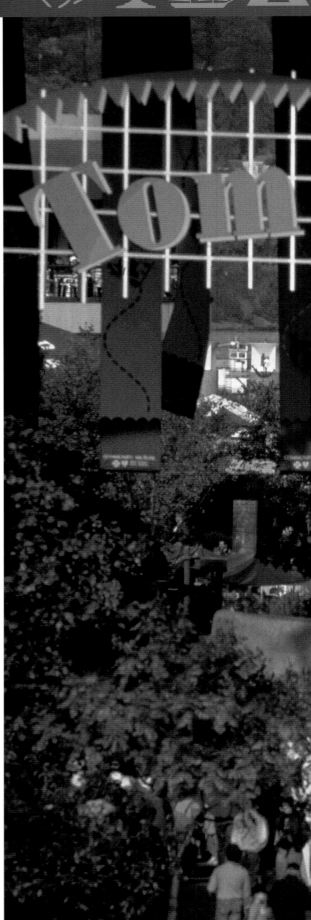

Photo: ©Jeff Friedman.

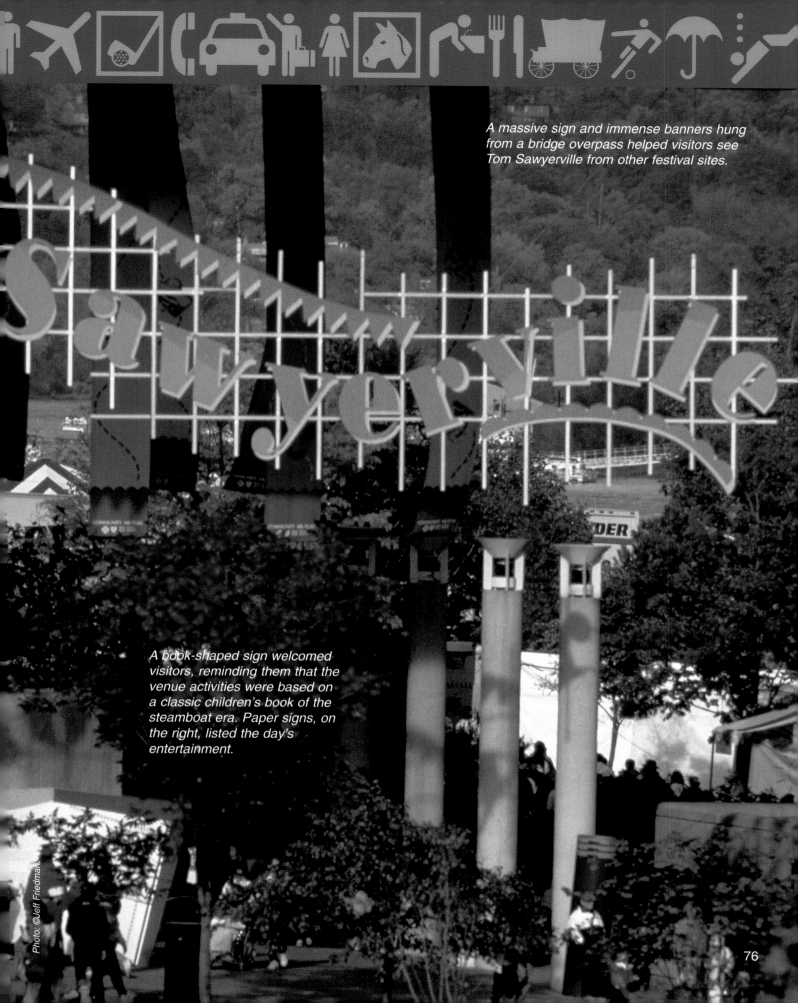

A massive sign and immense banners hung from a bridge overpass helped visitors see Tom Sawyerville from other festival sites.

A book-shaped sign welcomed visitors, reminding them that the venue activities were based on a classic children's book of the steamboat era. Paper signs, on the right, listed the day's entertainment.

Photo: ©Jeff Friedman

76

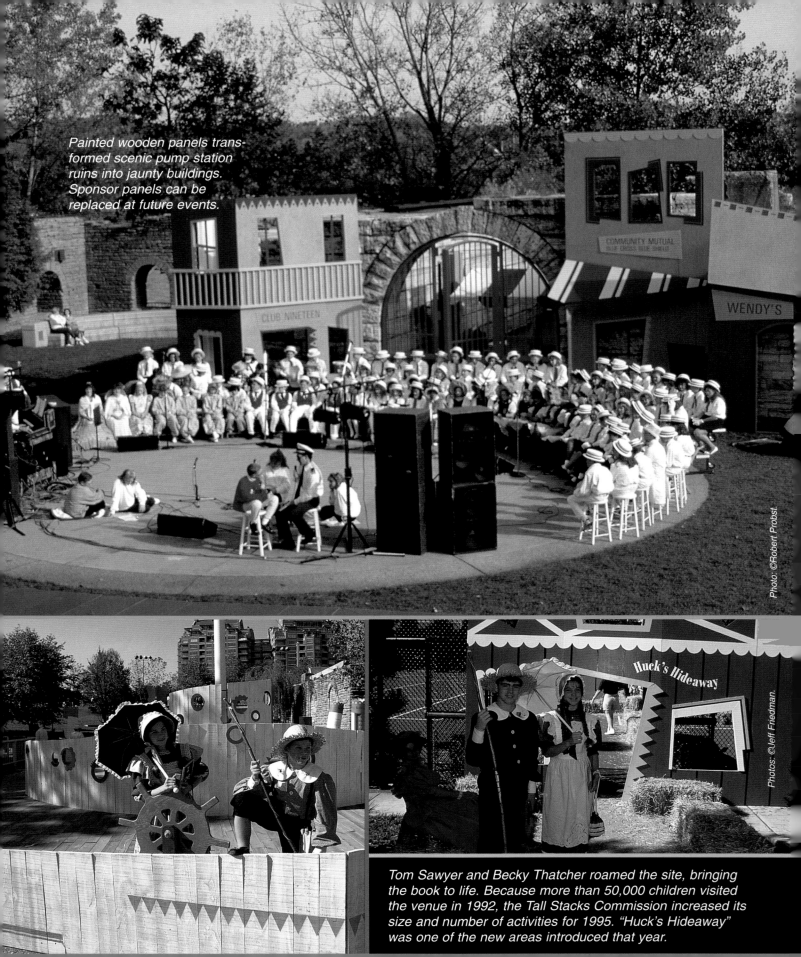

Painted wooden panels transformed scenic pump station ruins into jaunty buildings. Sponsor panels can be replaced at future events.

Photo: ©Robert Probst.

Photos: ©Jeff Friedman.

Tom Sawyer and Becky Thatcher roamed the site, bringing the book to life. Because more than 50,000 children visited the venue in 1992, the Tall Stacks Commission increased its size and number of activities for 1995. "Huck's Hideaway" was one of the new areas introduced that year.

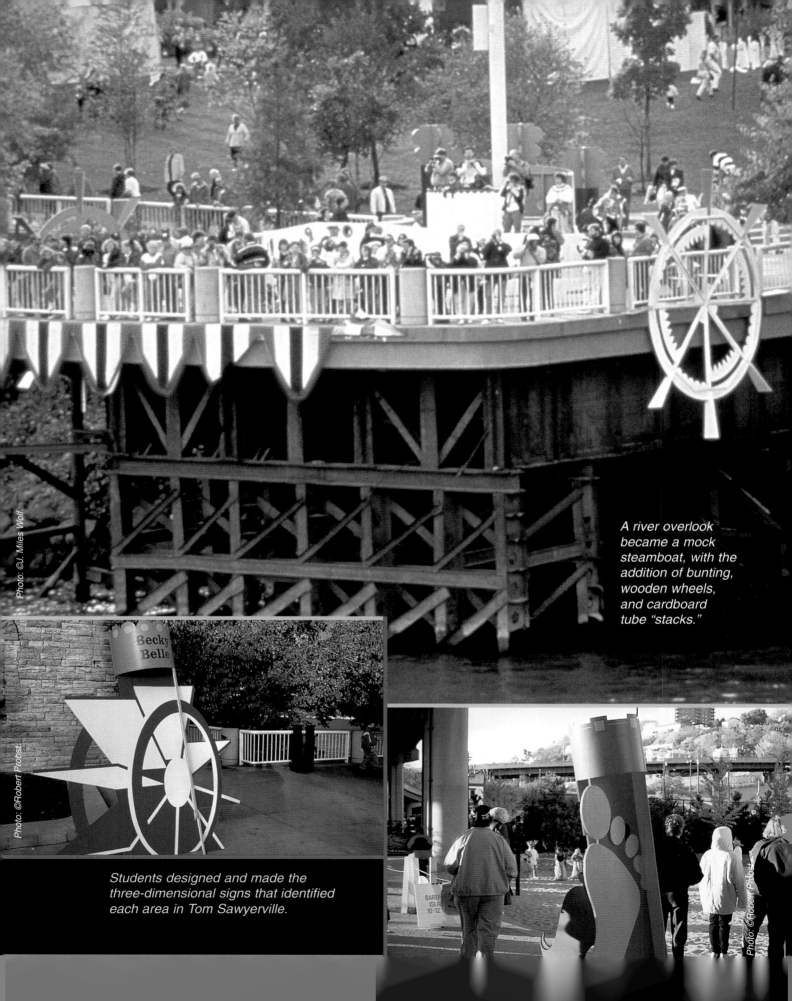

A river overlook became a mock steamboat, with the addition of bunting, wooden wheels, and cardboard tube "stacks."

Students designed and made the three-dimensional signs that identified each area in Tom Sawyerville.

A Japanese Identity

All Olympic Games share one common symbol, the Olympic Rings. The International Olympic Committee controls all use of this famous design, created in 1913 by Baron Pierre de Coupertin, who founded the modern Games. The rings symbolize what de Coupertin called the five parts of the world, and the six colors (including white) represent the colors of all national flags.

Since the ring logo first appeared at the 1920 Games in Antwerp, designers have incorporated the symbol into identity systems created for the host country and city. These designs express the Olympic ideals of peace and sport, but they also communicate something of each country's character and aspirations.

More than 100 designers in Tokyo, London, Paris, and San Francisco worked on the identity for the 1998 Winter Olympics. Created by Landor Associates, one of the world's top corporate identity firms, the design is inspired by nature—like much of Japanese art.

Landor Associates
Klamath House
1001 Front Street
San Francisco, CA 94111

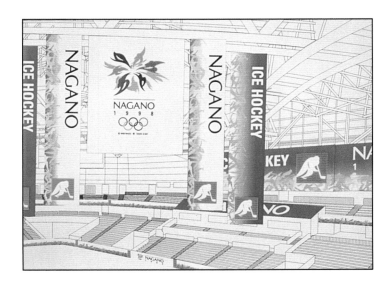

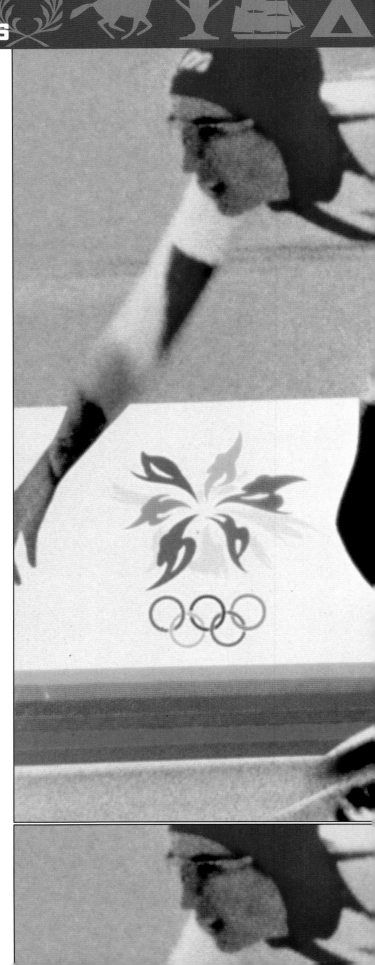

WINTER GAMES

NAGANO

9 9 8

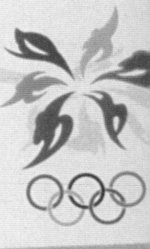

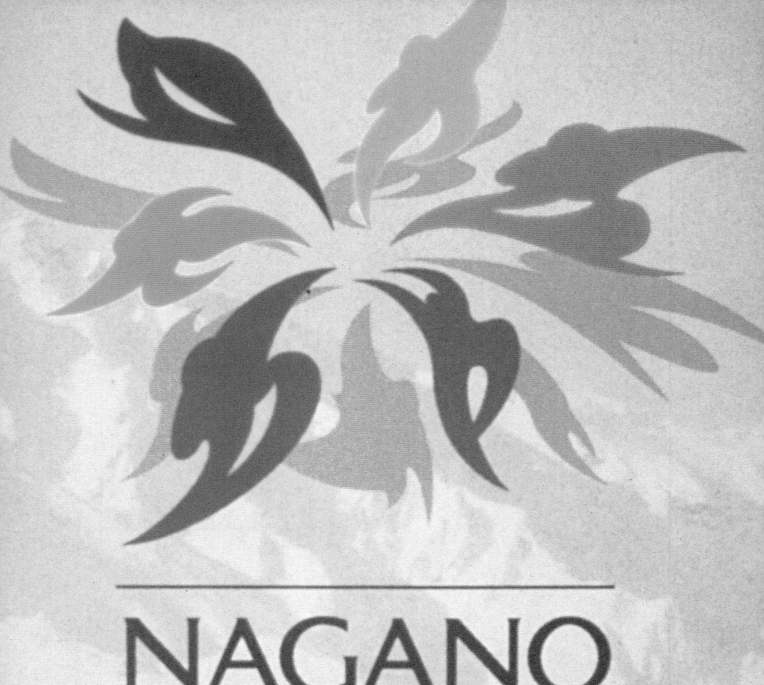

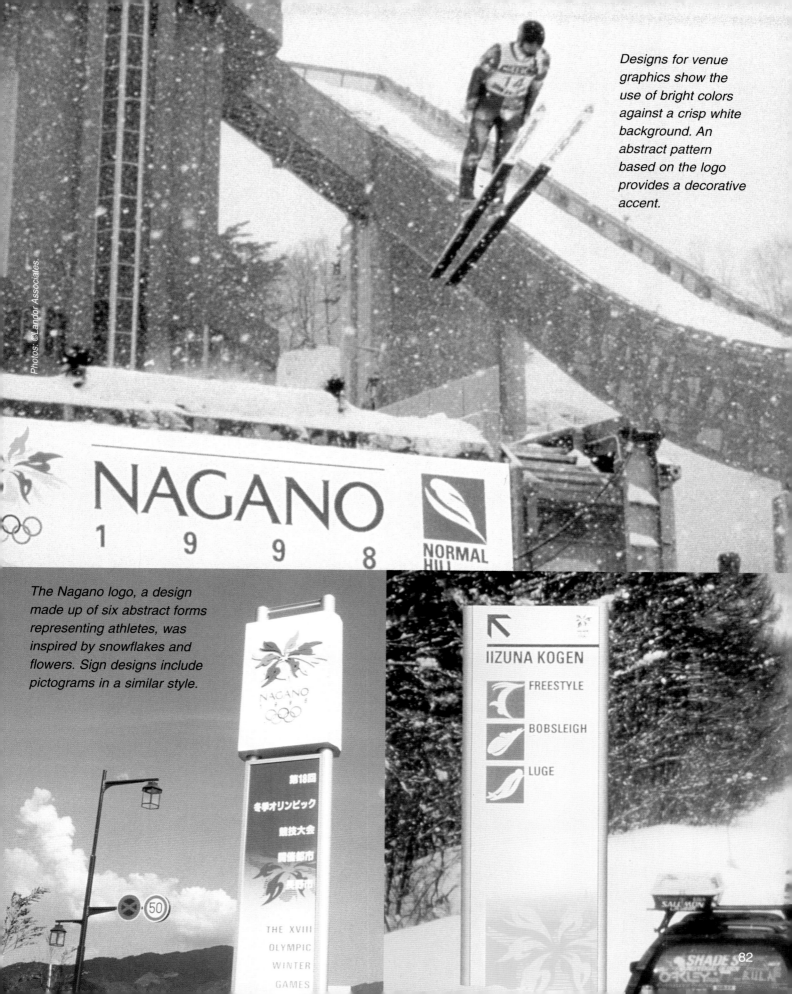

Designs for venue graphics show the use of bright colors against a crisp white background. An abstract pattern based on the logo provides a decorative accent.

NAGANO 1 9 9 8

NORMAL HILL

The Nagano logo, a design made up of six abstract forms representing athletes, was inspired by snowflakes and flowers. Sign designs include pictograms in a similar style.

NAGANO

第18回
冬季オリンピック
競技大会
開催都市
長野市

THE XVIII
OLYMPIC
WINTER
GAMES

IIZUNA KOGEN

FREESTYLE

BOBSLEIGH

LUGE

82

Initial designs show how the identity adapted to small print graphics, as well as venue supergraphics. Careful choices in typefaces harmonized messages in French and English, the official Olympic Games languages, with Japanese.

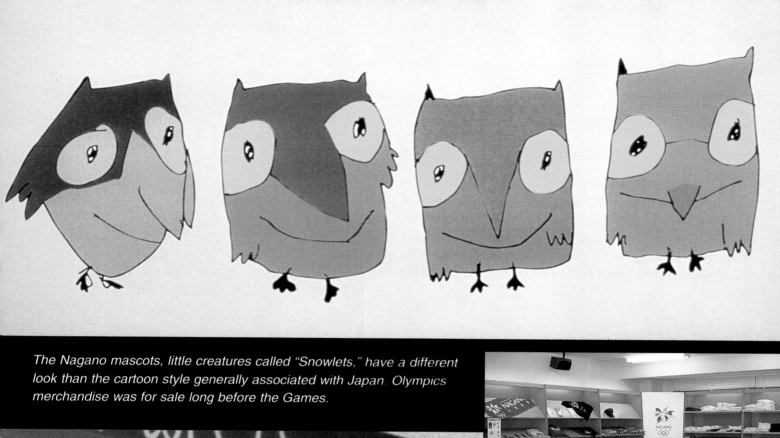

The Nagano mascots, little creatures called "Snowlets," have a different look than the cartoon style generally associated with Japan. Olympics merchandise was for sale long before the Games.

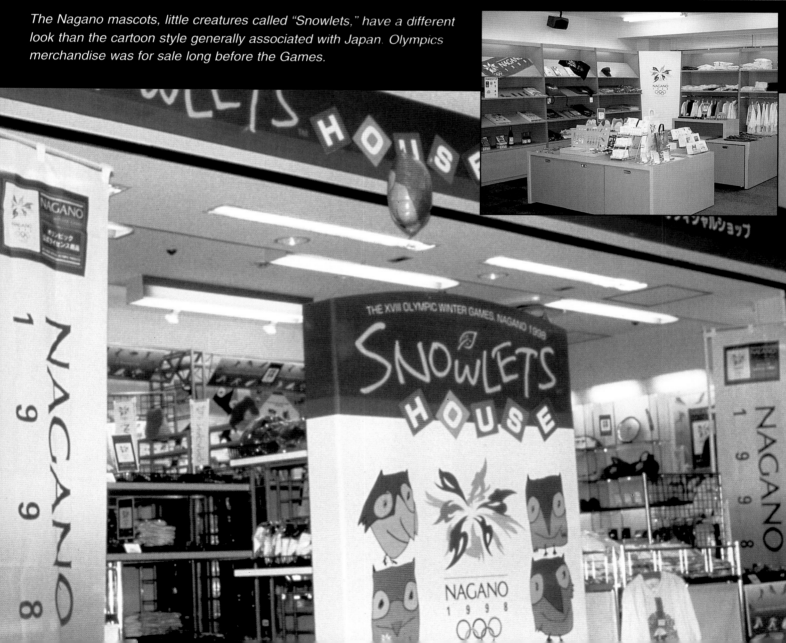

From One, Many

To celebrate its Moravian heritage, the city of Bethlehem, PA, began a yearly summer music festival. From its beginnings in 1983 as a festival with five sites and 150,000 visitors, Musikfest has grown to a ten-day festival in 14 sites throughout the city, with more than 675 free concerts of all kinds and more than 1 million visitors.

But Musikfest has grown in more ways than one. The Bethlehem Musikfest Association now runs two other festivals, both with Christmas themes. Christkindlmarkt Bethlehem, a month-long festival featuring an outdoor Christmas market in heated tents, runs through December and ends with a no-alcohol New Year's Eve celebration. A summer Christmas City fair, run by the Musikfest Association for the Bethlehem Fine Arts Commission, is a craft and community festival held in July.

All three festivals have official logos. The two larger festivals have official colors, and also commission posters each year. These are used on all print graphics, as well as merchandise. Since 1994, Musikfest has commissioned its posters from artists, and has produced limited edition prints of the original artwork in addition to collectible posters.

Musikfest
Musselman Advertising
601 Hamilton Mall
Allentown, PA 18101

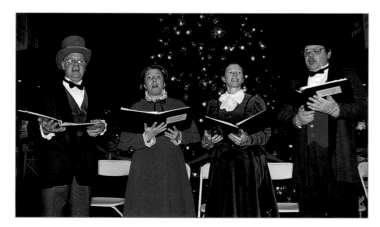

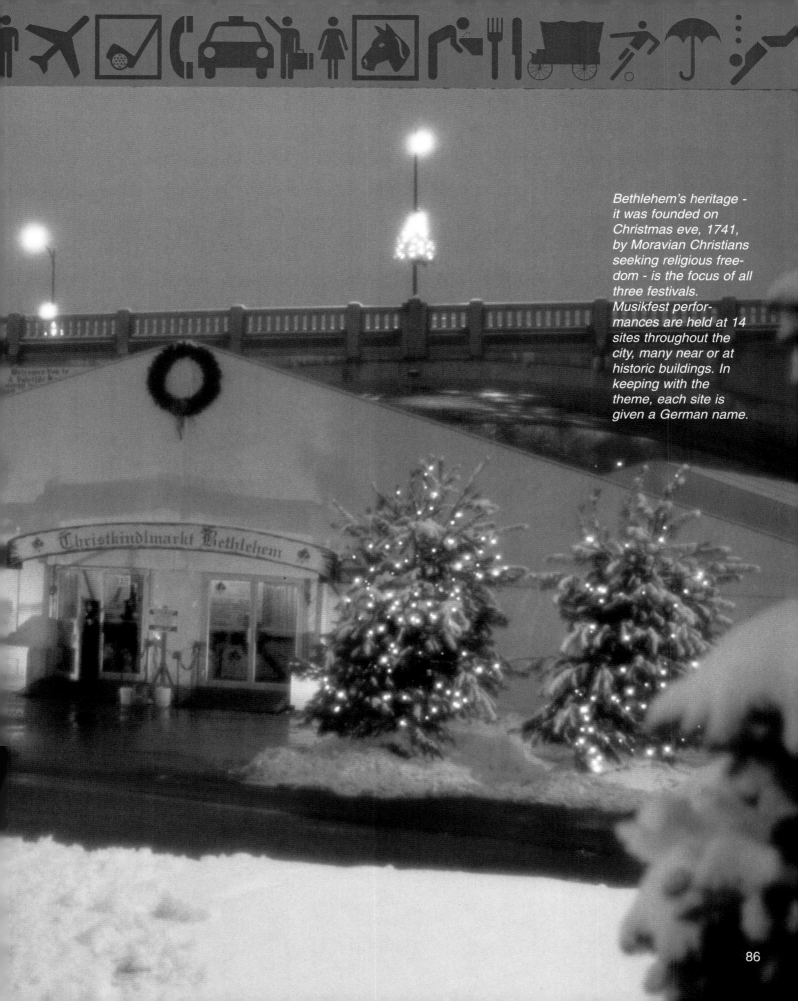

Bethlehem's heritage - it was founded on Christmas eve, 1741, by Moravian Christians seeking religious freedom - is the focus of all three festivals. Musikfest performances are held at 14 sites throughout the city, many near or at historic buildings. In keeping with the theme, each site is given a German name.

The Musikfest colors (blue and gold) and logo (a lyre) are used whenever possible at the site.

CHRISTMAS CITY
FAIR

**Greene & Company
Lehigh Valley Corporate Center
1655 Valley Center Parkway
Suite 100 Bethlehem, PA 18017**

Christmas City Fair uses the Christkindlmarkt site for a one-weekend summer craft and performance festival. Although it has an official logo, it does not have official colors or any other identity system.

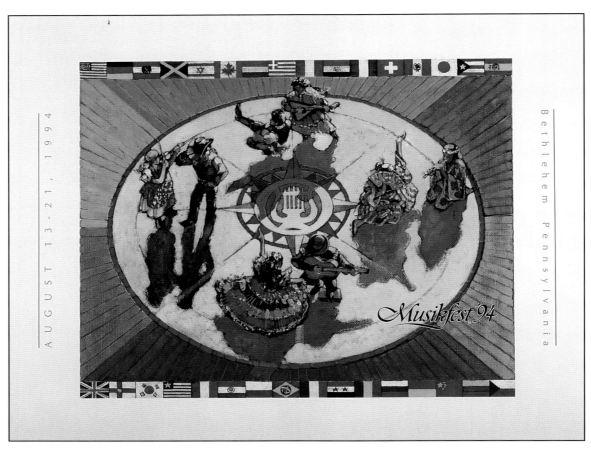

AUGUST 13-21, 1994

Bethlehem Pennsylvania

Musikfest '94

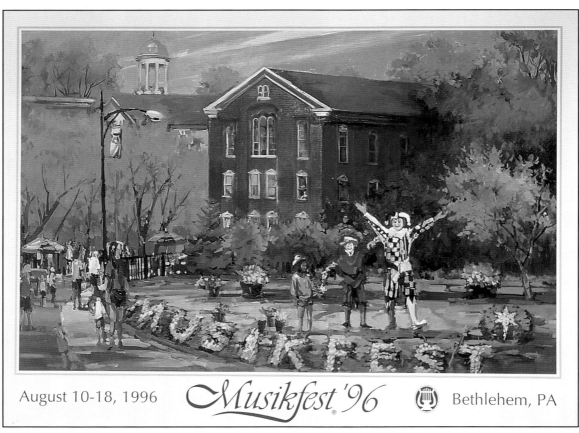

August 10-18, 1996 Musikfest '96 Bethlehem, PA

Designed by artists, the festival posters are eagerly collected by visitors, who come from all over the world. 1994 artwork by Michael Sayre, 1996 artwork by Ben Marcune.

Musikfest '97

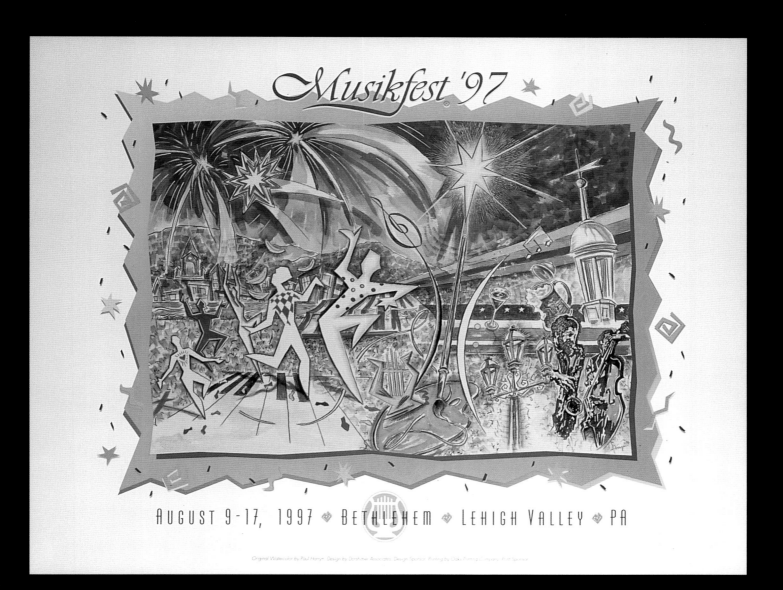

Musikfest produces limited edition prints of the festival artwork, as well as posters. They have been so popular with art-loving visitors that in 1997 the festival added a booth where visitors could order custom frames and posters from 25 other popular festivals. 1997 artwork by Paul Harryn.

Christkindlmarkt

Greene & Company
Lehigh Valley Corporate Center
1655 Valley Center Parkway
Suite 100 Bethlehem, PA 18017

Christkindlmarkt Bethlehem (Christ Child Market) is an outdoor craft market based on ones held in Germany for centuries. Father Christmas and the Christ Child open the market, held inside heated tents, with a parade.

For the festival's first three years, planners emphasized the Christkindlmarkt logo. After establishing it to their satisfaction, planners then commissioned official artwork for posters, promotional pieces, and merchandise. 1995 artwork by Heidi Smeibidl, 1996 artwork by Sergei Yaralov.

Directions signs and festive banner inside the market feature the festival logo and official dark green. Simple but stylish banners identify sponsors.

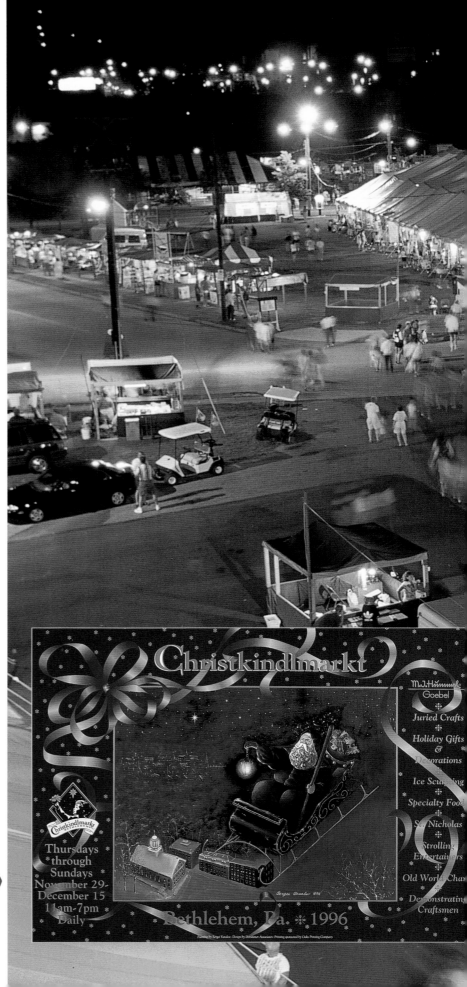

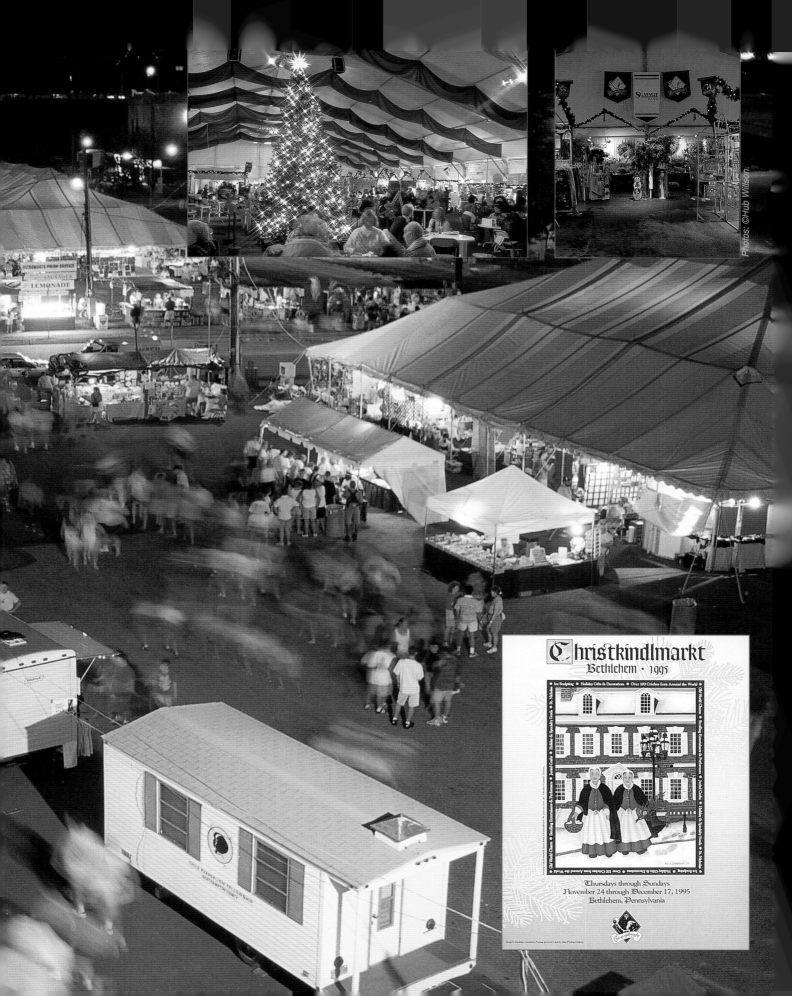

Photos: ©Hub Willson.

Christkindlmarkt
Bethlehem · 1995

Thursdays through Sundays
November 24 through December 17, 1995
Bethlehem, Pennsylvania

Graphics as Theater

For a performing arts festival held by 651, a Brooklyn cultural center dedicated to art of the African Diaspora, projected graphics became a performance. The seven-week festival, which concentrated on the interplay between many cultures in the United States, had no graphic identity or exterior graphics.

Light Projects of New York created the show, which combined graphics by Dmitry Krasny, text by 651 staff, and art by the firm's principal Leni Schwendinger. The images were projected onto 651's headquarters at the Brooklyn Academy of Music's Majestic Theater, from computerized projectors in a parking lot across the street. About 500 people over both nights viewed the 40- x 40-ft. images, and many more saw them in a video documentary that played in the theater lobby throughout the seven weeks.

Light Projects Ltd.
448 West 37th St., 8G
New York, NY 10018

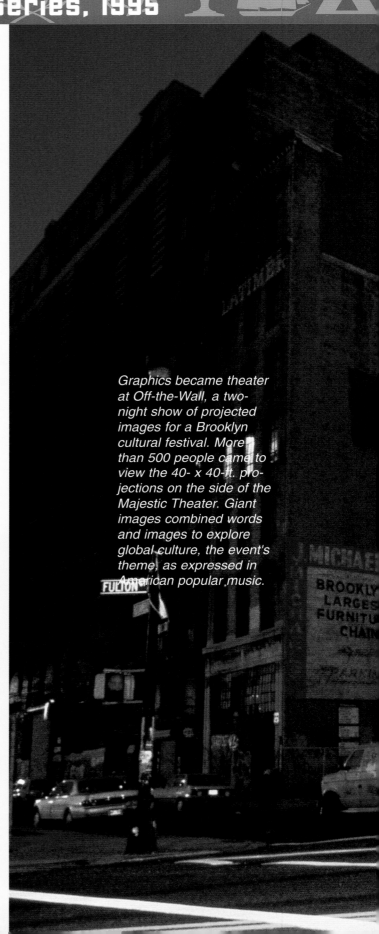

Graphics became theater at Off-the-Wall, a two-night show of projected images for a Brooklyn cultural festival. More than 500 people came to view the 40- x 40-ft. projections on the side of the Majestic Theater. Giant images combined words and images to explore global culture, the event's theme, as expressed in American popular music.

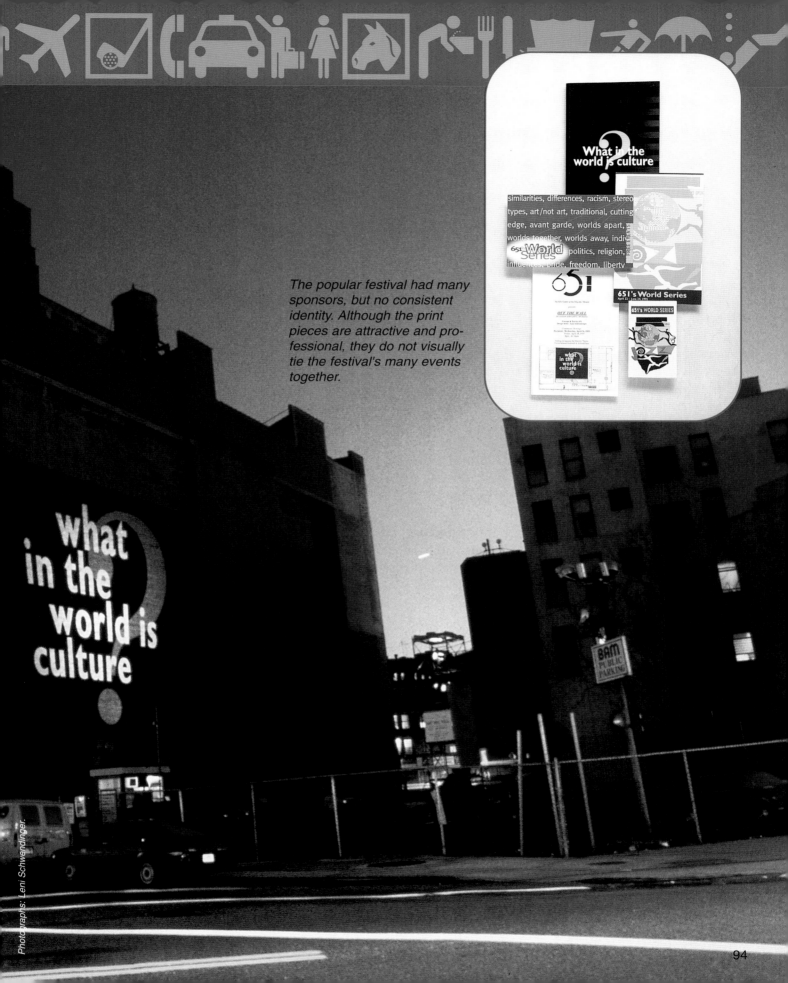

The popular festival had many sponsors, but no consistent identity. Although the print pieces are attractive and professional, they do not visually tie the festival's many events together.

1996 Centennial Olympic Games

Atlanta 1996

Perhaps the biggest festival design project ever, the 1996 Summer Olympic Games were dogged by dissension and complaints. But in the end they delivered on their promises to thousands of athletes, millions of spectators, and billions of television viewers. And the graphic identity, roundly criticized before the Games, did its job superbly.

There is much to learn from this mammoth project. The complex "look of the Games" was used in almost every conceivable way by a variety of people, from the Atlanta Committee for the Olympic Games's own staff of 11 (who handled more than 80 print projects each week for two years) to numerous design firms, vendors, and corporate sponsors. Despite a budget in the millions, the event's sheer scope meant that many planned banners, structures, and other environmental graphics were never made.

Corporate identity designers Landor Associates created the Atlanta Games logo. A team of five design firms then created the games identity, a design called the "quilt of leaves," under the direction of ACOG's Director of Corporate Services Ginger Watkins. The bulk of design and design direction work then went to Copeland Hirthler design + communications, who had designed Atlanta's bid graphics. A number of "clients," from ACOG to broadcasters and international sports federations, had to approve designs. And the graphics had to represent not only the Olympic ideals of sportsmanship and peace, but also the city of Atlanta, the United States, and the 100th anniversary of the Olympic movement.

Copeland Hirthler design + communications
40 Inwood Circle
Atlanta, GA 30309

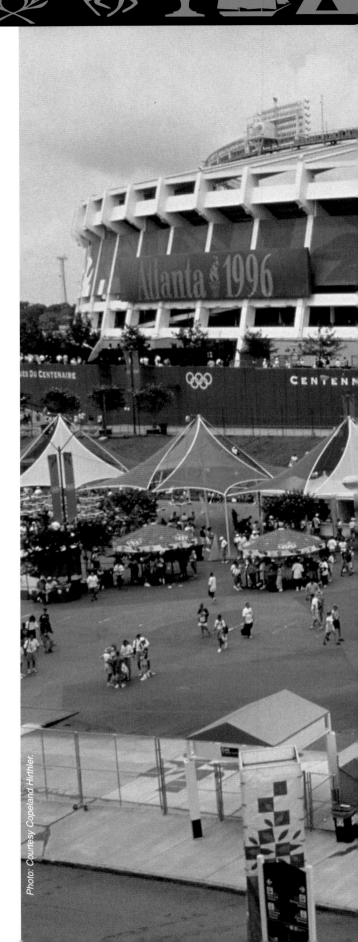

Photo: Courtesy Copeland Hirthler.

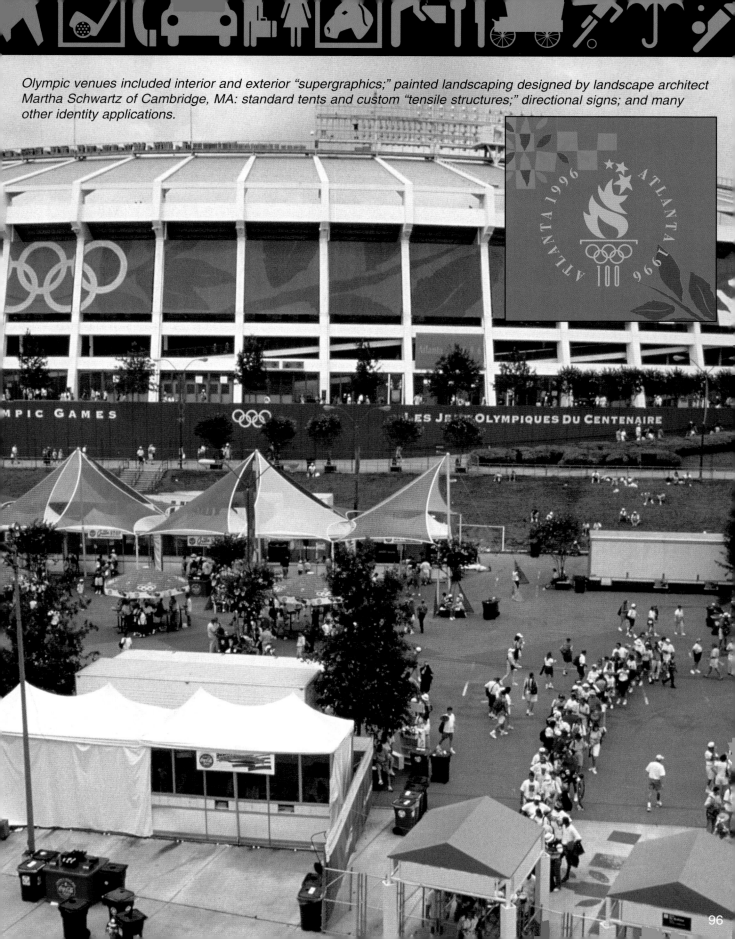

Olympic venues included interior and exterior "supergraphics;" painted landscaping designed by landscape architect Martha Schwartz of Cambridge, MA: standard tents and custom "tensile structures;" directional signs; and many other identity applications.

MPIC GAMES LES JE OLYMPIQUES DU CENTENAIRE

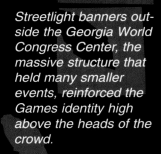

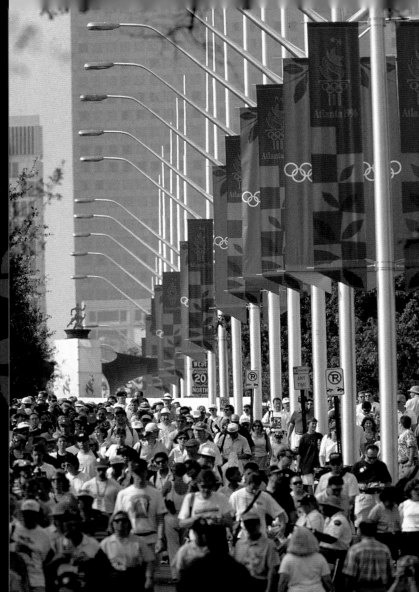

Streetlight banners outside the Georgia World Congress Center, the massive structure that held many smaller events, reinforced the Games identity high above the heads of the crowd.

Mesh fabric covers over miles of temporary chain link fencing were both decorative and practical. They also allowed for tasteful sponsor identification. No advertising graphics are ever allowed within Olympic venues.

JEUX OLYMPIQUES DU CENTENAIRE

VISA

Photo: ©1996, Jones Worley Design.

Atlanta 1996

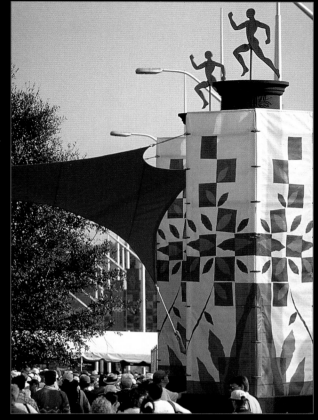

Because environmental graphics were built last, many plans were scrapped for budget reasons. However, enough were built to create a festive atmosphere around venues.

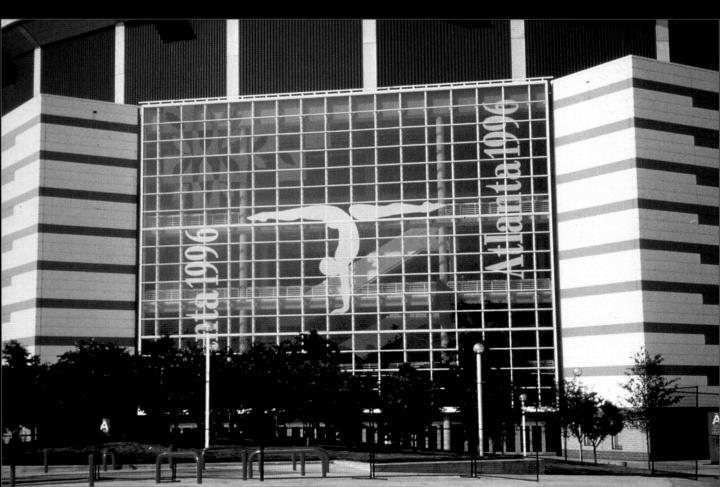

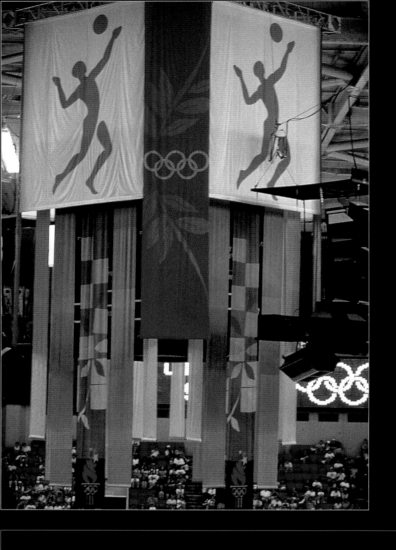

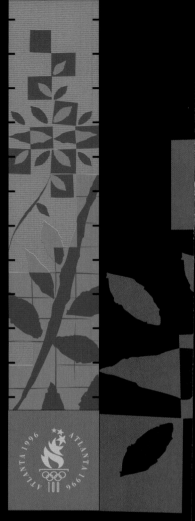

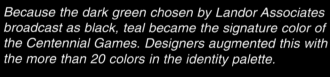

Because the dark green chosen by Landor Associates broadcast as black, teal became the signature color of the Centennial Games. Designers augmented this with the more than 20 colors in the identity palette.

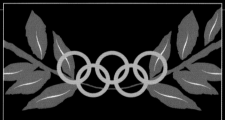

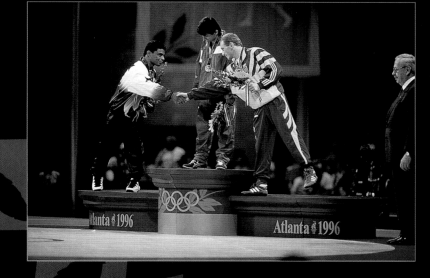

From tiny medals (designed by Malcolm Grear Designers) to giant banners, every object associated with the Games included some aspect of the identity. Winner's pedestals in "Olympic green" bore the Atlanta Games logo (by Landor Associates) and the logo developed for the Centennial Games (by Copeland Hirthler).

Whenever possible, designers applied to the identity to the field of play. These, however, had to be approved by the international sports federations, and many refused. The basketball federation allowed designers to decorate the edge of the Georgia Dome court with identity graphics and the main identity color, teal.

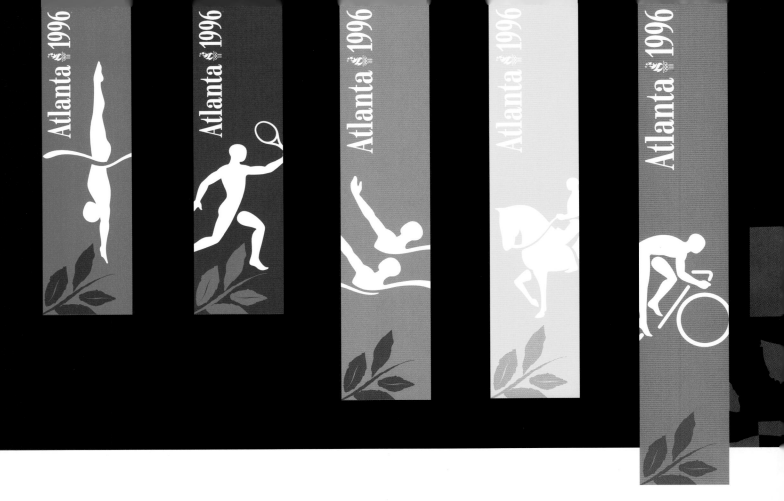

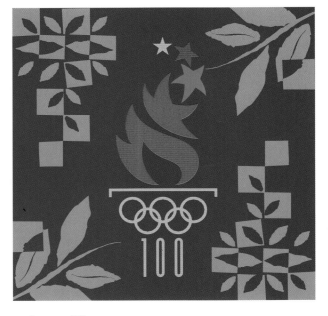

Atlanta 1996

Atlanta 1996

Atlanta 1996

Atlanta 1996

Atlanta 1996

Atlanta 1996

Look of the Games Development Team: Primo Angeli Inc., San Francisco; Copeland Hirthler/Murrell, Atlanta; Favermann Design, Boston; Malcolm Grear Designers Inc., Providence, RI; Jones Worley Design Inc., Atlanta; Turner Associates/Architects & Planners, Atlanta

Atlanta 1996

Atlanta 1996

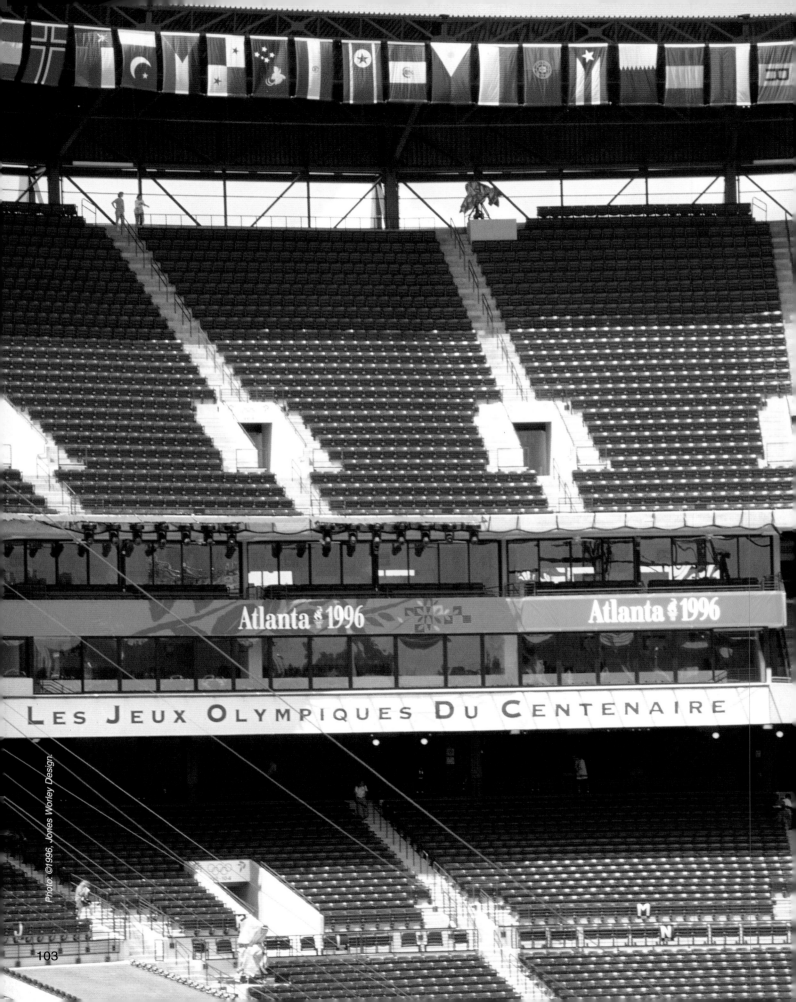

Atlanta ᏚᏱ 1996 Atlanta ᏚᏱ 1996

LES JEUX OLYMPIQUES DU CENTENAIRE

103

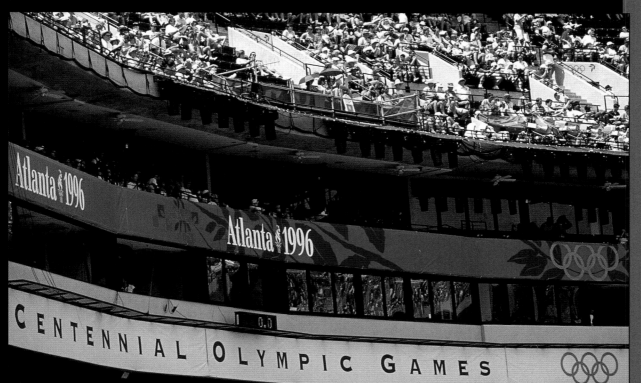

Vinyl banners covered stadium walls, their sheer size allowing designers to use the many logos and colors freely. Each venue had a custom combination of the identity graphics, which featured the "quilt of leaves," pictograms (designed by Malcolm Grear Designers), and the Atlanta Games and Centennial Games logos. Fabric surrounds also included the words "Centennial Olympic Games" in French and English, the two official Games languages.

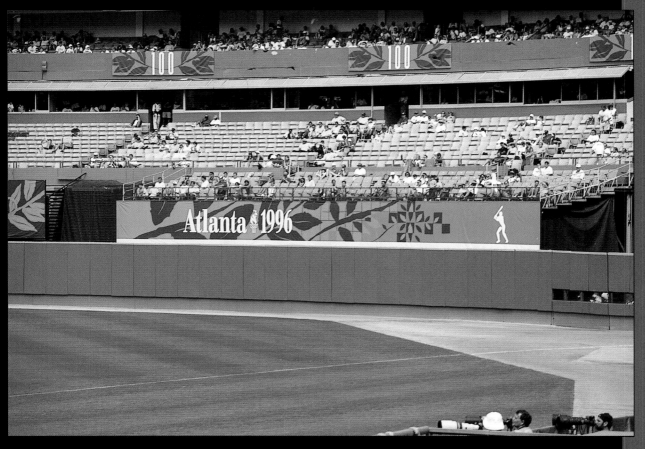

Inside and out, the new swimming venue was decorated with teal graphics. Designers chose accent colors for each venue; here it was white. The identity graphics appear everywhere: printed on banners and backsplash pennants, reproduced on electronic signs, painted on pillars and walls. Existing venues were not decorated as extensively.

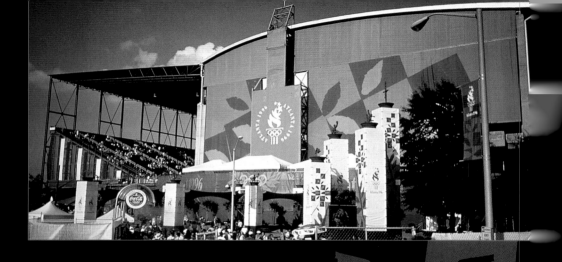

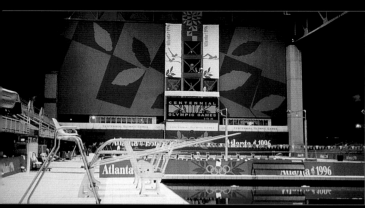

Designing the swimming venue was one of the greatest challenges. A massive sun screen added at the last minute took a huge bite out of the graphics budget, and the manufacturing time for the green mesh fabric meant there was no time to prototype. Fabricators painted the design and hoped it would fit.

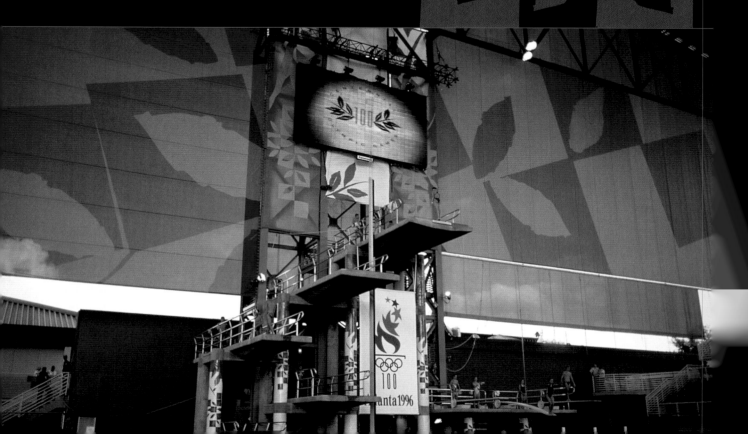

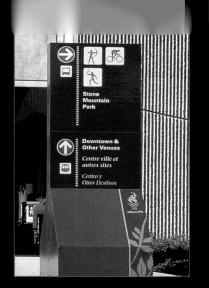

Transit Signs

Miller Graphic Design
500 Bishop Street, Suite F-8
Atlanta, GA 30318

Fabrication: Artografx, Inc., Dallas

MDO panels created a temporary Olympic look on existing mass transit signs.

The $1.8 million sign program directed visitors to 14 venues from more than 30 transit stations. Temporary signs were made of wood with MDO faces and applied vinyl graphics; metal bases kept them firmly in place. Similar signs were made in several dimensions.

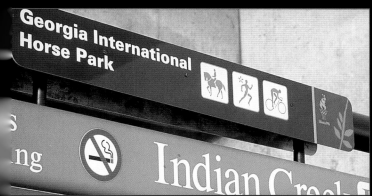

Information kiosks repeated the basic sign shape and design. Dark blue backgrounds signal pedestrian directions, while extensive use of pictograms and Games graphics helped communicate without words. Four typefaces allowed designers to use a pleasing mix of standard lettering.

MARTA (Metropolitan Atlanta Rapid Transit Authority) stations required many temporary signs – some freestanding, others bolted to existing signs.

Highway and street signs may have been temporary, but they nevertheless had to conform to federal and local standards. All signs were removed and sold after the Games.

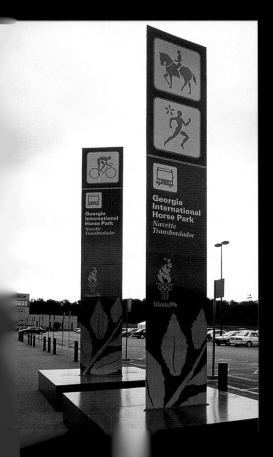

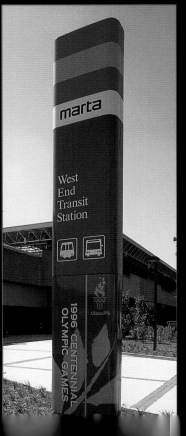

Torch Run

Murrell Design Group
1280 West Peachtree St.
Suite 120
Atlanta, GA 30309

Designers created a separate Torch Run identity, adapting the "quilt of leaves" from the Games identity and transforming it into a "quilt of flames." Seen here embroidered on a staff uniform hat, the identity is clearly related.

A new pictogram, seen here on a souvenir pin, symbolized the ceremonial Olympic flame relay.

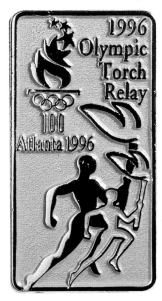

Commemorative torches were designed by Malcolm Grear Designers, one of the firms who helped design the Look of the Games. Runners could buy their torches as souvenirs, although many sold them to eager collectors.

Staff uniforms show different applications of the Torch Run identity combined with the official Games identity. Some designs also displayed the logo of the relay's major sponsor, Coca-Cola. For the Torch Run standards, designers chose the brightest colors from the Games palette and added a metallic silver.

Numerous vehicles helped carry the Torch Relay staff on its 15,000 mile journey across the United States. All were decorated with the identity graphics.

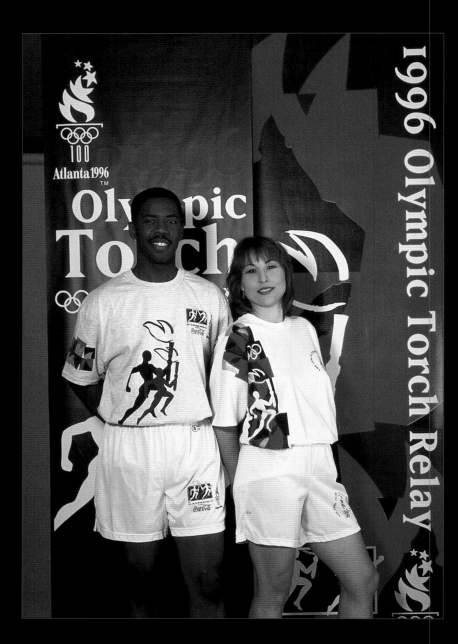

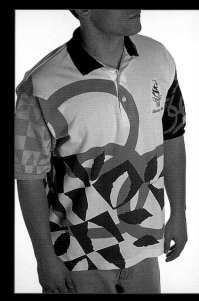

Photos: Kelli Coggins and Tony Schannel.

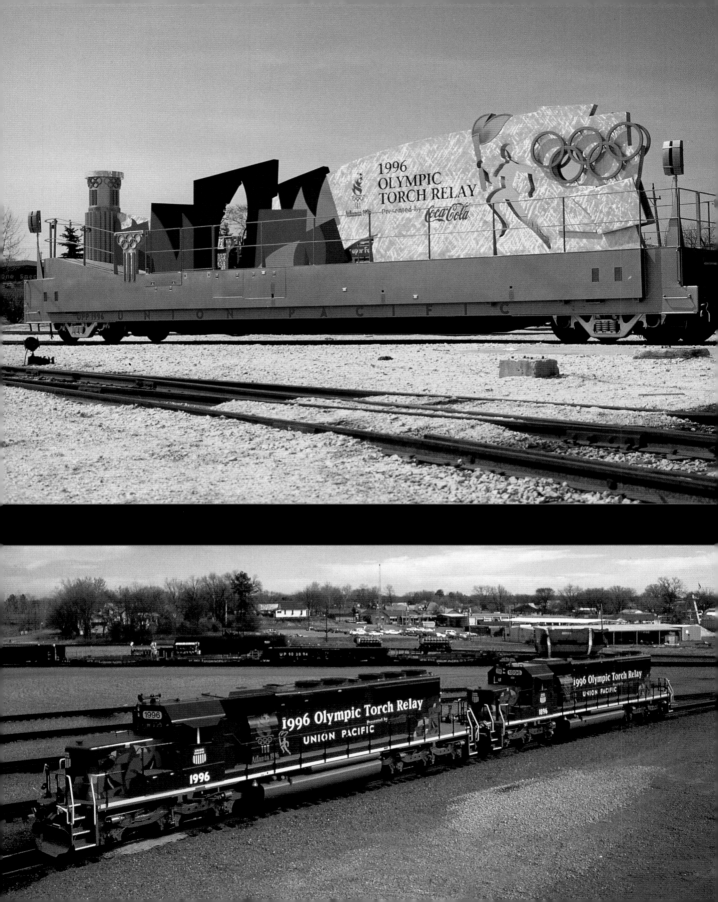

Olympic Hospitality Center

Favermann Design
18 Aberdeen St.
Boston, MA 02215

Designers had to design around an existing fabric sculpture, (plain orange), for the 490-ft. atrium at the Olympic Hospitality Center. Although the new sculpture was meant to be temporary, the Marriott Marquis has kept it up.

To enliven the vast empty space, designers used the brightest colors in the Games palette and featured the lively leaf and stem designs from the standards. The sculpture required 28,000 sq. ft. of nylon fabric, and was so large that it had to be assembled on a rented stage at the Six Flags Over Georgia theme park.

Each of the sculpture's three 50-ft. sections revolves in the building's self-generated breeze.

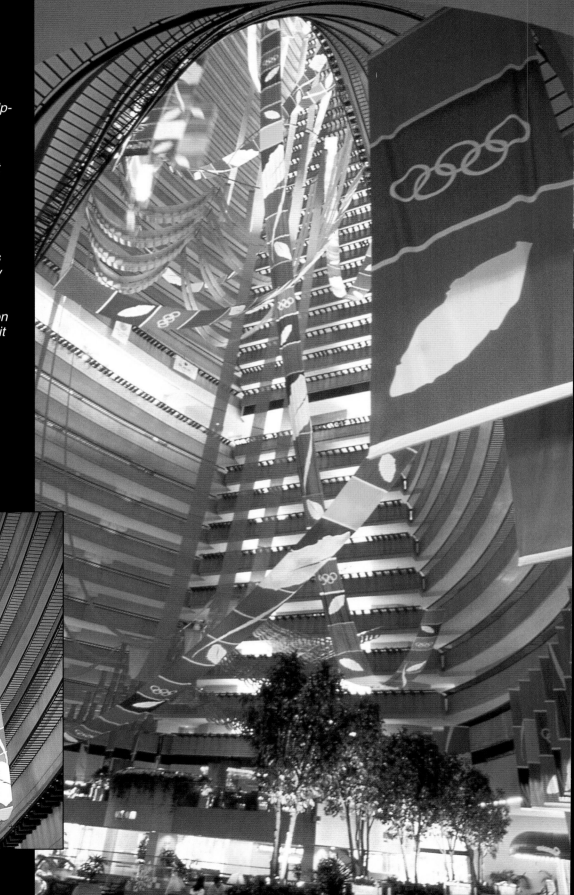

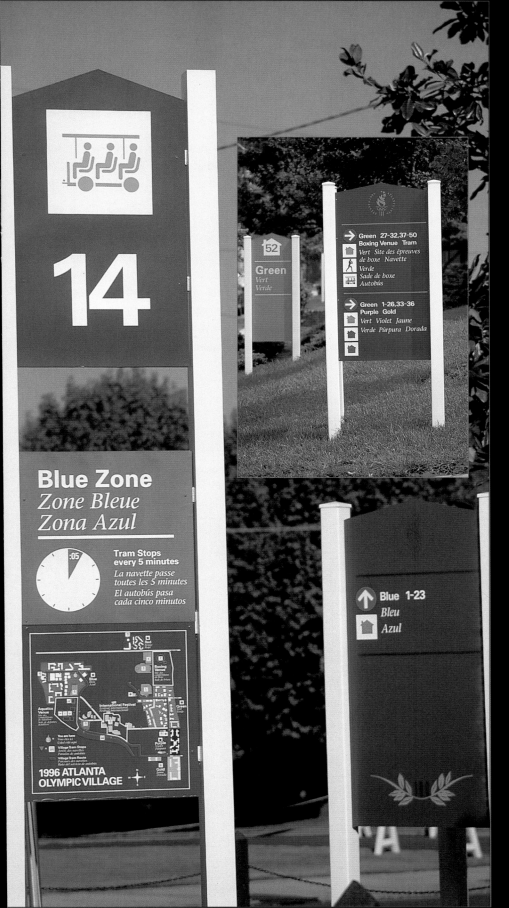

Olympic Village/Venue Signs

Jones Worley Design Inc.
723 Piedmont Avenue, NE
Atlanta, GA 30365

Fabricator: Environmental
Graphic Systems, Atlanta

*Jones Worley designed the Olympic
Games venue directional signs, and
used the same specifications for the
Olympic Village at the Georgia Institute
of Technology. The graphics were
detailed enough to help athletes
speaking dozens of languages find
their way around their temporary
home.*

*Color coding, pictograms, and maps
helped athletes get where they wanted
to go, even if they didn't speak any of
the three languages used on the signs.*

*Made of reusable plywood or fiber-
board on square PVC posts, the post
and panel signs had to be both inex-
pensive and durable. Messages and
pictograms were made of computer-cut
vinyl.*

TAKING OVER A SITE

For several decades, the international Paralympic Games have followed the Olympic Games, using the same sites. While future Olympic Games bids will include running the Paralympics, the 1996 Paralympic Games were run by a separate committee with separate funding. The committee hired Copeland Hirthler design + communications to create the event graphics, because the firm was intimately familiar with the sites after coordinating the Olympic Games graphics.

The Paralympic design budget was much smaller, and the graphics were consequently simpler. The designers scaled down what they had done for the Olympic Games, applying the Paralympic logo, colors, and motto ("The Triumph of the Human Spirit") to a sign package made up primarily of fabric banners.

Much of the challenge for this identity package was logistical. Because the Paralympic Games take place two weeks after the Olympic Games, the Olympic signage had to be removed quickly. And because the Paralympic Games take place while the sites are being used for other purposes, their graphics had to be put in and replaced even more quickly.

Copeland Hirthler design + communications
40 Inwood Circle
Atlanta, GA 30309

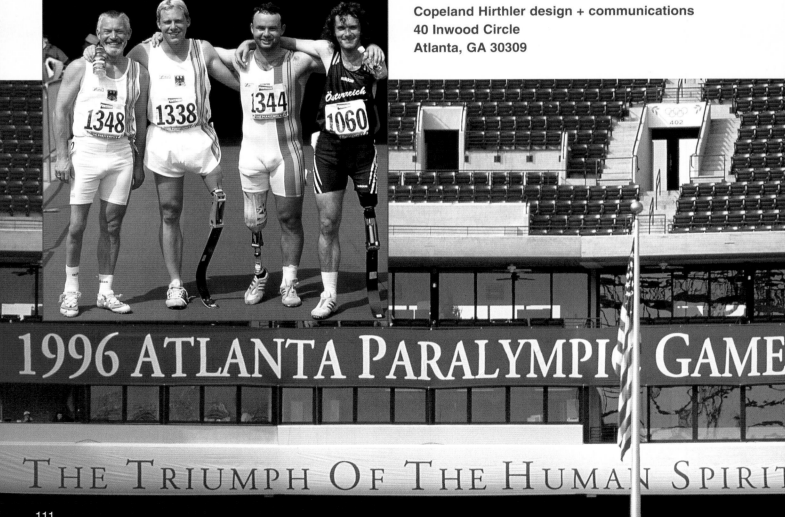

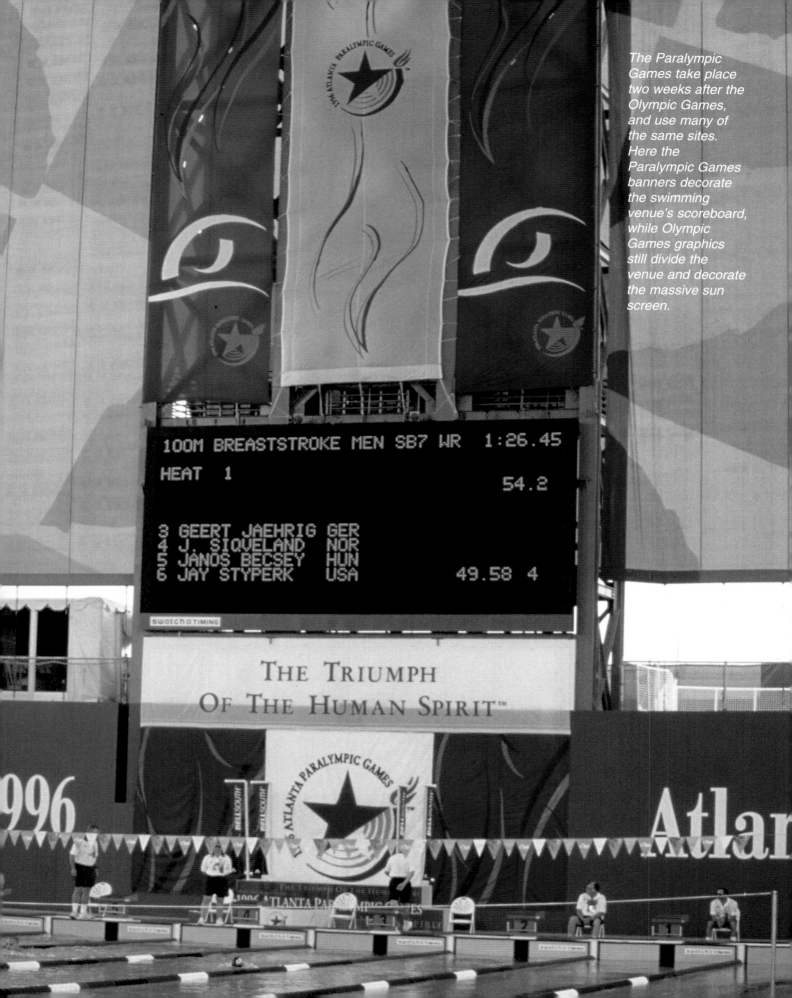

The Paralympic Games take place two weeks after the Olympic Games, and use many of the same sites. Here the Paralympic Games banners decorate the swimming venue's scoreboard, while Olympic Games graphics still divide the venue and decorate the massive sun screen.

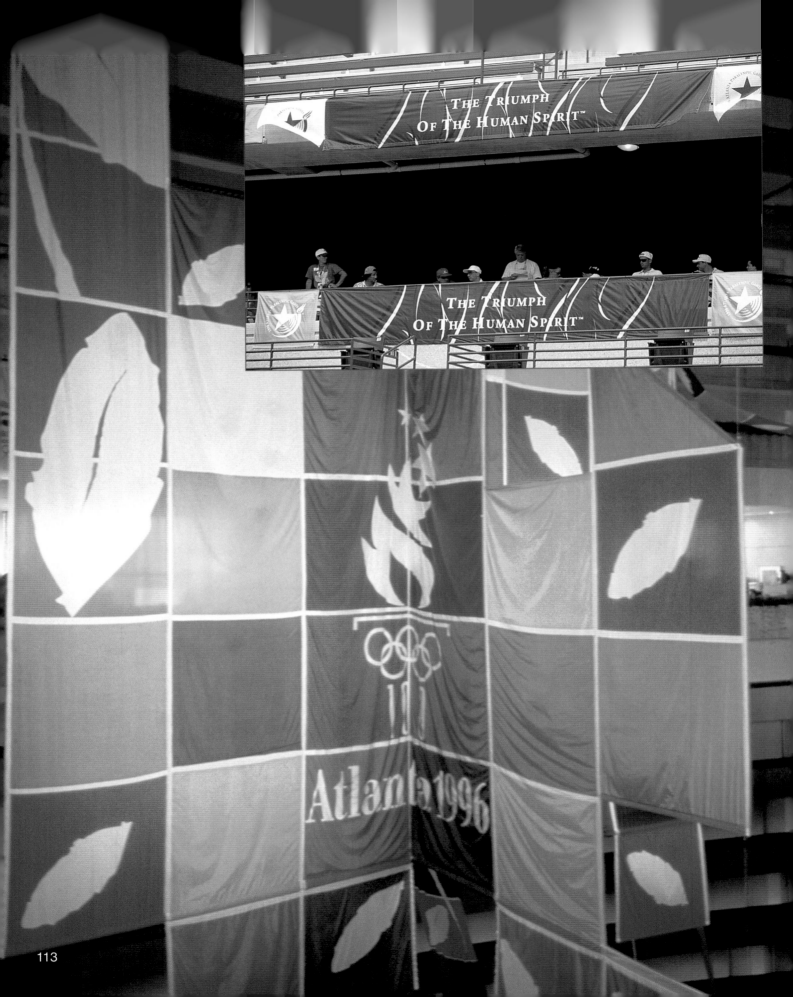

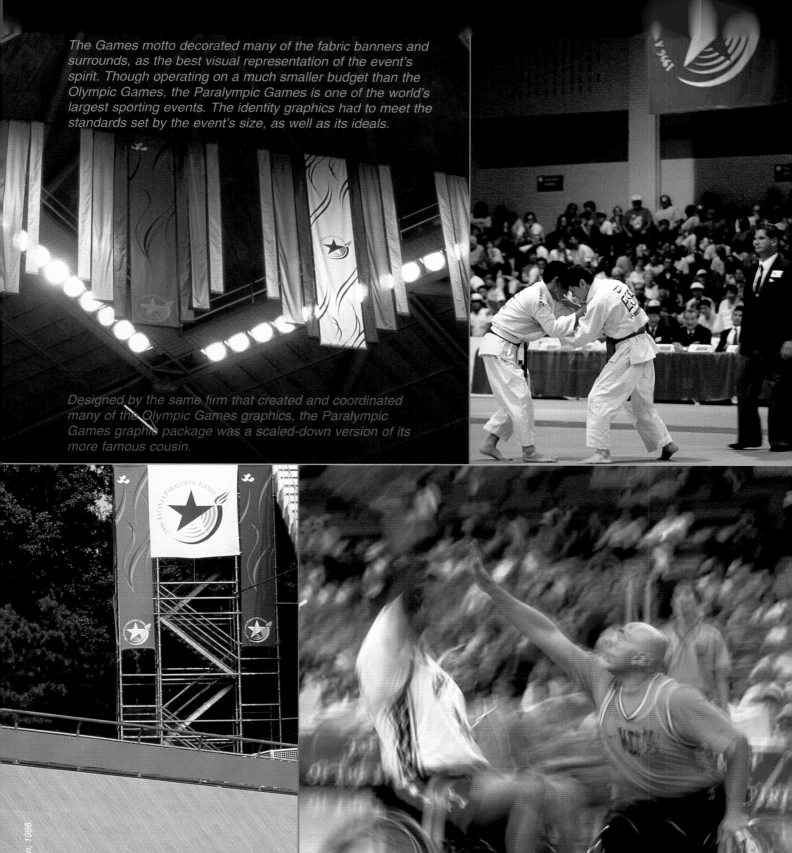

The Games motto decorated many of the fabric banners and surrounds, as the best visual representation of the event's spirit. Though operating on a much smaller budget than the Olympic Games, the Paralympic Games is one of the world's largest sporting events. The identity graphics had to meet the standards set by the event's size, as well as its ideals.

Designed by the same firm that created and coordinated many of the Olympic Games graphics, the Paralympic Games graphic package was a scaled-down version of its more famous cousin.

Photos: ©Chris Hamilton, 1996.

A Bold New Direction

For years, designer Paul Davis brought The Public Theater's summer New York Shakespeare Festival to life with vivid, romantic posters. Free performances of the classic plays, performed in Central Park, became benchmarks for productions around the world. But when director Joseph Papp died, the company had to take a new direction. In 1992, producer George C. Wolfe made major changes in the festival and other Public Theater projects, changes that the New York offices of Pentagram made visible with new graphics.

Pentagram's designs for the Shakespeare Festival are part of an overall identity for The Public Theater. At once modern and classic, it combines blocks of traditional wood type with photographs and round "stamps" representing each theater or project. The consistent identity helps people connect the many productions with each other, and recognize the organization from year to year.

The identity is applied to banners, posters and signs at The Public Theater's headquarters and theater; and to Shakespeare Festival literature and merchandise. Future plans include extending the graphics to Delacorte Theater, the Central Park amphitheater where the Festival takes place.

Pentagram Design

204 Fifth Avenue, New York, NY 10010

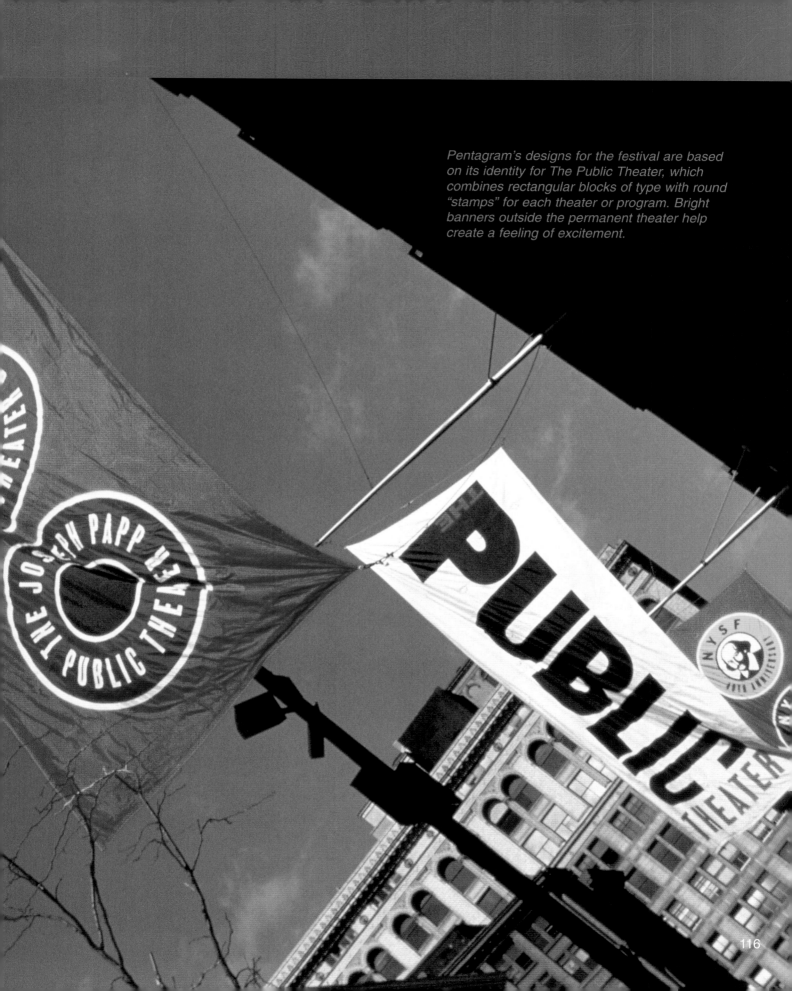

Pentagram's designs for the festival are based on its identity for The Public Theater, which combines rectangular blocks of type with round "stamps" for each theater or program. Bright banners outside the permanent theater help create a feeling of excitement.

116

Pentagram's first project for The Public Theater was to graphically portray the dramatic change t
its popular New York Shakespeare Festival had taken. In place of romantic posters by famed de
Paul Davis, Pentagram created a bold, all-type style for the 1994 season. Print graphics continue

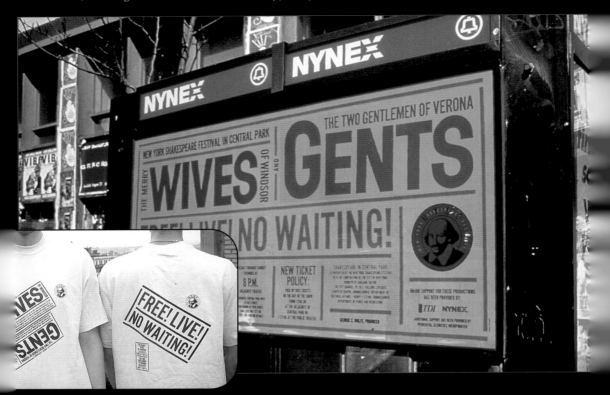

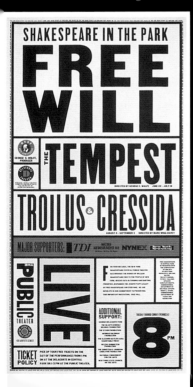

The all-type graphics continued
for the festival's 1995 season,
with an even blockier grid.

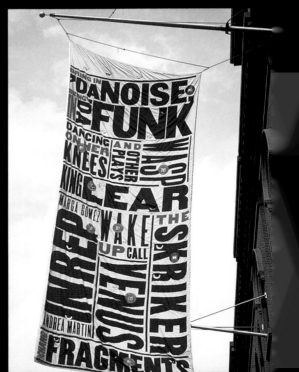

The 1996 season graphics took the versatile
look another step forward. Freestanding sign
at the Central Park amphitheater are current
the only graphics at performances. Future
plans call for signs and graphics at the site.

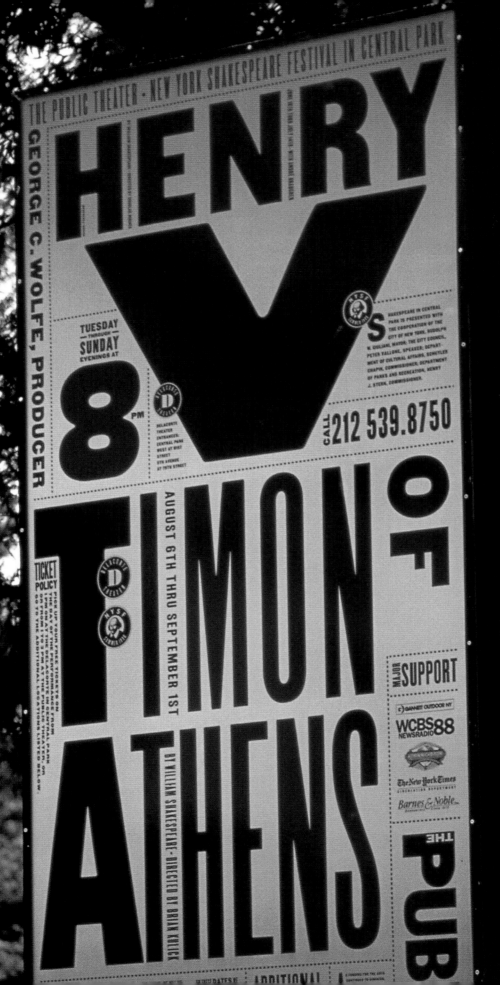

A Low-Cost Experiment with Identity

The Big 12 Conference of college athletic departments formed in 1994 when four schools from the Southwest Conference (Baylor, Texas, Texas A&M, and Texas Tech) joined the former Big Eight (Colorado, Iowa State, Kansas, Kansas State, Missouri, Nebraska, Oklahoma, and Oklahoma State). In the Conference's first competition season, 1996-97, commissioners decided to experiment with identity graphics away from the glare of football.

Favermann Design created a Conference look, pictogram system, and color palette that was inaugurated at the 1997 swimming and diving championships. Designers created an event logo that combined the official Big XII logo with the sponsor name, pictograms symbolizing swimming and diving, and with an abstract pattern representing water. They then used the various elements throughout the Texas A&M site.

Because the budget was tight, Favermann Design worked hard to ensure that the fabrication dollars were spent wisely. They chose low-cost banners to get the largest graphics at the lowest price, and worked with the Fox network, which televised the events, to ensure that the colors worked well on television as well as at the site. They also worked from blueprints and computer photos of the site to ensure that the banners would have maximum impact. Official timers wore t-shirts printed with a two-color version of the event logo.

Following the successful launch, the commissioners planned to expand the look to additional sports over the next academic year.

Favermann Design
18 Aberdeen St.
Boston, MA 02215

Fabrication: Flying Colors, Boston

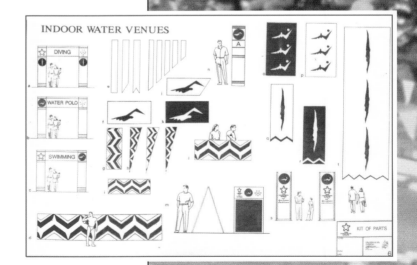

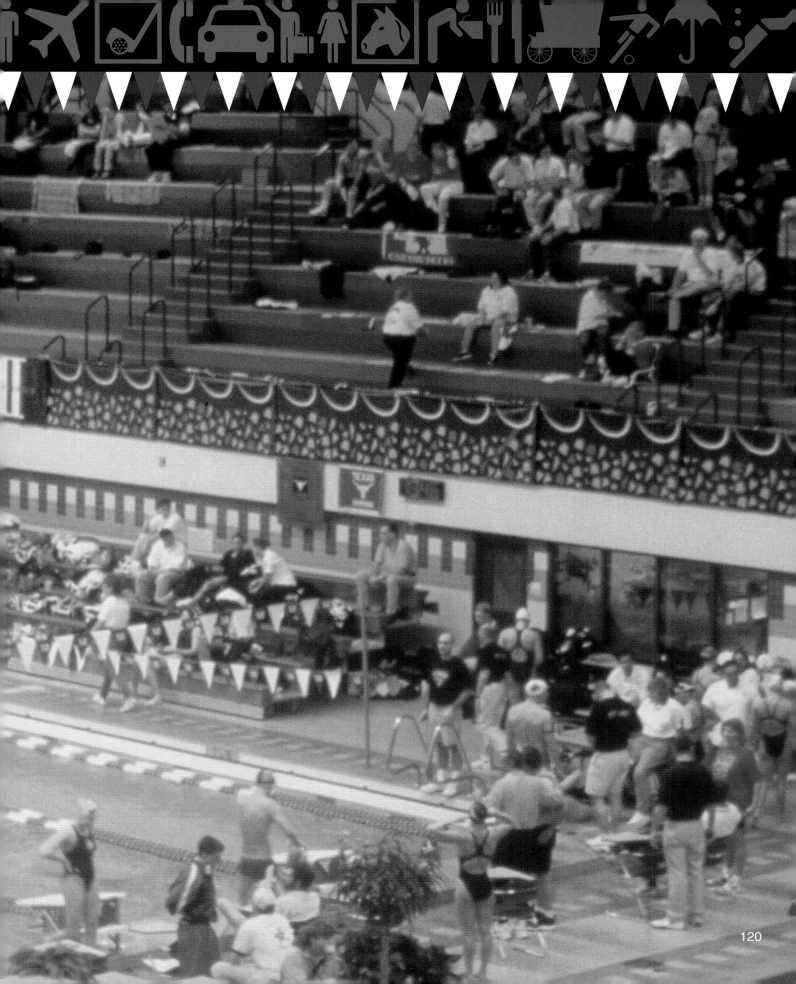

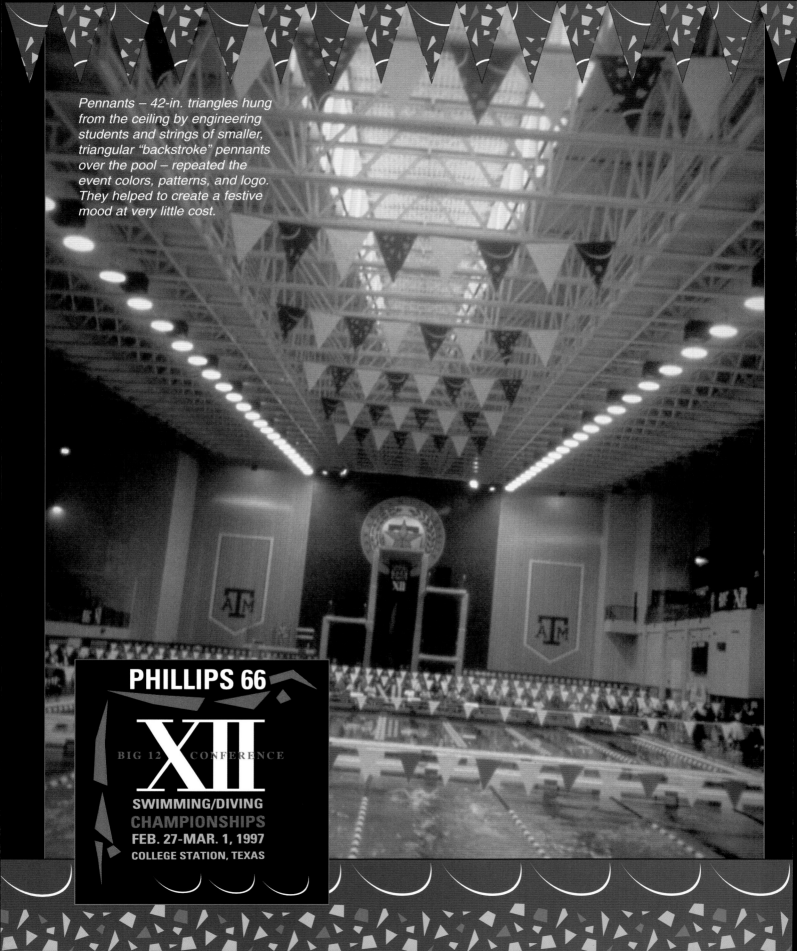

Pennants – 42-in. triangles hung from the ceiling by engineering students and strings of smaller, triangular "backstroke" pennants over the pool – repeated the event colors, patterns, and logo. They helped to create a festive mood at very little cost.

PHILLIPS 66

XII

BIG 12 CONFERENCE

SWIMMING/DIVING
CHAMPIONSHIPS
FEB. 27-MAR. 1, 1997
COLLEGE STATION, TEXAS

Spread out, the complex graphics took on an orderly, pleasing appearance. The running vinyl surround on the seating tier features an abstract pattern representing water (curving waves above a celebratory confetti pattern representing crowds), punctuated by the Conference and sponsor logos and the swimming pictogram. The low-cost banners are simply tied to the existing railing. "Big XII" banners were made separately so they could be used at other events.

The 34-ft. appliqued nylon banner under the 10-meter diving board featured the pictogram for diving and the Conference logo, and placed the sponsor's logo in a prominent position that harmonized with the graphics.

Building special winners' stands was not an option, but Favermann Design gave the existing stands a custom look by adapting one of the same vinyl banners used on the surrounds.

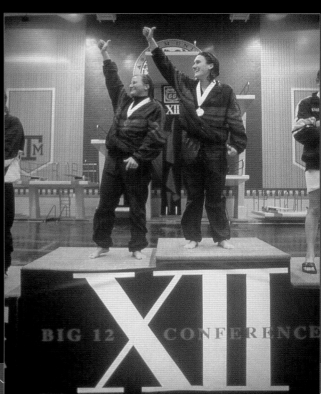

Photos: Courtesy Favermann Design.

Stressing Sponsor Identity

For the five years that super-luxury CIGA Hotels sponsored Europe's premiere thoroughbred racing weekend, John Lees & Associates created an equally premiere identity. Uniforms by Givenchy, Austrian crystal trophies by Swarowski, enameled plaques by Bulgari, and specially labeled Veuv Cliquot champaign set the tone for this sophisticated weekend at Lonchamp hippodrome (track) in Paris, highlighted by the Prix de l'Arc de Triomphe.

The chain (now a part of ITT), took on sponsorship as part of its efforts to position itself as a European, rather than simply Italian, business. The event graphics therefore stressed the sponsor name, not the races or the track. Graphics focus on horses and horse racing in art, spearheaded by the company's logo: the four horses of St. Mark's Basilica. The Italian bronze sculptures, cast in the fourth century B.C., have long been a Venetian tourist attraction. Souvenirs featured the logo, a specially commissioned painting of the previous year's winner, and the weekend's gold and green colors.

Banners bearing the crests of CIGA hotels, temporary wooden winners' platforms and other structures, and a temporary souvenir boutique transformed the famous hippodrome for the two-day event, and were then packed away for another year. Printed racing forms and schedules, usually printed cheaply, were produced to the same standards as the event's museum-catalogue-quality souvenir program.

John Lees & Associates, Inc.
8 Myrtle Street
Boston, MA 02114

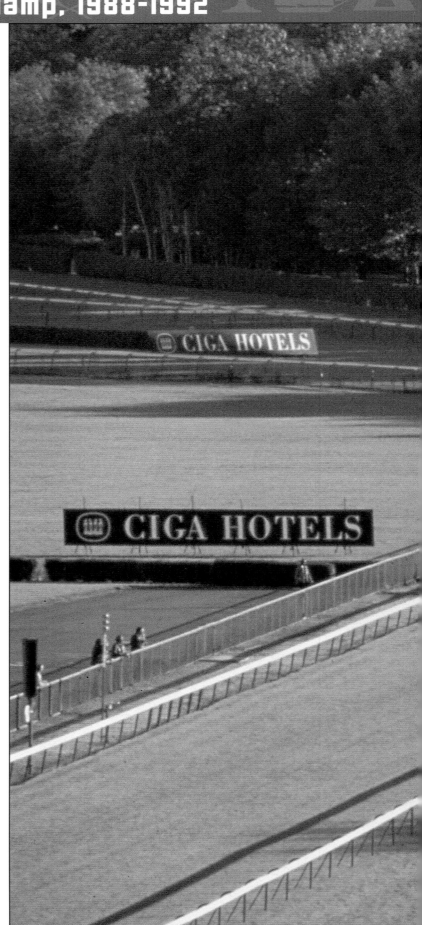

123

Glamour, wealth, and fashion are an integral part of European horse racing. A weekend of racing at Longchamp Hippodrome in Paris culminates in the Prix de l'Arc de Triomphe, one of the races in the French Triple Crown. The CIGA chain of luxury hotels sponsored the event for five years and controlled the festival graphics.

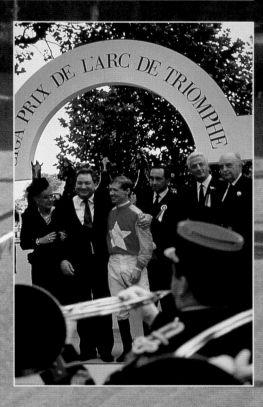

Souvenir booklets resembled museum catalogues and became collectors' items. Other printed pieces, including the racing programs printed hours before the races, maintained the same printing standards.

Souvenirs, like the identity graphics, stressed the connection between racing and art. They included expensive items such as watches, fountain pens, and silk scarves, and were sold in a temporary "boutique" with their own signature packaging.

Uniforms by Givenchy continued the event color palette of dark jewel tones inspired by racing silks.

Thirty-six banners lined the hippodrome's plaza, decorated with the crests of the 35 CIGA luxury hotels in gold adhesive vinyl. Like the wooden structures, the fabric banners and their metal poles were all stored at a local sign shop and reused the following year.

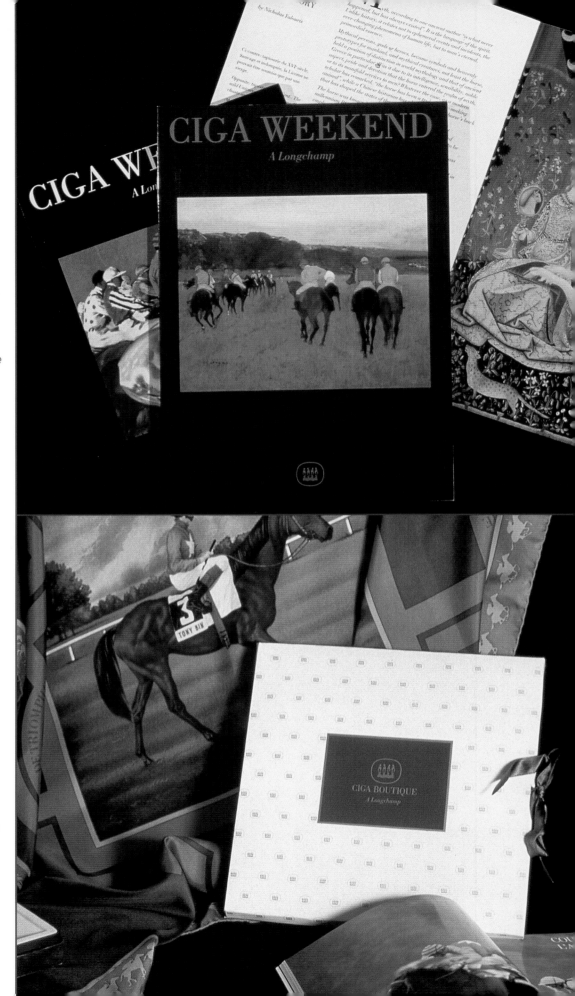

Austrian crystal trophies made by Swarowski continued the four horses of St. Mark's motif.

The French Foreign Legion Band entertained race enthusiasts next to a temporary gateway. The statue of racehorse Gladiateur is one of Longchamp's famous sites.

For CIGA Weekend a bronze replica of the four horses of St. Mark's, the CIGA logo, took center stage at the winner's platform.

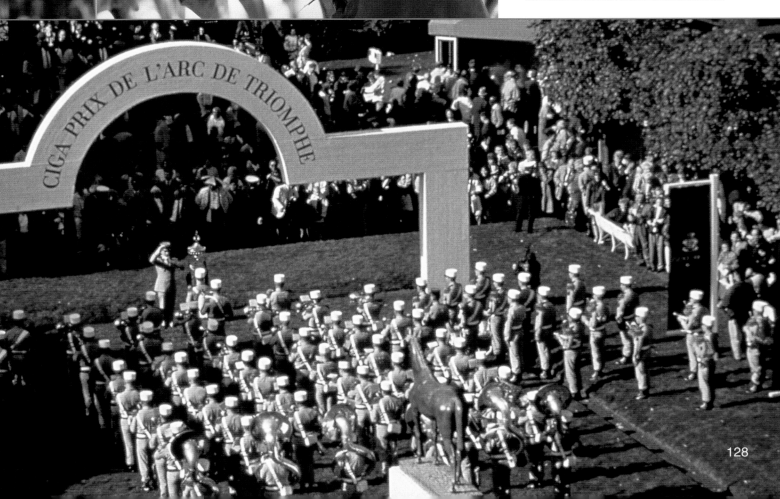

Environmental Art and Environmental Graphics

For a new Cincinnati arts festival, Kolar Design created a kinetic and contemporary design. The all-type logo, which included the major sponsor's name, could be stepped and repeated to make an almost abstract pattern. Signs and graphics used the pattern and bold green and purple color scheme—or were works of art themselves.

University of Cincinnati architecture students created many of the designs, and built several structures. Sponsors also helped. An engineering firm, for instance, made sure that structures were strong enough to withstand wind and crowds.

The event centered on Fountain Square, Cincinnati's central public plaza. Performers and fine artists held the Square while art exhibits were spread throughout surrounding buildings and elevated walkways. Another designer did the graphics for the 1995 and 1996 events, which are not documented, and in 1997 the event was replaced with a song festival. The site, planners felt, was too large and complex for the event.

Kolar Design
308 E. 8th Street
Cincinnati, Ohio 45202

Photos: ©Brad Livingston.

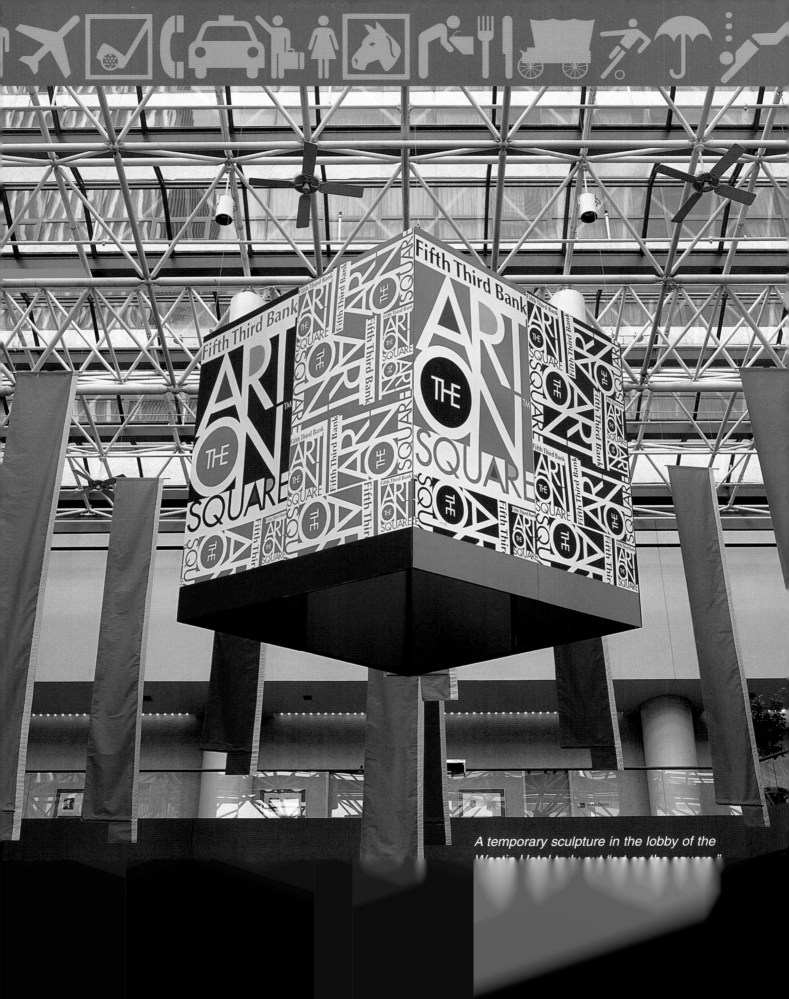

A temporary sculpture in the lobby of the
Westin Hotel touts part "art on the square."

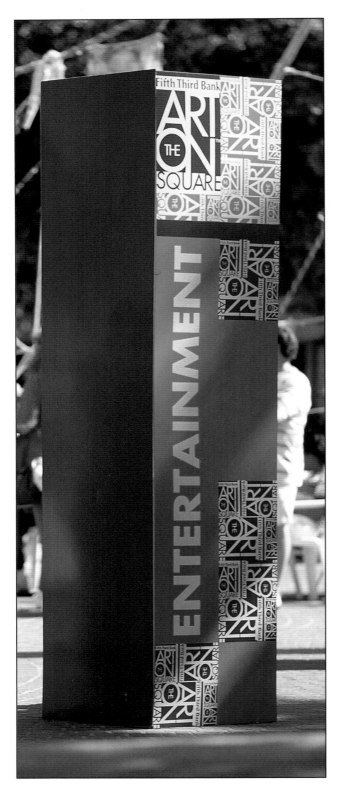

Seeing practicing performing artists, plein air painters, and other fine artists was part of the festival's appeal. To avoid competing with the city's popular summer craft fair, crafters were not included in the displays or exhibits.

A pattern made of the event logo decorated information kiosks, made of screenprinted corrugated plastic on wooden frames. The name of the major sponsor is clearly visible, and part of all decor.

An interactive exhibit designed and built by University of Cincinnati architecture students included a "teepee" made of fabric, string and beads hung from real wooden teepee poles.

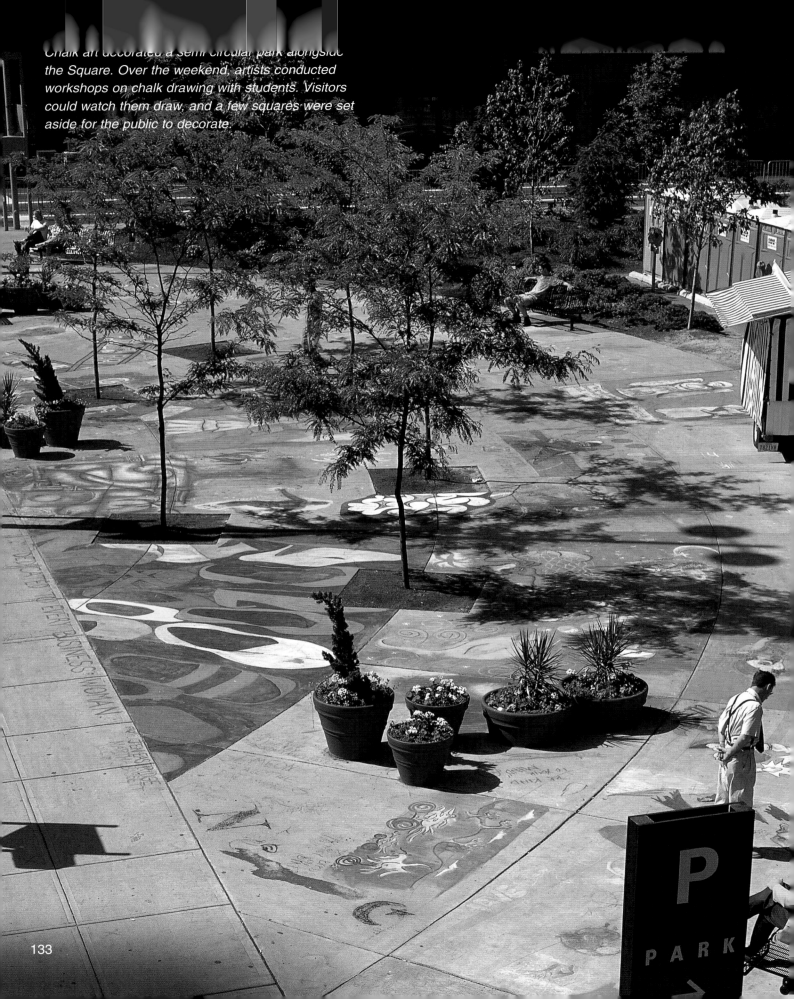

Chalk art decorated a semi-circular park alongside the Square. Over the weekend, artists conducted workshops on chalk drawing with students. Visitors could watch them draw, and a few squares were set aside for the public to decorate.

133

Outside the teepee, a hanging wall of fabric, beads and rope invited visitors to walk in and out of the artwork.

A maze of x-shaped structures, decorated with painted handprints and towels used to wipe paint-covered hands, also identified sponsors.

Championship Graphics

When soccer's World Cup, arguably the world's greatest sports championship, came to the United States in 1994, organizers wanted to give it a world-class graphic identity program. Inspired by the 1984 Olympic Games, they envisioned blockbuster graphics at all nine host cities.

They had to start from scratch, because no World Cup had ever had an identity program. Pentagram New York designed the corporate logo in 1991. Los Angeles-based Runyan Hinsche Associates revised it a year later, adding other elements such as colors, patterns, and stylized soccer players to make a complete identity package. For the final designs, Maury Blitz, vice president of the World Cup Organizing Committee, gathered a team of design consultants to build on Runyan Hinsche's work. Larry Klein Design of Venice, CA, and Environmental Image of San Francisco, headed the design team, while Blitz and three full-time designers implemented the program.

Soccer balls, soccer players, the World Cup name, and a palette of bright colors not associated with any particular country formed the graphic basis of the program. Fabric banners and flags, painted ground surfaces, 16-ft. pylons, and even wacky site furniture created distinctive spaces. Though seemingly generous, the $5 million fabrication budget became fairly tight when stretched to cover nine sites.

Design Team: Larry Klein Design, Venice, CA, and Environmental Image, San Francisco, CA, principal consultants; Avery Wu Signologists, Los Angeles, Selbert Perkins Design, Cambridge, MA, Wayne Hunt Design Associates, Pasadena, CA, Martha Schwartz, Inc., Cambridge, MA, consultants

Fabricators:
Entry gates: Aztec Tent, Torrance, CA; inflatable soccer balls: Bigger than Life, El Cajon, CA; Small screenprinted banners: Blazing Banners, San Diego; Pylons: Eide Industries, Cerritos, CA; Benches, scaffold structures, icons, and letters on poles: George P. Johnson Co., Torrance; Street banners: Gold Graphics, Pacoima, CA; Giant "XV": Jomac Graphic Communications, Alameda, CA; Sponsor acknowledgement kiosks; Metro Sport/Event Signage, Louisville, KY; Rotating pennants: Vince Mackel Inc., Alameda; Painted plywood disks: Freeman Decorating Company, Las Vegas

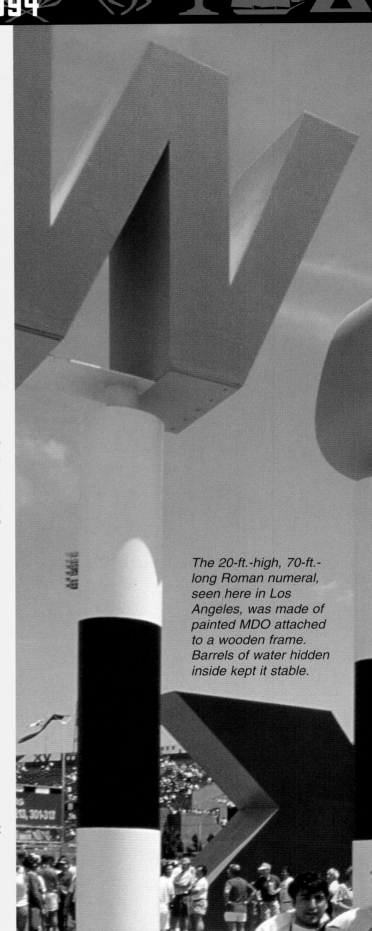

The 20-ft.-high, 70-ft.-long Roman numeral, seen here in Los Angeles, was made of painted MDO attached to a wooden frame. Barrels of water hidden inside kept it stable.

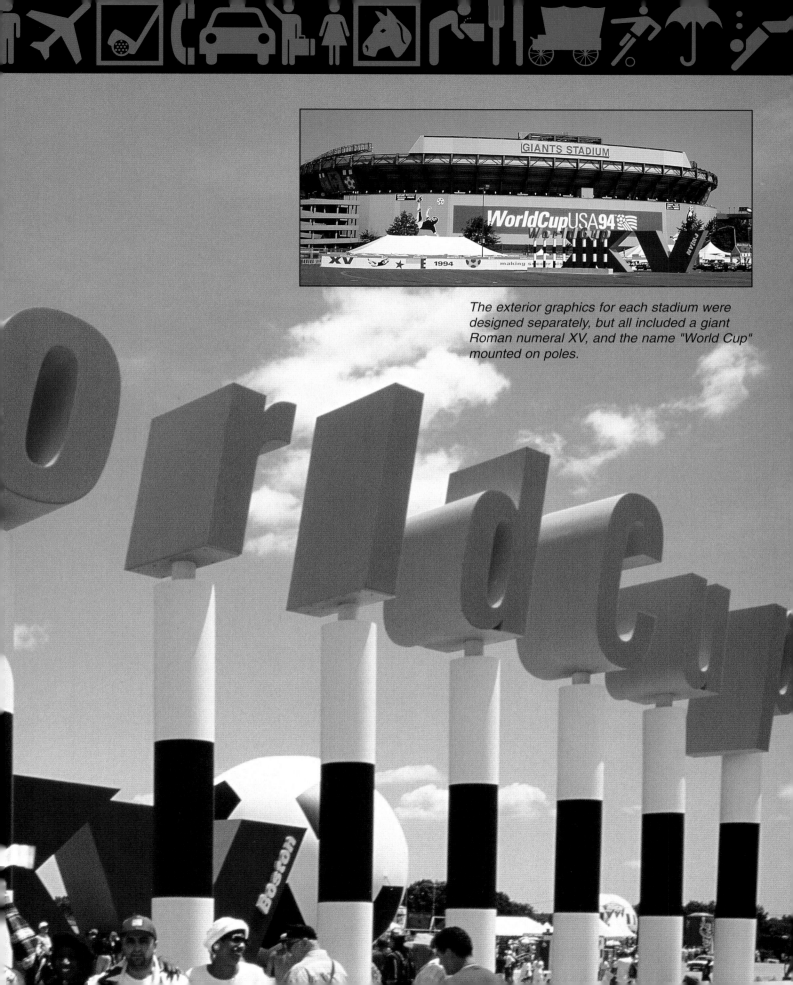

The exterior graphics for each stadium were designed separately, but all included a giant Roman numeral XV, and the name "World Cup" mounted on poles.

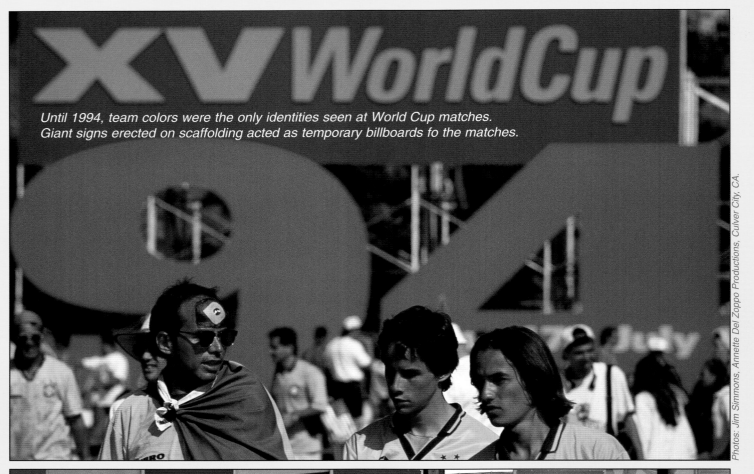

Until 1994, team colors were the only identities seen at World Cup matches. Giant signs erected on scaffolding acted as temporary billboards fo the matches.

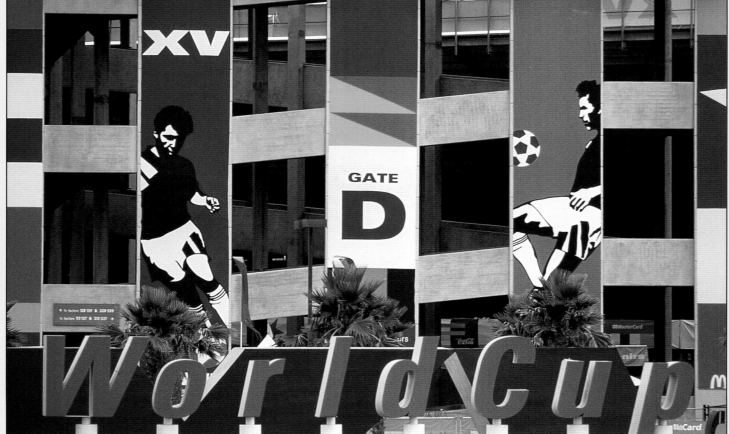

Forty-ft. inflatable soccer balls, like this one in Orlando, FL, also decorated all nine venues. Like the other elements, these were made for each site rather than shared—one reason the $5 million fabrication budget was less generous than it first appeared. To avoid vandalism, the balls were inflated and deflated every game day.

Two different looks in vertical exterior graphics: Orlando and Los Angeles.

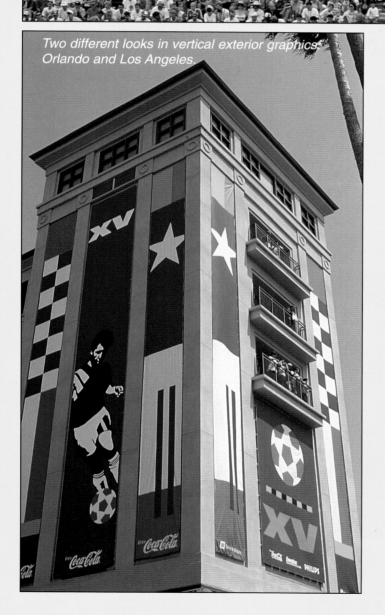

With landscape architect Martha Schwartz on the design staff, even the ground became part of the decor. Here in Detroit, giant squares painted on the pavement add to the festivities, as does the entry portal made of a standard pipe structure tent frame, decorated with spiral corrugated pipes and graphic panels made of vinyl and plywood.

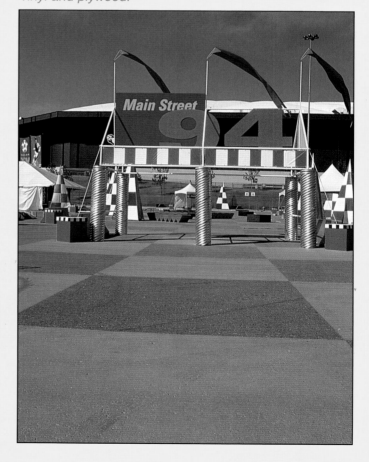

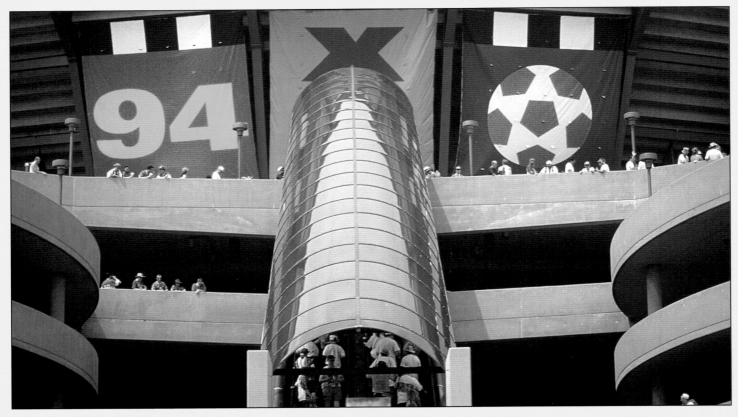

Mounted on 13-ft. PVC pipes, the 5-ft. painted wooden letters (shown here in Boston) made a temporary 35-ft. sign.

One of the design creeds was "Big or nothing." Here in Los Angeles, giant checkered pyramids take the place of trees in the event landscape. Benches made of Astroturf-covered plywood seem ordinary next to fanciful benches made of gel-coated fiberglass with Astroturf inserts.

Massive banners over the escalator of New York's Giants Stadium add drama to the structure. Oversized banners were used in all the stadiums to create a festive look and to cover existing advertising.

Oversized graphics in action in Washington, DC. Unlike at the Olympic Games, sponsor graphics are allowed on the field at World Cup games--but only on the "dasher boards" around the field. All existing stadium advertising had to be covered.

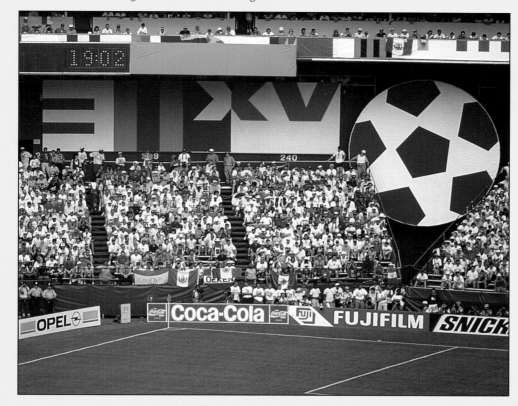

Instead of words, many site signs relied on pictograms to communicate with attendees from around the world. These icons, made of painted foam mounted on 13-ft. PVC poles, featured conical fiberglass bases. Fabricators erected them on site and filled them with concrete, water, or sand for ballast.

Kiosks, like these in New York, recognized corporate sponsors in a way that was both efficient and decorative.

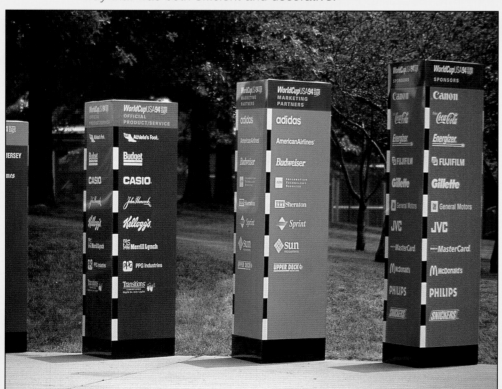

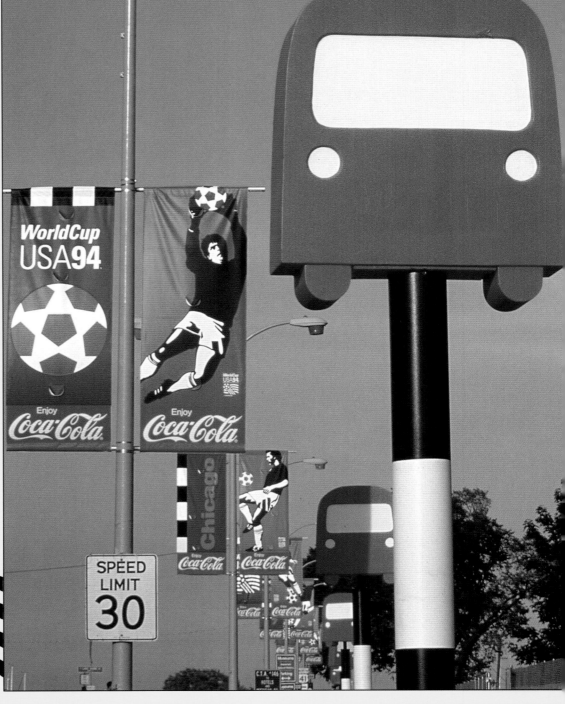

Outside Chicago's Soldier's Field, street banners worked together with temporary signs and with vinyl fence covers decorated with screenprinted and hand-painted graphics.

© 1991 WC '94 TM

Highway and street signs by Wayne Hunt Design, shared the same colors, patterns, typeface, and pictograms. Avery Wu Signologists developed the master "message schedule," or plan for what signs needed to say. All venues used the free-standing directional signs, but some cities did not allow the highway signs.

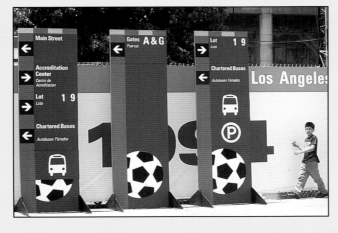

141

Contracts for uniforms and licensed merchandise were awarded before the identity team was formed, so the collateral items did not all match. Uniforms bore only the official logo, but some printed items carried the identity.

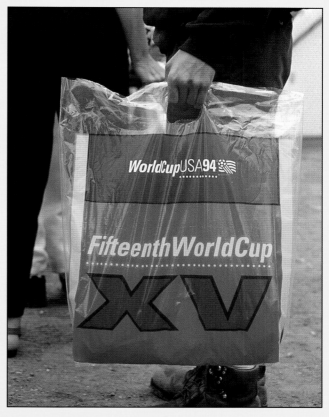

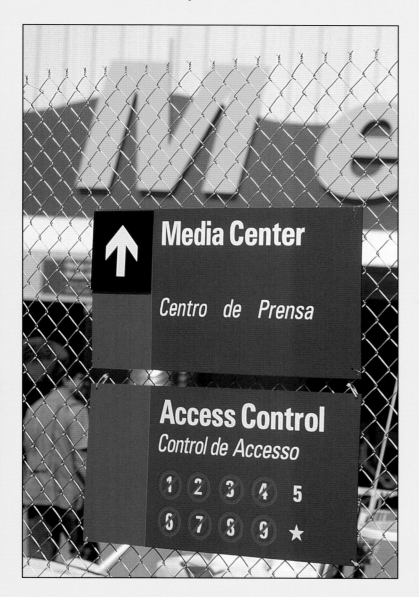

Designers worked to ensure that everything made for the event – even small temporary signs and press box numbers – carried the identity colors, graphics, and typefaces.

FIFA

The design team deliberately kept most signs and graphics to rectangular shapes. "Solving the rectangle" became a design mantra. These 40-ft. structures, made of painted metal with painted plywood graphics, feature soccer players. To avoid dealing with portrait licenses, members of the World Cup Organizing Committee posed for the pictures.

All World Cup graphics were made in simple shapes and materials, so that fabricators could make them quickly and easily. Giant fabric banners in Chicago identify a major sponsor, while checkered skirts decorate plain white tents.

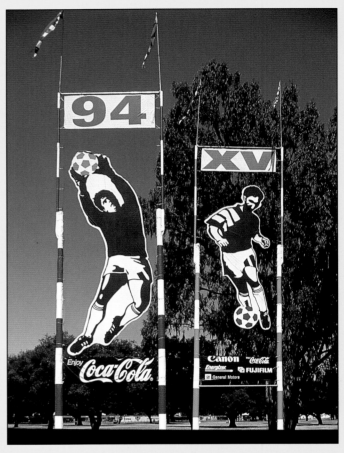

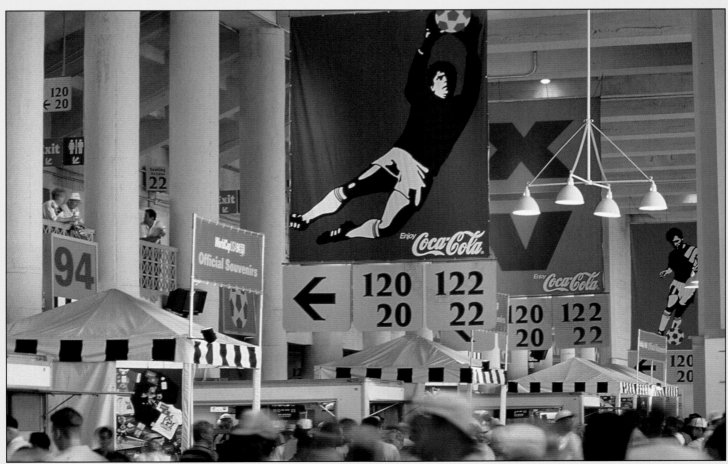

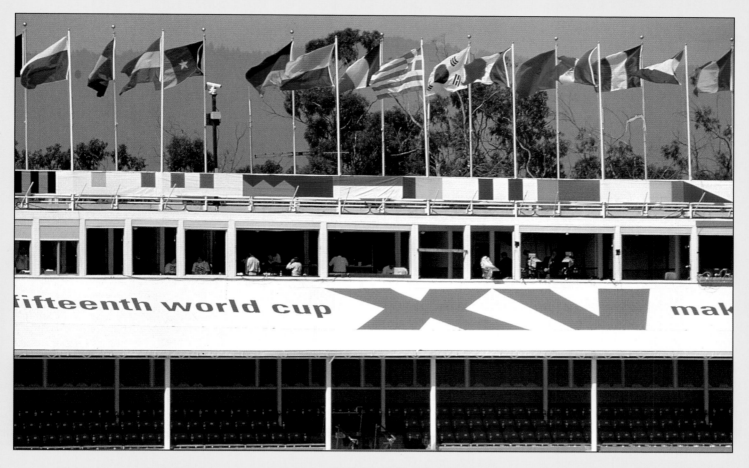

Flags and horizontal bands of patterned fabric decorated the San Francisco Venue.

Flags, soccer ball balloons, and fabric bands covering the fronts of the stadium tiers transformed Los Angeles's Rose Bowl, site of the World Cup's final games.

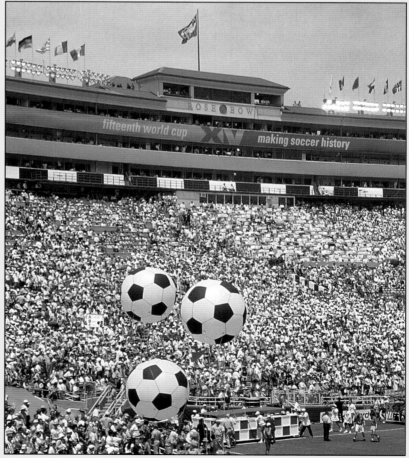

People become graphics

Nine artists from around the world created works for "OPEN HOUSE, Art & Life (an Inter-Media Event)," a celebration of Tokyo's Truss-Wall-House. The experimental, poured-concrete structure designed by architects Ushida/Findlay Partnership caused an architectural sensation.

For her contribution, designer Leni Schwendinger created a collaborative show combining projected graphics and moving human shadows. She projected a series of 20 hand-painted slides onto the house's curved walls while students from Shibaura Institute, wearing specially designed costumes and carrying plastic Mobius strips and clear plastic pillows filled with feathers, cast their shadows. Audience members also stepped up to cast shadows during the show, which lasted several hours.

The artwork explored ideas about homes and hearts, and about the city as the heart of contemporary life. The shadows hid and revealed images as they moved. While not traditional signs or graphics, they added an interactive, festival element to an event based on architecture and artworks.

Light Projects Ltd.
448 West 37th St., 8G
New York, NY 10018

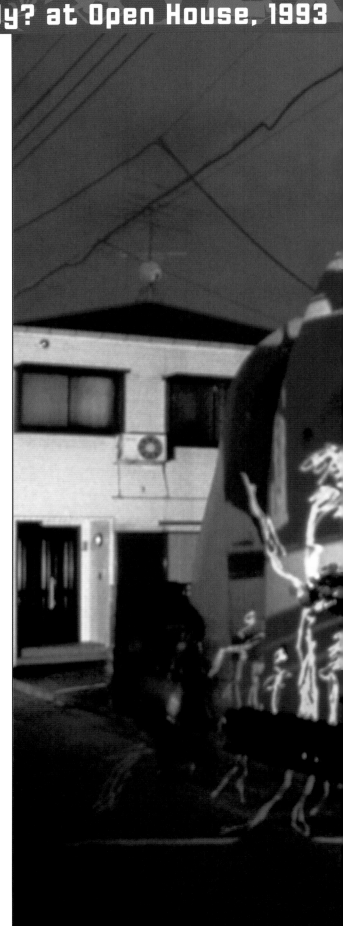

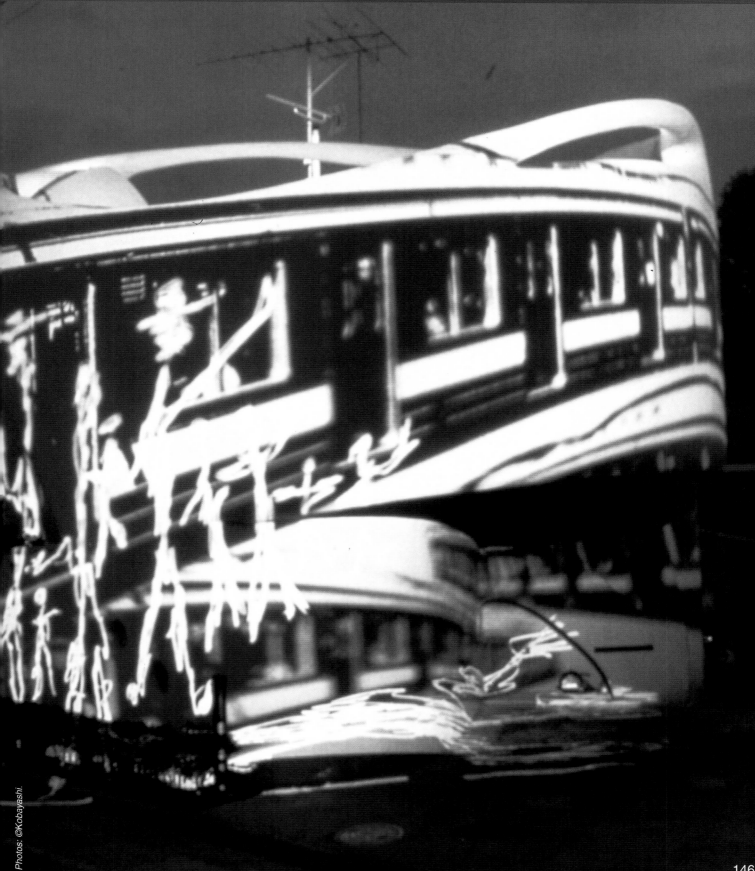

146

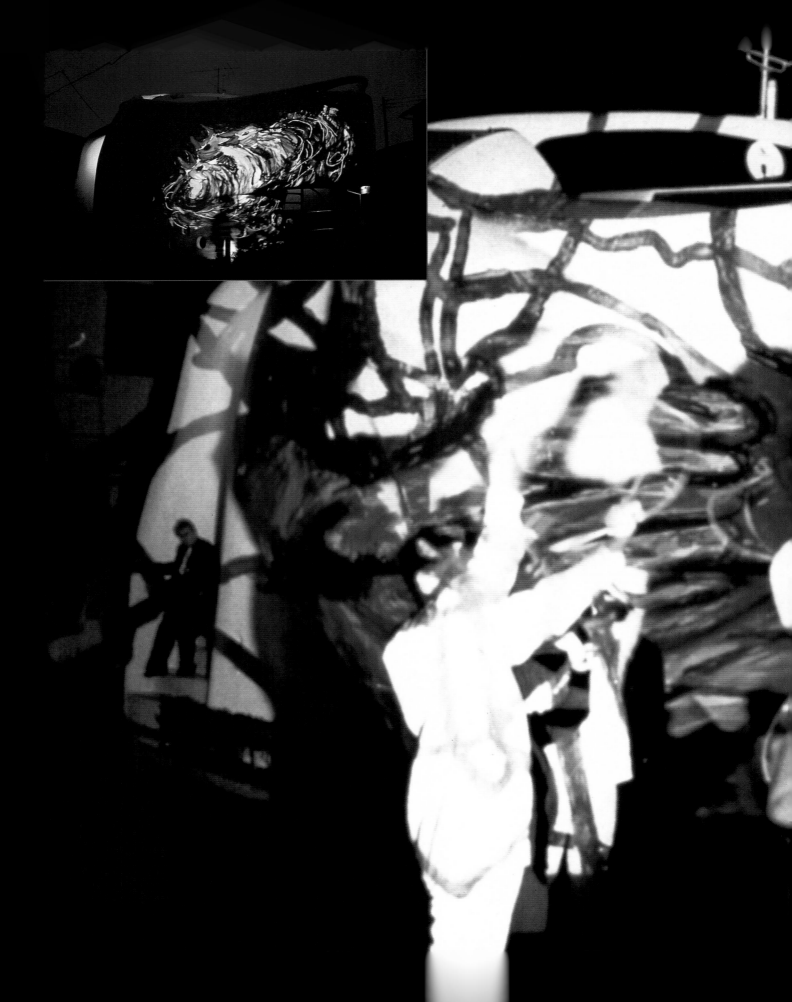

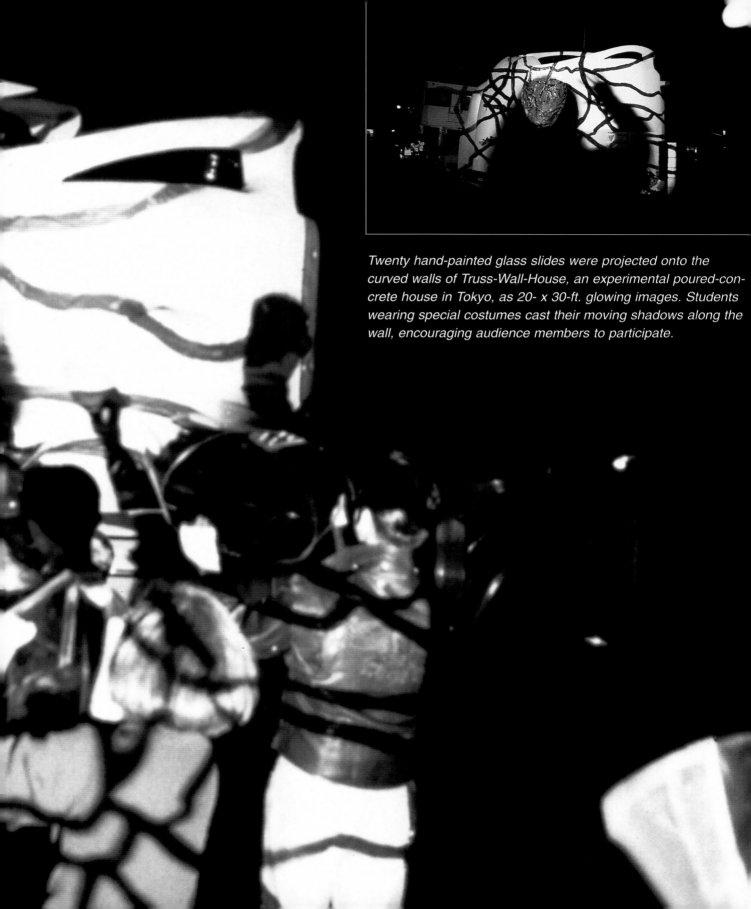

Twenty hand-painted glass slides were projected onto the curved walls of Truss-Wall-House, an experimental poured-concrete house in Tokyo, as 20- x 30-ft. glowing images. Students wearing special costumes cast their moving shadows along the wall, encouraging audience members to participate.

Consistent Graphics
Behind One of the Nation's Finest

Since 1988, the Kentucky Derby Festival has had a consistent festival identity to unify its 72 events, which includes the largest fireworks show in the United States. Considered by many to be the country's premier festival, the 40-year-old event lasts 10 days and attracts more than 1 million visitors. It takes 4000 volunteers and a staff of 20 to run the $4.3 million festival, which in 1996 contributed more than $53 million to the local economy (less than 1% of festival revenues are spent out of town).

According to Bill Campbell, director and past president, the identity designed by The DeLor Group of Louisville, KY, is used wherever possible. Studies show that the Pegasus logo has a 92% recognition factor, about as high as possible. Consistent use of the official magenta, teal, and yellow color scheme also helps visitors identify festival events, which are public, and differentiate them from events run by the Churchill Downs racetrack.

Print graphics are redesigned every three years, but always based on the festival identity. Because of the festival's brief two-month "shelf life," planners feel comfortable using each design several times before it becomes outdated.

The festival has also profited from the identity, which is used on collectible pins. An official pin program raises more than $500,000 every year, in addition to sales from official merchandise such as t-shirts, posters, and hats.

The DeLor Group Inc.
732 West Main St., Louisville, KY 40202

KENTUCKY DERBY
FESTIVAL

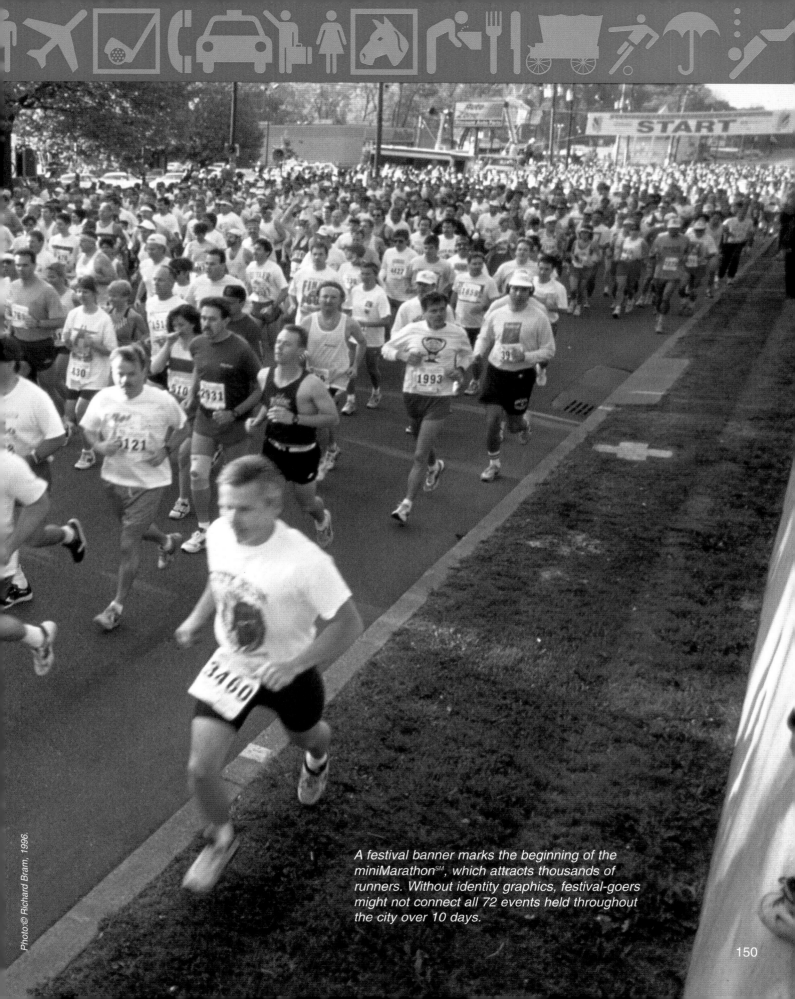

A festival banner marks the beginning of the miniMarathon℠, which attracts thousands of runners. Without identity graphics, festival-goers might not connect all 72 events held throughout the city over 10 days.

Larry King accepts a thank-you for being keynote speaker at the annual kick-off luncheon. The presenter, former festival Chairman Don McClinton, wears the instantly recognizable official blazer reserved for festival chairmen and past chairmen.

Waiters and waitresses don official tunics for the Run for the Rosé® race, held at lunch hour on a business day. Local restaurants with beer or liquor licenses may enter two runners, who must uncork and pour six glasses of wine, then carry them around an obstacle course. Tunics, which bear the logos of the official sponsor and contributing sponsors, also have space for each restaurant's name.

51

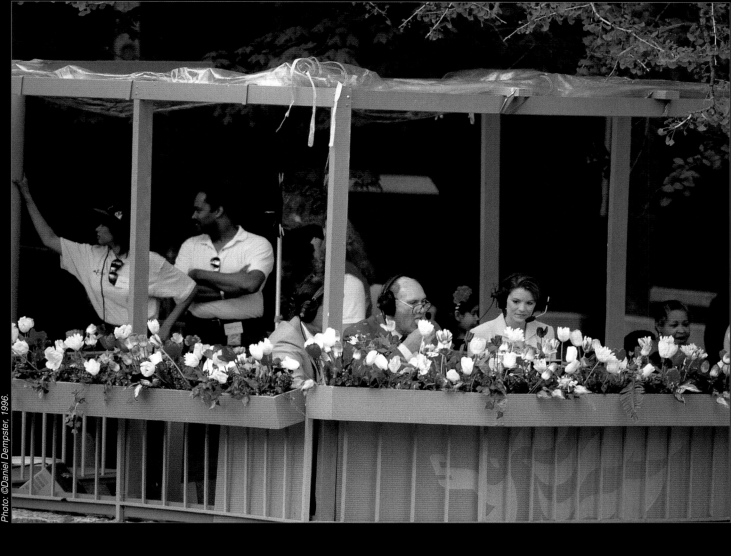

Bright identity graphics mark the broadcast booth for the annual Pegasus Parade, which is shown locally and nationally.

Cadillac, an official sponsor, provides 75 cars to board members for the festival month. The only other event the car maker supports this way is the Master's Tournament. The board member is wearing a teal staff jacket, and the car is decorated with a festival decal.

TEMPORARY ARCHITECTURE

Many festivals feature temporary architecture, generally rented tents or simple, disposable gateways. For several years in the early '90s, designer/architect Jan Lorenc took the idea of temporary architecture in a new direction in his work for Habitat for Humanity.

Every year at a local mall, the Atlanta chapter of Habitat auctioned bird houses designed by artists. Instead of rented tables and skirting, Lorenc designed an exhibit and display made of walls - complete with doors and windows - made for Habitat houses. These were then removed and used for housing. Each year the display got bigger and more elaborate, and raised more money. In 1995, the fundraising committee changed to another location and another design.

Lorenc capped his work for Habitat in 1995, with a pavilion at the Arts Festival of Atlanta. Designed for his Master's thesis, Lorenc's pavilion again used materials that were later used in Habitat houses. Lorenc, his design firm staff, and volunteers built the structure, just as Habitat houses are built by volunteers. The pavilion raised $20,000.

Lorenc + Yoo Design

109 Vickery Street

Roswell, GA 30075

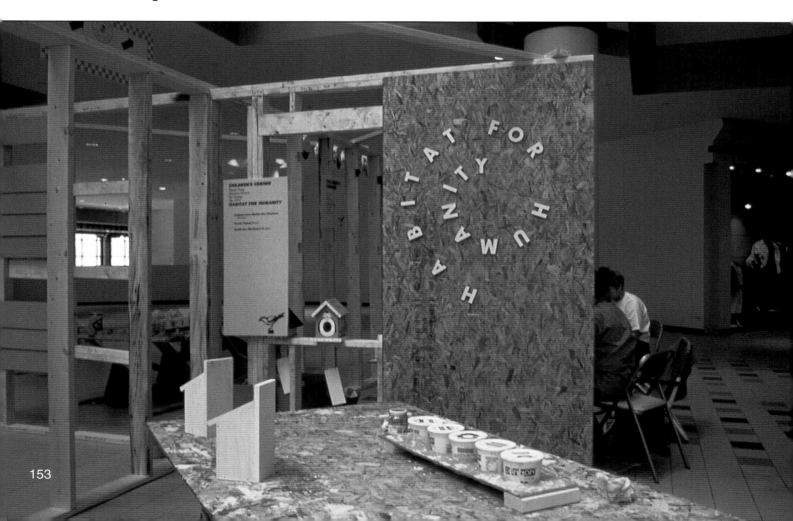

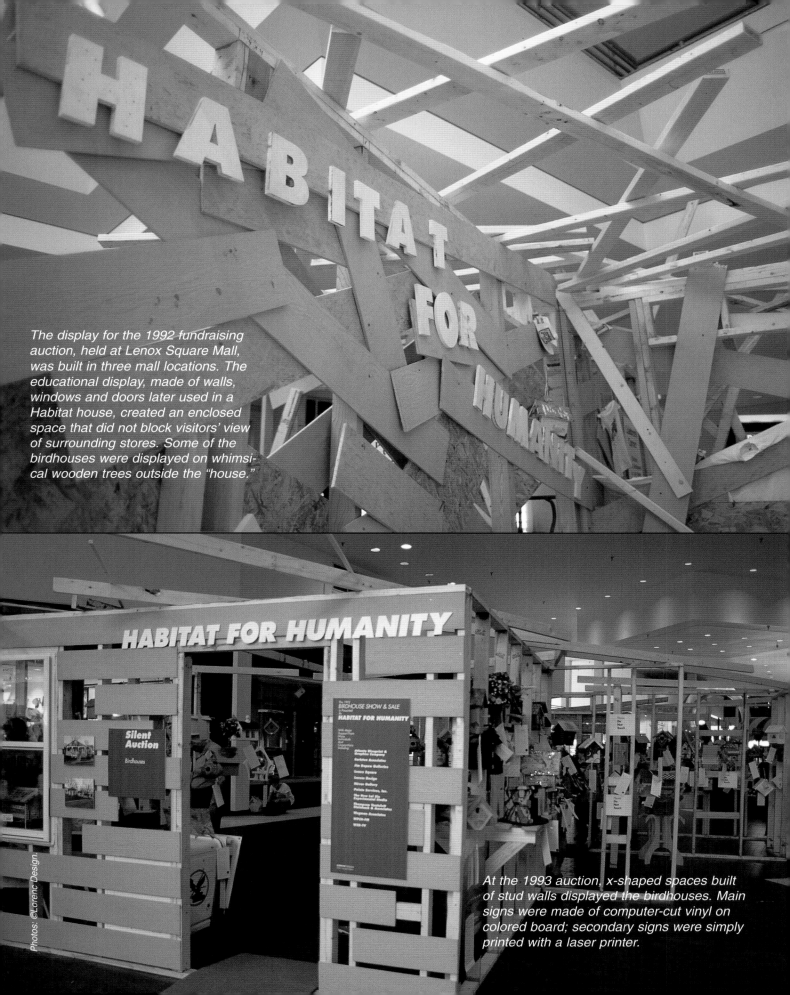

The display for the 1992 fundraising auction, held at Lenox Square Mall, was built in three mall locations. The educational display, made of walls, windows and doors later used in a Habitat house, created an enclosed space that did not block visitors' view of surrounding stores. Some of the birdhouses were displayed on whimsical wooden trees outside the "house."

Photos: ©Lorenc Design.

At the 1993 auction, x-shaped spaces built of stud walls displayed the birdhouses. Main signs were made of computer-cut vinyl on colored board; secondary signs were simply printed with a laser printer.

HABITAT FOR HUMANITY

Silent Auction

Birdhouses

The 1993
BIRDHOUSE SHOW & SALE
to benefit
HABITAT FOR HUMANITY

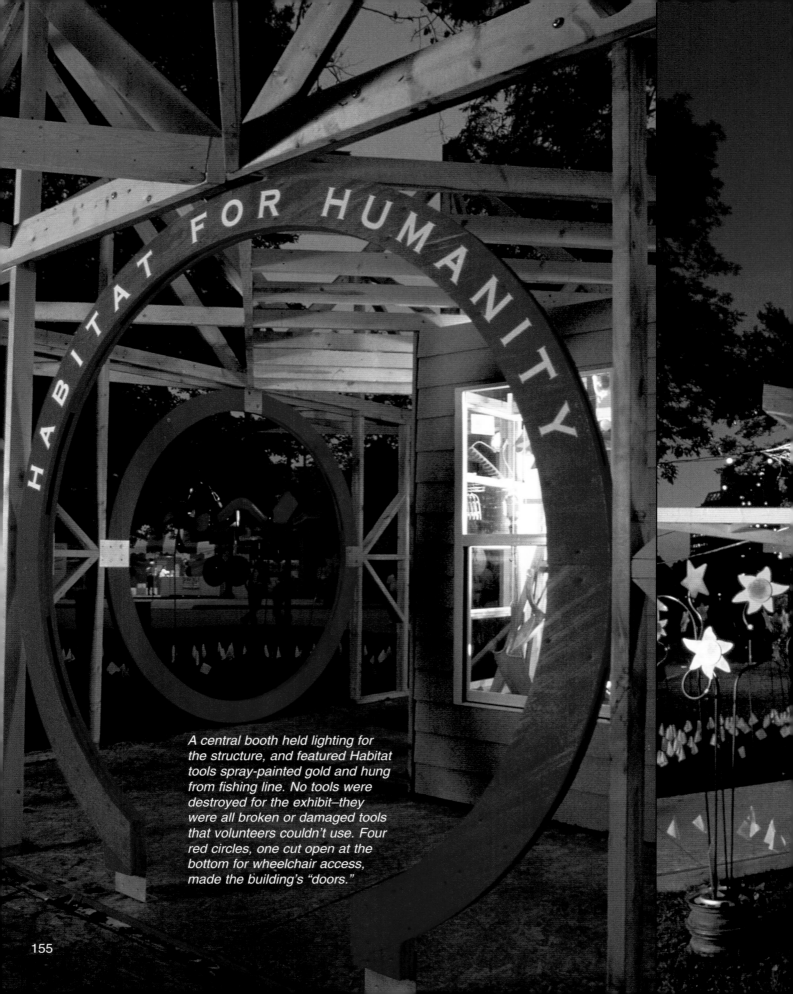

A central booth held lighting for the structure, and featured Habitat tools spray-painted gold and hung from fishing line. No tools were destroyed for the exhibit—they were all broken or damaged tools that volunteers couldn't use. Four red circles, one cut open at the bottom for wheelchair access, made the building's "doors."

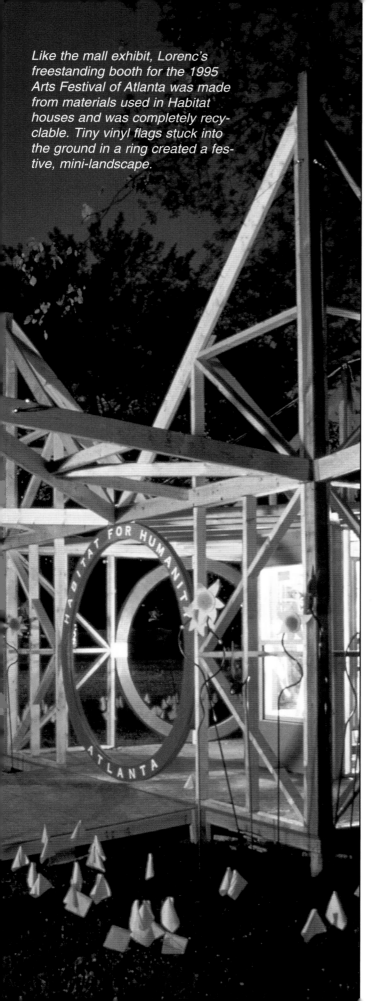

Like the mall exhibit, Lorenc's freestanding booth for the 1995 Arts Festival of Atlanta was made from materials used in Habitat houses and was completely recyclable. Tiny vinyl flags stuck into the ground in a ring created a festive, mini-landscape.

In 1993, a simple area was set aside for children to paint their own birdhouses. The unusual sign is simply lettering applied to the particleboard wall.

By 1994, the display had become an elaborate construction. The x-shaped children's area had a free-form wooden "roof," visible from the mall's second floor. Inside, a wall made of random boards was also decorated with foamboard letters and, later, Habitat t-shirts.

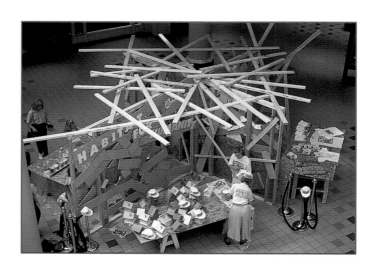

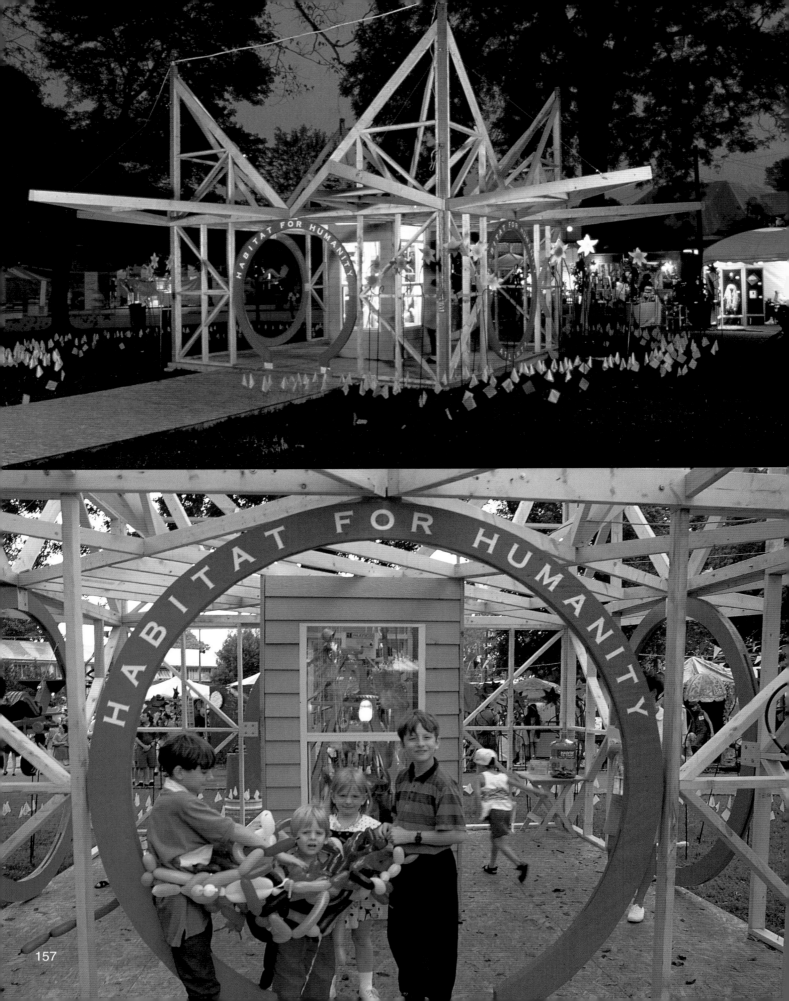

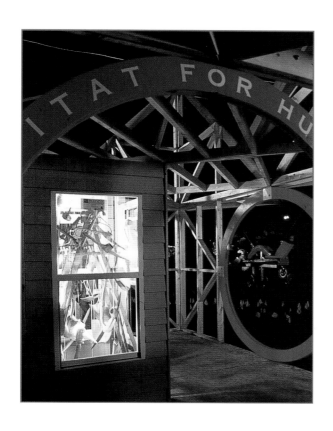

DOWNSIZING and UPSCALING

Major League Soccer's problem could only be solved with graphics. For its first professional season, the league knew that its teams would not draw enough fans to fill the nine stadiums it would use. Planners expected between 20,000 to 30,000 fans in stadiums built for 60,000 to 100,000. MLS needed a way to make those stadiums look full and exciting, both from within the stands and on television. Project manager Maury Blitz, who had managed the 1994 World Cup, knew what graphics could do.

Treehouse Design Partnership created a package of flexible, reusable graphics that would add color and festivity to the empty seats, and that could be installed and removed within 24 hours. The $1.6 million package included tie-on mesh fabric seat covers, freestanding entry portals, fabric surrounds that could be suspended or hung on temporary frames, and hanging banners. These graphics adapted equally well to enclosed and bowl stadiums, and to historically significant stadiums requiring "minimal impact" graphics. Computer-generated designs were created for large-format graphics printing equipment, the technology that made this project possible.

Bold colors and graphics kept the feel festive, and the distinctive look accomplished another important goal: making visiting the stadium for soccer games different and exciting.

Treehouse Design Partnership
1731 Ocean Park Blvd.
Santa Monica, CA 90405

Fabrication: Metromedia Technologies, Los Angeles; Peter Carlson Enterprises, Sun Valley, CA; AAA Flag & Banner, Los Angeles

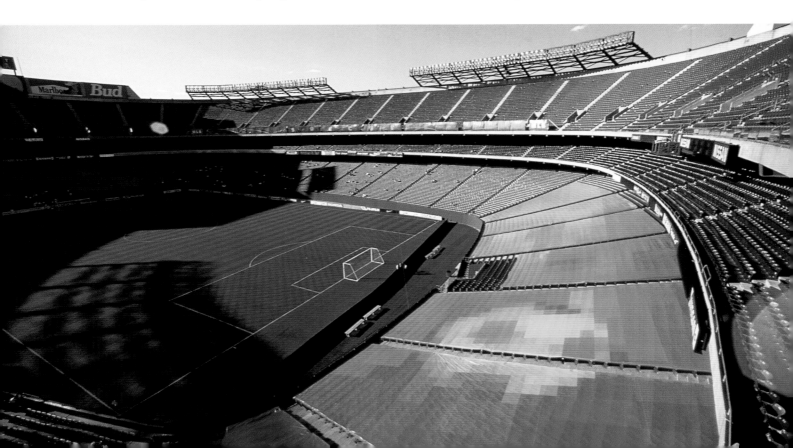

BiC Marine Midland Bank ◇ HACKENSACK UNIV
 MEDICAL CEN

Tie-on seat covers made the empty seats an attraction rather than a liability. The graphics were printed on 4-ft. strips of mesh vinyl and sewn together into sections as large as 60- x 100-ft. Shown here at Giants Stadium, the giant graphics were produced using large-format printing equipment.

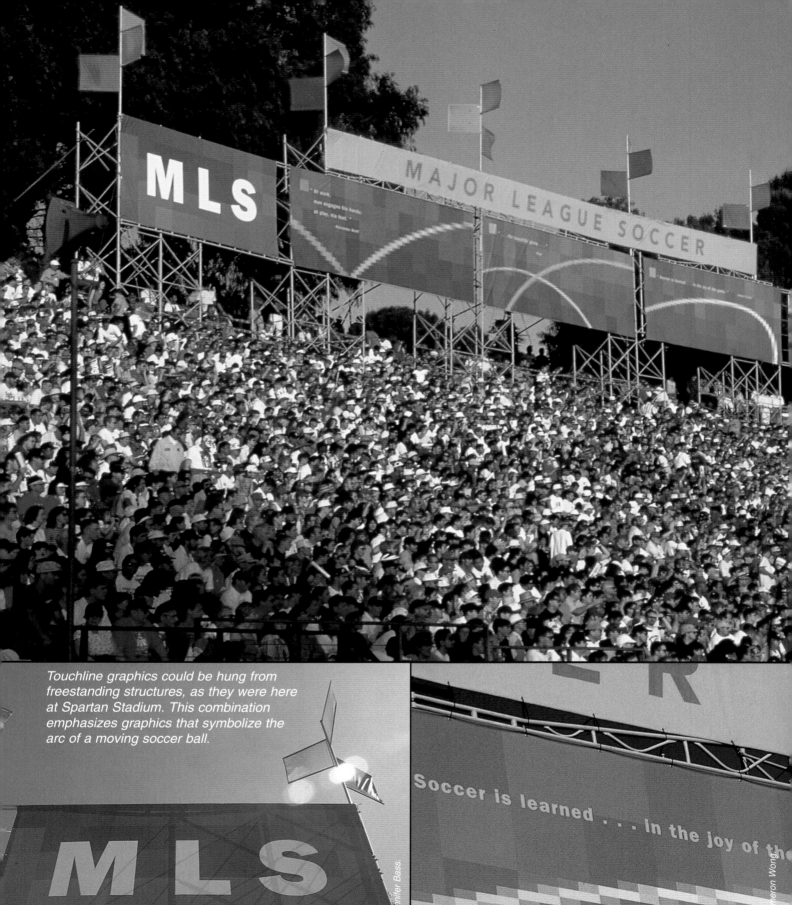

Touchline graphics could be hung from freestanding structures, as they were here at Spartan Stadium. This combination emphasizes graphics that symbolize the arc of a moving soccer ball.

Photo: ©Jennifer Bass.

Photo: ©Cameron Wong.

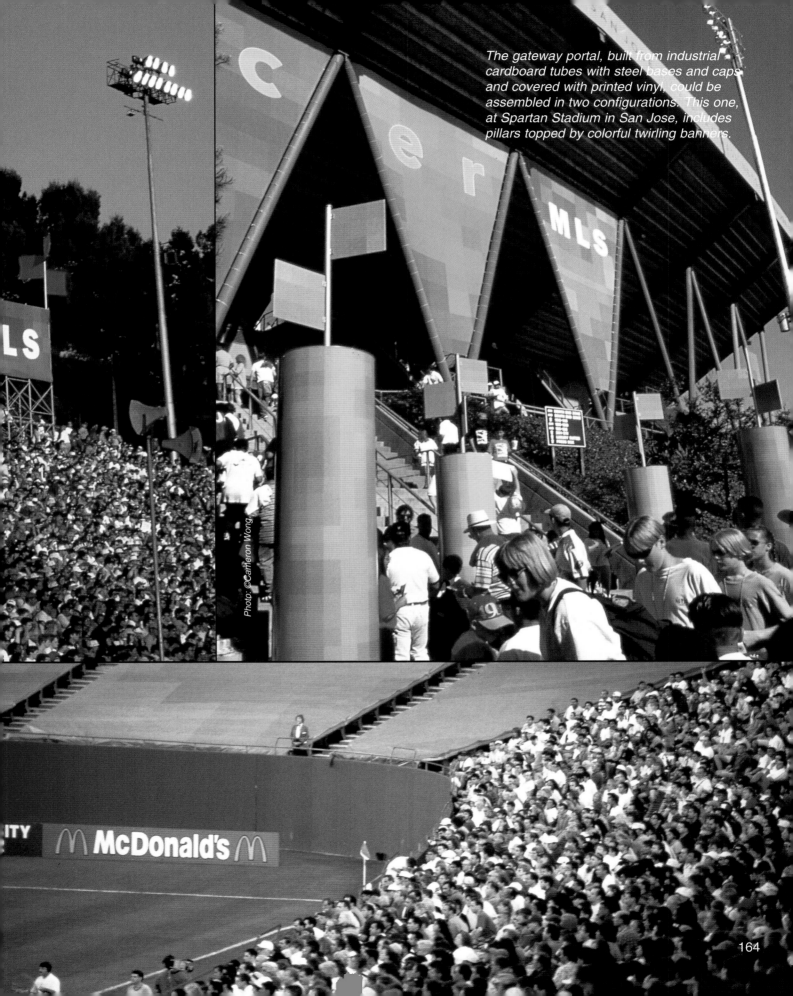

The gateway portal, built from industrial cardboard tubes with steel bases and caps and covered with printed vinyl, could be assembled in two configurations. This one, at Spartan Stadium in San Jose, includes pillars topped by colorful twirling banners.

Photo: ©Cameron Wong

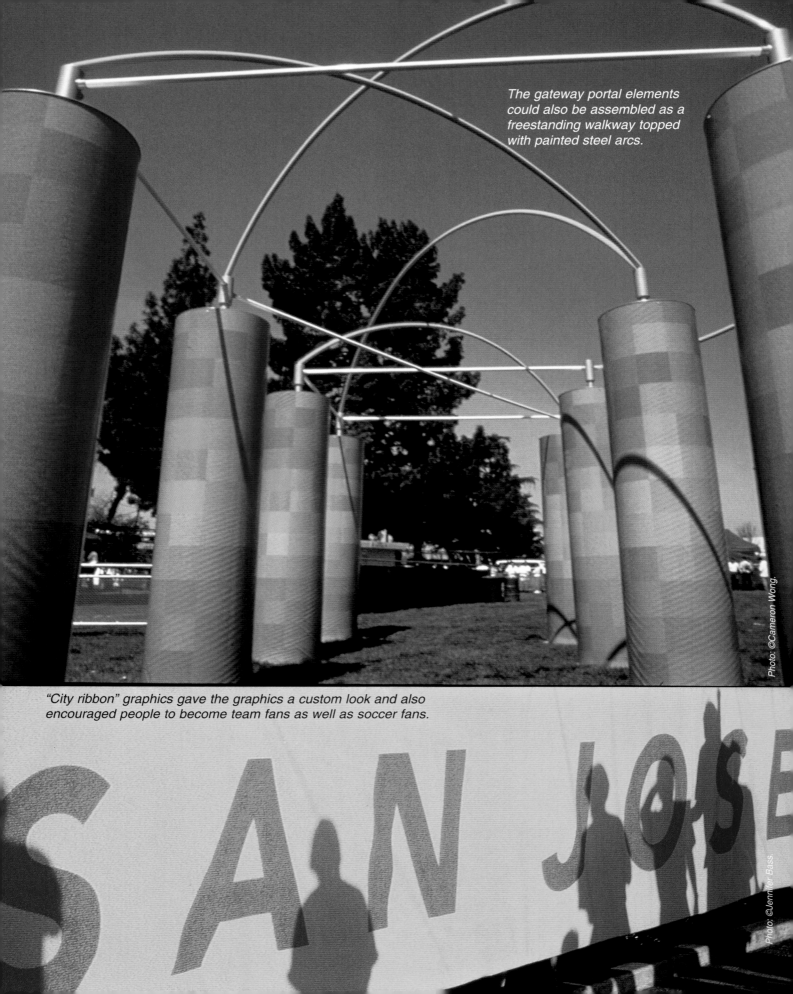

The gateway portal elements could also be assembled as a freestanding walkway topped with painted steel arcs.

Photo: ©Cameron Wong.

"City ribbon" graphics gave the graphics a custom look and also encouraged people to become team fans as well as soccer fans.

SAN JOSE

Photo: ©Jennifer Bass.

Not just a convenience for printing, "pixillated" graphics and graduated changes from one identity color to another were a major part of the graphic look. Two palettes, warm reds and yellows symbolizing "passion and guts" and cool blues and greens symbolizing "precision and grace," interpreted the sport visually. Rotating signs gave the system a permanent look.

166

Index of design firms

Primo Angeli, Inc.
590 Folsom St.
San Francisco, CA 94105
phone: 415-974-6100
fax: 415-974-5476

Centennial Olympic Games, p. 95

Avery Wu Signologists
1918 North Main Street, Suite 204
Los Angeles, CA 90031
phone: 213-223-1862
fax: 213-223-0484

World Cup 1994, p. 135
Designers: Eileen Avery
and Ted Wu, AIA, principals.

Cloud and Gehshan Associates, Inc.
919 South Street
Philadelphia, PA 19147
phone: 215-829-9414
fax: 215-829-9066

RiverRink, p. 41
Designers: Virginia Gehshan,
project manager; Jerome Cloud,
design director; Jerome Cloud and
Cheryl Hanba, designers; Virginia Gehshan
and Dorothy Funderwhite, trolley design;
Jerome Cloud and Ann McDonald,
Penn's Landing banner design

Copeland Hirthler design+communications
40 Inwood Circle
Atlanta, GA 30309
phone: 404-892-3472
fax: 404-876-9355

1996 Centennial Olympic Games, p. 95
Designers: Brad Copeland and George
Hirthler, creative directors; Michelle Stirna,
David Crawford, Sarah Huie, Raquel C.
Miqueli, Erik Bronw, Jeff Haack, David Park,
Mike Wiekert, Melanie Bass, designers

1996 Paralympic Games, p. 111
Designers: Brad Copeland and George
Hirthler, creative directors; Todd Brooks,
Raquel Miqueli, Michelle Stirna, Suzy Miller,
David Crawford, David Warner, Erik Brown,
Jeff Haack, David Park, Mike Weikert,
designers

The DeLor Group Inc.
732 West Main St.
Louisville, KY 40202
phone: 502-584-5500
fax: 502-584-5543

Kentucky Derby Festival, p. 149

Degnen Associates
181 Thurman Ave.
Columbus, Ohio 43206
phone: 614-444-3334
fax: 614-444-3066

AmeriFlora, p. 47
Designers: Stephen Degnen, Mark Denzer,
Cara Cox, Julia Dougherty, Laura Hensel,
Jim Lytle, Neil Motts, Rod Arter, Mark Bartlett

Environmental Image
111 Crescent Rd.
San Anselmo, CA 94060
phone: 415-455-5600

World Cup 1994, p. 135
Designers: David Meckel,
Michael Manwaring, Tim Perks

Favermann Design
18 Aberdeen St.
Boston, MA 02215
phone: 817-247-1440
fax: 617-247-1945

Big XII Swimming & Diving Championship, p. 119
Design: Mark Favermann, creative director and
designer; Paul Cunningham, designer

1996 Centennial Olympic Games, p. 95
Designers: Paul Cunningham, Mark Favermann,
and Deniece Acosta (from the Atlanta
Committee for the Olympic Games)

kyle c. fisk design consultancy
8209 Rhine Way
Centerville, Ohio 45458
phone/fax: 937-435-5154

Century of Flight, p. 23
Designer: Kyle C. Fisk

Malcolm Grear Designers Inc.,
391-393 Eddy Street
Providence, RI 02903
phone: 401-331-2891
fax: 401-331-0230

Centennial Olympic Games, p. 95

Greene & Company
Lehigh Valley Corporate Center
1655 Valley Center Parkway, Suite 100
Bethlehem, PA 18017
phone: 610-868-4100

Bethlehem Festivals, p. 85
Christkindlmarkt, p. 85
Christmas City Fair, p. 87

Hunt Design Associates
25 N. Mentor Ave.
Pasadena, CA 91106
phone: 626-793-7847
fax: 626-793-2549

World Cup,1994, p. 135

Jones Worley Graphic Design Consultants
723 Piedmont Avenue NE
Atlanta, GA 30365
phone: 404-876-9272
fax: 404-876-9224

Centennial Olympic Games, p. 95
Designers: Cynthia Jones, Barry Worley,
Tony Pickett, Ron White, Dennis Hoover,
Katy Berry, Lynne Bernhardt, Riley Lawhorn,
Sue Youngblood, Carr McCuiston

Larry Klein Design (see Point Zero)

World Cup, 1994, p. 135
Designers: Larry Klein, Krister Olmon,
Trisha Ferry, Inge Krei

Kolar Design
308 E. 8th Street
Cincinnati, Ohio 45202
phone: 513-241-4884
fax: 513-241-2249

Tall Stacks, p. 65
Designers: Kelly Kolar, design director,
Joell Angel Chumley, associate design
director, Janice Radlove, Deborah Vatter,
Keith Kitz, Wendy Zendt, Jenny Burtchin,
Jeff Grimes, Art Spon, Doug Klocke,
designers; volunteers Sylvia Edwards,
Bud Fugate, Lois Davis, Janice Campion,
Laura Long, Betty Daniels, props and
decorations; Zender & Associates,
Cincinnati, Sternwheeler Age in America
exhibit; KZF Architects, Cincinnati, and
Bruce Robinson Associates, Cincinnati,
1880s Public Landing facade; FRCH Design
Worldwide, Cincinnati, Historic Covington
and Packet Boat exhibit; City of Newport
Historic Preservation Office and PDT
Architects/Planners, Newport Barracks;
University of Cincinnati Senior Graphic
Design Class of 1992, Tom Sawyerville;
Human Nature Landscape Architects

Art on the Square, p. 129
Designers: Kelly Kolar, Deborah Vatter,
Joell Angel Chumley, Scott Frendhoff,
Janice Radlove; University of Cincinnati
architecture and interior design students,
designers, and Terry Brown, professor.

Landor Associates
Klamath House
1001 Front Street
San Francisco, CA 94111-1424
phone: 415-955-1361
fax: 415-956-5436

1996 Winter Olympic Games,
Nagano, Japan, p. 79
Designer: Fumi Sasada,
Tokyo creative director

Centennial Olympic Games logo, P. 95

John Lees & Associates, Inc.
8 Myrtle Street
Boston, MA 02114
phone: 617-248-9633
fax: 617-720-5584

CIGA Weekend á Longchamp, p. 123
Designers: John Lees, Karen Stockert,
John Bach, Peter Latimer

Light Projects Ltd.
448 West 37th St., 8G
New York, NY 10018
phone: 212-947-6282
fax: 212-947-6289

Off-the-Wall at 651's World Series, p. 93
Designers: Leni Schwendinger, Dmitry Krasny
Public Dramas/Passionate Correspondents, at

Brooklyn Academy of Music Gala, p. 63
Designers: Leni Schwendinger, art;
David Lander, project manager

The Urban Heart, A Homebody?
at Open House, p. 145
Designers: Leni Schwendinger and
Kathryn Findlay, concept; Leni Schwendinger
and students at Shibaura Institute, art;
David Lander, project manager

Lorenc + Yoo Design
109 Vickery Street
Roswell, GA 30075
phone: 770-645-2828
fax: 770-998-2452
www.lorencdesign.com

Habitat for Humanity displays, p. 153
Design: Jan Lorenc

Bazaar Bizzoso, p. 57
Design: Jan Lorenc, Gaelle Husson

Miami University
Planning and Construction,
Physical Facilities Department
103 Edwards House
Oxford, Ohio 45056
phone: 513-529-5413
fax: 513-529-4101

Performing arts series banners, p. 20
Designer: Lynne M. Wagner

Miller Graphic Design
500 Bishop Street, Suite F-8,
Atlanta, GA 30318
phone: 404-355-0155
fax: 404-355-0776

Centennial Olympic Games, p. 95
Designers: Tim Miller, Marty Thompson,
Riley Lawhorn, Joe Whisnant, Paul Bailey

Minale Tattersfield Bryce and Partners
212 Boundary St. Spring Hill, Brisbane,
Queensland, Australia 4067
phone 61-7-3831-4149
fax 61-7-832-1653

2000 Olympic Games, Sydney, Australia p.95
Designers: Michael Bryce, Ron Hurley

Montgomery and Associates
344 South Garden St.
Bellingham, Washington 98225
phone: 360-676-9587

Ski to Sea Festival, p.25
Design: Scott Montgomery

Murrell Design Group
1280 West Peachtree St., Suite 120
Atlanta, GA 30309
phone: 404-892-5494
fax: 404-874-6894

Centennial Olympic Games
and Torch Run, p. 95
Designers: James Murrell,
art director; Ines Eidenschink,
Lotte Winkel, Rita Bazinet,
Cathy Schmelig, Stan Zienka, designers

Musselman Advertising
601 Hamilton Mall
Allentown, PA 18101
phone: 610-435-5102

Musikfest, p. 85

Pentagram Design
204 Fifth Avenue
New York, NY 10010
phone: 212-683-7000
fax: 212-532-0181

Shakespeare in the Park, p. 115
Designers: Paula Scher, partner;
Ron Louie, Lisa Mazur, designers

7th on Sixth, p.33
Designers: Michael Beirut, partner;
Esther Bridavsky, Lisa Anderson, designers

Next Wave Festival, p. 20
Designers: Michael Bierut, partner;
Emily Hayes, designer

World Cup, 1994 logo, p. 135

Point Zero (formerly Larry Klein Design and
Runyan Hinsche Associates)
42223 Glencoe Avenue, Suite A223
Marina del Rey, CA 90292
phone: 310-823-0975 fax: 310-823-0975

World Cup, 1994, p. 135

Selbert Perkins Design
(formerly Cliff Selbert Design)
2067 Massachusetts Avenue
Cambridge, MA 02140
phone: 617-497-6605

World Amateur Golf Team Championships, p. 37
Designers: Cliff Selbert, Maury Blitz, Amy Lukas,
Heather Watson

World Cup, 1994, p. 135

Runyan Hinsche Associates (now Point Zero)

World Cup, 1994 logo, p. 135

Treehouse Design Partnership
1731 Ocean Park Blvd.
Santa Monica, CA 90405
phone: 310-399-3840
fax: 310-399-5891

Major League Soccer Launch, p. 159
Designers: Jennifer Bass, Lance Glover,
creative directors; Mary Ellen Buttner,
Caroline Caldwell, Francis Cusak,
Kristen Dietrich, Lynn Easley, Rob Niles,
Billy Rosbottom, designers

University of Cincinnati
School of Design College of Design,
Architecture, Art and Planning
PO Box 210016, Cincinnati, Ohio 45221-0016
phone: 513-556-6282 • fax: 513-556-3288

Oktoberfest Zinzinnati traveling exhibit, p. 18
Designers: Senior Graphic Design Class of 1996;
Katie McCormick and Casey Reas, project leaders;
Steve Arengo, Ann Beiersdorfer, Matt Berninger,
Katrina A. Berta, Jenny Bolin, Miechael Brewer,
Jen Burtchin, Matt Burton , Jeff Cancelosi,
Brinda Chatterjee, Scott Devendorf, Beth Fritzsche,
Andrea Gaskey, Jean Ha, Peggy Henz,
Cindy Kieffer, Keith Kneuven, Ami Lambright,
Jason Langdon, Mikki Maguire, Kevin Morrison,
Catherine O'Brien, Jennifer Oen, Emily Raively,
Steve Ruff, Kelly Salchow, Amy Schroeder,
R. Barrett Schubert, Chris Seager, Andrew Short,
Daniel Skurow, Amanda Steel, Vernon Turner,
Jeff Tyson and Wendy Zent, designers;
Nick Chaparos and Robert Probst, professors

Tom Sawyerville, p. 75
Designers: Kolar Design, Cincinnati, design direc-
tors; Senior Graphic Design Class of 1992:
Stephanie Wade and Nancy Smith,
project managers; Nicki Adrian, Chris Barcelona,
Esther Bridovsky, Bonni Brodsky, Kelly Clark,
John Deoss, Joan Bittner, Greg Fehrenbach,
Julie Ferguson, Elizabeth Hecker, Joana Huey,
Alicia Hubbell, Liz Jarrard, Mike Kraine,
Laura Kuhlman, Bill Lambrinides, Sandra Liu,
Leslie Loftus, Todd Lott, Laurie Martin, Wendy Paffe,
Shawn Powers, Victor Russo, Jill Ryland,
Lynn Sampson, Ben Sauer, Kellie Schroeder, Julie
Schweickart, Jon Shapiro, Ty Webb, designers;
Nick Chaparos and Robert Probst, professors

Art on the Square exhibit, p. 129
Designers: 1994 Architecture and Interior Design
third- and fourth-year students;
Terry Brown, professor.

Witherspoon Advertising/Public Relations
1000 West Weatherford
Fort Worth, TX 76102
phone: 817-335-1373
fax: 817-332-6044

Racefest, p. 22

World Cup 1994 Internal Design Team
c/o Maury J. Blitz, LLC
27601 North Danton Court
Valencia, CA 91354
phone: 805-296-7699
fax: 805-296-7599

World Cup 1994, p. 135
Designers: Maury J. Blitz, associate vice
president/project director; Suzanne DeMers,
project manager; Kenneth C. Gilbert and
Kristen Dietrich, design and production

Index of Events

Resources

The Society for Environmental Graphic Design
401 F Street NW, Suite 333, Washington, DC 20001
phone: 202-638-5555 • fax: 202-638-0891

The International Festivals & Events Association
PO Box 2950, Port Angeles, WA 98362
phone: 360-457-3141 • fax: 360-452-4695